Foreword
– Charles Stankievech

If there is a leitmotif to be found in this issue, it is in the variations of these mutating questions: What is indigeneity? Who defines it? Where does it exist? What is the role of kinship, *communitas, comunalidad*? And what role does art or the museum play? The rhythm might loop, it might skip, it might enter a fugal dissonance. And at times it might go silent.

A year ago, the *Afterall* editorial team met in Toronto to work on the issue you hold in your hands. Conscious that it was the first time the London-anchored journal met in the 'colony', Wanda Nanibush and myself organised a private round table with local Indigenous elders, artists, curators, students, professors and writers as well as the *Afterall* editorial team.[1] As the day grew long, the conversation shifted from histories of inclusion to understandings of structural change, which resulted in an invitation to documenta 14 curatorial advisor and Indigenous curator Candice Hopkins to join the editorial team. The current issue is also one of our most global issues to date, bringing together artists and communities that have manifested a collectivity for *resistance, visibility* and *imagined political futures*. Within these pages are artists, writers and organisations from South, Central and North America; the UK, Europe, Russia and Africa; and now Asia, since, with this issue, the journal has added the NTU Centre for Contemporary Art Singapore and Ute Meta Bauer to the editorial team.

Lee Maracle's poem 'Dedicated to the Anishnawbekwe' opens this issue as we attempt to reorientate the scope of the journal's voice. In establishing unprecedented histories, several of the essays make inclusionary moves, such as Lee-Ann Martin's, Griselda Pollock's and Cédric Vincent's. Martin recounts her insider's view of the catalysing protests, exhibitions and symposia from 1988 to 1992 that radically reshaped the cultural sphere of Canadian museums and the practice of exhibiting Indigenous art. In parallel, Pollock writes about the importance, in the UK, of ensuring she acquired a work by Black diasporic painter Lubaina Himid in the 1990s – just so 'that *Lubaina Himid* was visible in a public gallery'. Vincent's contextualisation of a contemporary art exhibition in Dakar in 1966, 'Tendances et confrontations', considers what was at stake at the Premier Festival mondial des arts nègres (First World Festival of Negro Arts). Vincent proposes the exhibition did not perform an 'expression of African cultural unity' as the overall festival was designed to do, but instead produced 'a great heterogeneity'. Such important histories must also take into account refusals, including that of the African-American artist William Majors when he did not accept his award from the festival on the grounds he kept his art and his identity claims separate.

The inauguration of a pan-Africanist political aesthetics in Dakar in 1966 is picked up in this issue's conversation concerning the South African collective Chimurenga, in which Kodwo Eshun, Emily Pethick and Avery F. Gordon discuss their Foucauldian-like (think of 'Fantasia of the Library') project at The Showroom in London. Ntone Edjabe, introduces their artistic intervention of maps into these pages in a short essay challenging the legacy of colonial surveying in Africa, which asks, 'How do we, on the continent, create a cartography that is so exactingly representative of our fluidities, complexities and material realities?'

In contrast, Anders Kreuger considers the counter-intuitive possibility of a European *indigeneity*. Kreuger has meandered through oil-rich western Russia, working with artists of the Finno-Ugrian region who have survived the ebb and flow of Russian oppression for over a century. As the USSR fractured, a sliver of artists initiated the techno-utopic art movement ethno-futurism. Perhaps unexpectedly, the most compelling section of Kreuger's essay is his philology of 'indigeneity', from the Samoyeds to *inorodtsy*. Tracing the *kisiskâciwani* river back to her birthplace, Métis scholar Zoe Todd challenges herself to imagine the 'carbon and fossil beings' of the oil that the Alberta tar sands industry is extracting as her ancestral kin. Todd's writing frames an intergenerational family narrative, transforming a story about her

1 We thank all the participants: Bonnie Devine, Charles Esche, Barbara Fischer, Luis Jacob, Duane Linklater, Anders Kreuger, Lee Maracle, Gerald McMaster, David Morris, Wanda Nanibush, Karyn Recollet, Ryan Rice, Jim Shedden, Stephanie Smith, cheyanne turions, Georgiana Uhlyarik, Helena Vilalta, Rinaldo Walcott and myself. Candice Hopkins teleconferenced in during the week, and graduate students sat in.

grandfather's resistance to colonial pressures into a manifesto for a future decolonised art based on care and kinship.

With the established incantation that coloniality is the dark side of modernity, Walter D. Mignolo's text on decoloniality directly responds to the *Afterall* editors' proposition to consider the relationship between the refugee crisis in Europe and the recentring of *indigeneity* on local practices instead of modernist ideas of decolonisation. In danger of creating an epistemological argument that cannibalises any knowledge system it encounters, Mignolo attempts to navigate the paradoxes of universal residues in academic Western thought while undercutting such deep biases with declarations of plurality. A strange pairing comes to mind: 'We have never been modern.' / 'We are all indigenous.' Similarly, Lucy R. Lippard wrestles with the tangled threads of artist and poet Cecilia Vicuña's self-identification with indigeneity and long-term engagement with environmental issues and colonisation. Her essay pivots around Candice Hopkins's nuanced position that while indigenous knowledges and cosmologies might provide strategies to resist environmental disaster, such universalising of identity can further efface the already dispossessed. Following Todd, self-identification is an important potential, but it must be met with community reciprocity.

Stavros Stavrides questions the real outcomes of documenta 14, which at this early stage is functioning like a franchise to gentrify Athens. Stavrides remains sceptical, saying despite all the curatorial declarations and signs of freedom, documenta 14 is currently only providing freedom for the already mobile, liberal, capitalistic elite as opposed to generating a healthy, local polis. He suggests considering, in contrast, Gustavo Esteva's concept of *comunalidad* (commonality), which Esteva defines as 'a collection of practices formed as creative adaptations of old traditions to resist old and new colonialisms, and a mental space, a horizon of intelligibility: how you see and experience the world as a We'.

Rewind back to the 1990s, where we started this foreword, to look at the source of two texts – one co-written by Pablo Lafuente and Michelle Sommer, another by Irmgard Emmelhainz – that historicise a small community museum, the Museo Comunitario del Valle de Xico, located on the outskirts of Mexico City and founded in 1996. Lafuente and Sommer's writing utilises the literary strategy of a fragmentary text and imaginary architectural ruin, but the piece shifts philosophically, from individual self-actualisation to the solidarity of *communitas*: the spirit of a community, self-managed and interested in shared experience rather than 'objects' and 'exhibitions'. Emmelhainz also lauds the Museo apropos a thorough institutional profile, and then focusses her address pointedly toward the reader, as a privileged 'We' that must support similar initiatives. Is the 'We' the same as Esteva's 'We', which Stavrides desires for Athens? Does Stavrides want documenta 14 to do the same thing as the Museo Comunitario de Xico? The two texts provide an uncanny doubling. Can this *communitas* become a *comunalidad*?

Part of me wants to end this foreword on a positive note – to refer, like many writers in this issue, to an inspiring line from the indomitable Fred Moten. But let me be clear: within what is an incredible issue, there are potential problems. Despite intentions, if one's position of privilege is not accounted for, and countered, the work rots – sometimes quickly, sometimes with a slow decay. Maybe before it goes to press, maybe after. Language – and there is an incredible variety in this issue – is impregnated with biases we do not inherently understand, and yet they uphold our whole world. Like a glistening web, we fall into our own traps when we marvel at their own construction. Conversations around community and indigeneity, or critiques of modernity and coloniality, often try to strip away suffocating universals. And yet we spew them out, unknowingly, in the next breath.

In reality, I need to address Hannah Black's piercing meditation on Lubaina Himid as well as Lee-Ann Martin's sobering conclusion – both difficult to stomach. Black makes the stark observation that if Himid was to remount the group exhibition 'The Thin Black Line' that she curated at the Institute of Contemporary Arts in London, the show would be just as fresh today. From a 'Black Ops' perspective this signifies Himid's genius, but, for Black, it also confronts 'the lie of the post-racial', indicating the British art world has barely changed in thirty years. Martin closes her essay with a different assessment of the past 25 years, one that makes her 'angry and frustrated. Indigenous arts professionals throughout Canada and the world have developed a formidable intellectual force that challenges the basic premise of Western mandates and practices. But drastic conditions still exist...' As Martin closes: 'Much work remains to be done.'

This is not the time for silence.

Dedicated to the Anishnawbekwe

(who founded the Barrie Native Friendship Centre)

— Lee Maracle

Words are breath tracks speaking to those who have already left their
 imprint
on our lives.

These words whisper softly from just behind the footprints of those
 who
first imagined this house.

Because so many of those who imagined this house were women it
 quickly became
a reality.

I look upon the journey you must have taken from the moment of
 conception to
this moment when our breath tracks speak to honour you.

I picture the endless nights of huddling over coffee, dreaming up the
 next step,
knocking down obstacle after obstacle.

I listen to the memories of phone calls to friends, to neighbours, to
 officials, even to
foes, to make this building happen.

I watch from behind you as your murmurs join each others words,
 listen to the words link
themselves to others until, the words became a mortgage, a building, a
 program...

I see the moments when, nearly disheartened, overworked and not
 quite there yet,
some of you must have considered throwing in the towel.

The sighs around the table must have occasionally been heavy, then
 some one of you
told a joke and the spirit changed.

I know before the programs, before the building, before the mortgage,
 there was an
amazing clutch of women, who journeyed to our success.

Amazing women with sure feet, endless energy and a great vision of
 community, *Migwech* to
each and every one of you.

This poem was originally published in Lee Maracle, Bent Box, Penticton, BC: Theytus Books, 2000, pp.127-28.
It is reproduced by kind permission of the author.

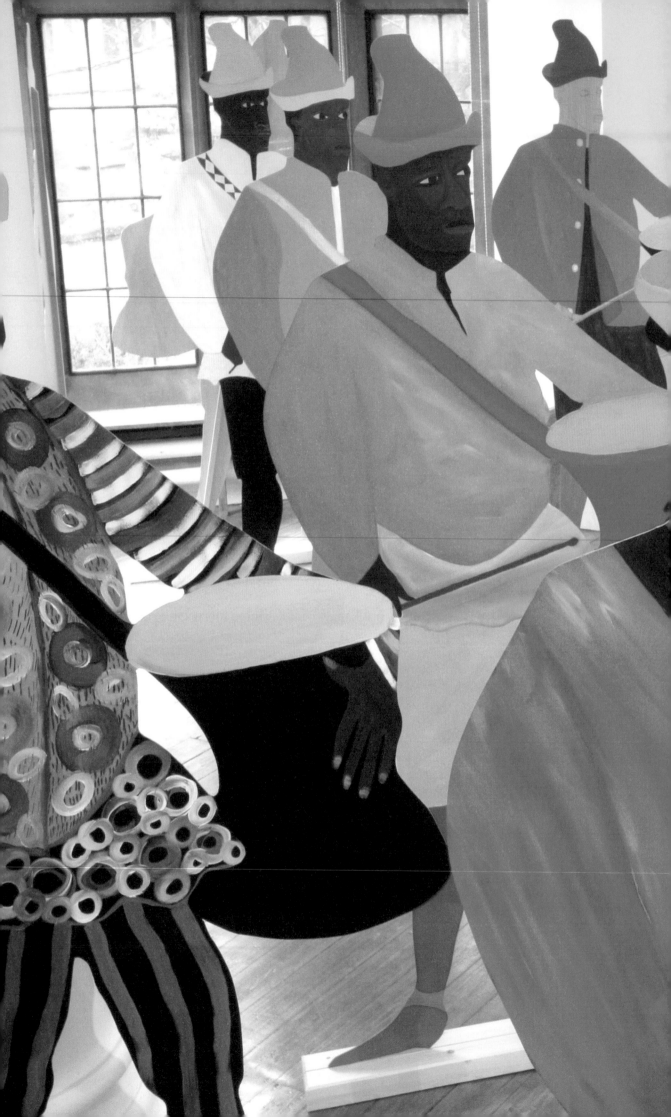

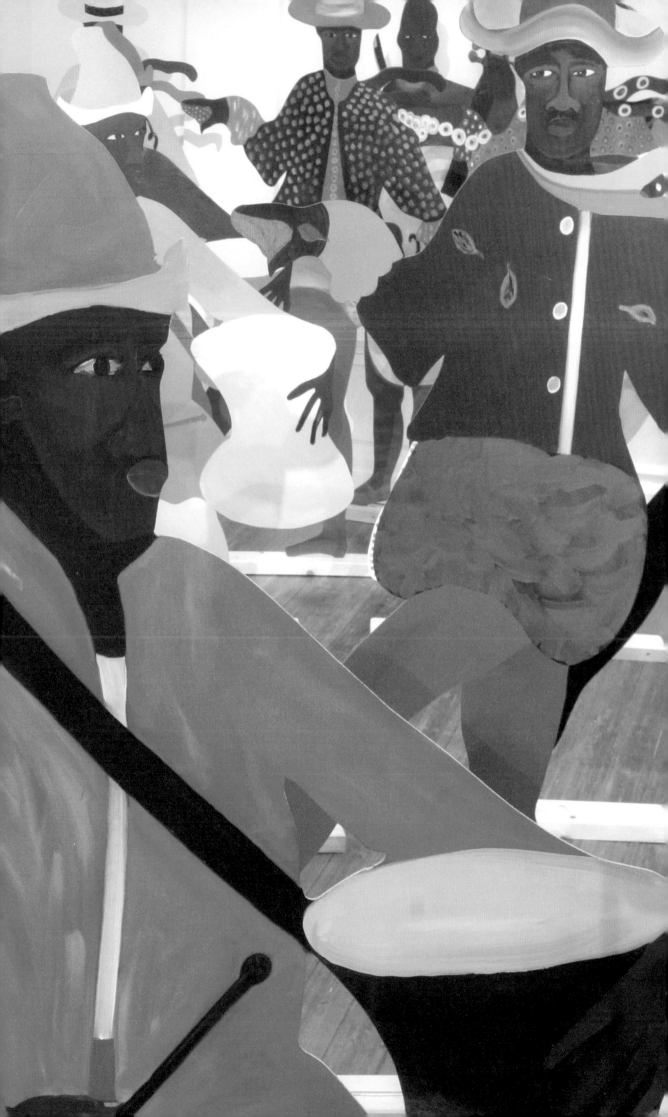

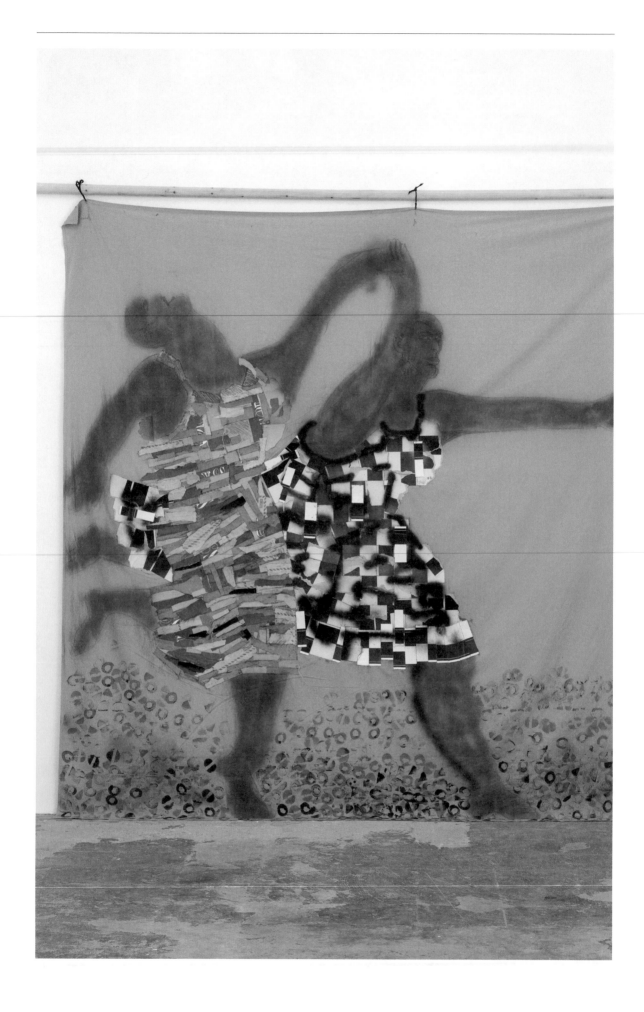

Lubaina Himid: Revision

– Hannah Black

My Parents, Their Children

There are two distinct figures in the painting, but there could be many more. There are two figures, a pale-skinned man and a dark-skinned woman, but there could be less than two, because their bodies dissolve into a deep-red background, onto the field of which black intrudes from the edges. The woman holds out two hands, in a shrug or a supplication or a gesture of persuasion, and the man holds out one hand. His left hand is nowhere. In the place where a left hand might go, if he had one, there is a white blur, like a tornado in a movie or chalk scrawled

Hannah Black explores the patterns of personal lives and transnational histories that are weaved in Lubaina Himid's work, and the multiplicity of their political dimension.

sideways on a surface. His right hand might be gesturing or giving up; it might have just let something fall to the impossible floor.

In the painting *My Parents, Their Children* (1986) by Lubaina Himid, the Black woman's hands are more definite than the white man's single hand, and her expression is more definite too, containing: one, sorrow; two, suspicion; three, fear of harm; four, concern; five, strength of will; six, inscrutable sense of self held away in private trust, just in case. Are these two 'my parents' or 'their children'? If they are the parents or the children, then the other – the parents or the children – might be the roughly, barely painted column of white that blocks the space in between them, at the base of which the proposition is reversed in neat lowercase letters: 'their children/my parents'. At the top of the column, suspended in its cloudy black head, these words appear: 'my grandfather never met my grandmother'.

In photographs of strangers, the kind you still find in overflowing boxes in vintage stores or just by browsing social media, sometimes the relationships feel instantly comprehensible – mother and father hold-

ing their child's hands, one each, the adults pressing close – while in others you don't know who anyone is. I want to think of the cloudy and careless entity made of white and black paint that separates the two figures as their unexpected child, the kind of thing that happens when two irreconcilable differences meet and have sex. But the words 'my grandfather' and 'my grandmother' hover above their heads like labels. These two are the grandparents. The title's declaration – 'My Parents, Their Children' – refers to the parents who are not depicted, or are depicted as this slur of white and black paint in the middle, which I cannot get over; nor can the two figures, because it separates them. In families that contain different histories of race, which is to say different histories of failure, courage, pride and humiliation, which is just to say 'histories', the simple facts – this person met this person, this person was born – take on strange dimensions. The acid bath of history can break up a body into parts, were it not that the body goes on insisting on its weird integrity, just by being factually present, just by the world emanating outwards from and falling into it as it does from and into all bodies.

Between a white woman and a Black man there might be the idea of sex, or the fear or promise of it, as these two characters in the *commedia dell'arte* of race relations have been tasked so many times with performing a pantomime of white fear of the body – the Black stranger and the trembling white wife, and so on. Against this background they can represent either the triumph of a liberal progression towards a mythic post-racial world or the exciting, awful danger of falling into animal nature, depending on where you look from. They play pantomime because their encounter is symbolically always mediated by a white man. This dance excludes Black women, as if excluding a difficult truth.

Between a Black woman and a white man – turned into a canvas, into symbols – there has been a more terrible proximity,

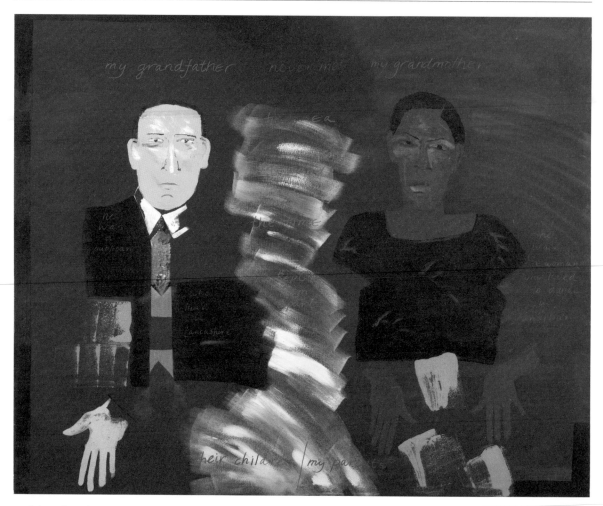

and therefore there is no available panto-mime. The figures hold their three hands out as if unsure of finding any other gesture, or any gesture at all. To a great extent, the problem of blackness as a question of category (authenticity, quantity, *personal brand*) rather than of experience has been determined by the ultra-productive sexual violence that white men have inflicted on Black women, formalised as *partus sequitur ventrem*: the mandate that slave status pass through the mother, the law that authorised the breeding of slaves. Had the grandparents met, family bonds might have mediated and domesticated this connection founded on property rights, on commodification and on extreme and permissible violence; but instead they float separately in a scab-red space.

But history is both gentler and worse than my telling of it. Grandpa and Grandma have both come beautifully dressed for the occasion of their first meeting, him in a suit and her in what looks like blue velvet. His shirt is buttoned all the way up and her hair is slicked down and neatly parted. Their faces show no hope, but their clothes look hopeful, like best clothes picked out for a

party. If their expressions are not the most welcoming, if they face us instead of each other, that is only to be expected from two people who have lived in the same world in different worlds. Their eventual encounter happened belatedly, in the body of the artist, who gives them a frame in which to stand almost together.

A grandmother and a grandmother are someone's children and someone's parents, in the endlessly recursive nature of a family tree, until it stops with someone who tasks herself with telling this endless recursion and gets lost and found in it, or goes on differently.

Away (Flat)
Himid's installation *Naming the Money* (2004) comprises speaking depictions of Black servants and slaves that hover between sculpture and painting. The money is named by the sculptures' flatness, their many-*ness*, and Himid refers to them as 'life-size cut-outs' – an absence the size of a life. The Black people represented in the cut-outs are lifted from portraits of wealthy white people and reimagined. In a sense they are set free from the frame and in a

Lubaina Himid, *My Parents, Their Children*, 1986, acrylic on canvas and mixed media, 151 × 184cm. Courtesy Birmingham Museums Trust, Birmingham and the artist

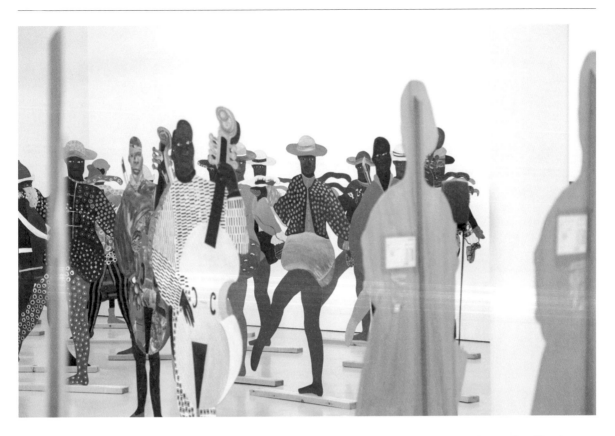

Lubaina Himid,
Naming the Money,
2004. Installation
view, 'Navigation
Charts', Spike
Island, Bristol, 2017.
Photograph: Stuart
Whipps. Courtesy
Hollybush Gardens,
London and the artist

sense (so flat!) they remain tied to it, because they originate there, or this origin is the justification for their renewed presence in the gallery. In the original paintings they symbolise white wealth, which is to say they symbolise their own absence from home. In Himid's work, they symbolise themselves. 'I used to live with my family; now my family lives apart', says one, or Himid has one say. With voices and names, they fall down from the high ceiling of something called history and onto the wooden floor of ordinary pain. The walls get the most attention, but a museum needs depth too, needs a ceiling and a floor.

All together, in a room at the Harris Museum and Art Gallery in Preston in 2007, the figures performed the necessarily clumsy procedure of introducing a new theory of history. Also in 2007, at the Victoria and Albert Museum in London, the sculptures of *Naming the Money* appeared next to white-marble ladies reclining.[1] There, their flatness became more like that of a knife, aimed uselessly at stone-cold, self-satisfied flesh. This kind of knife, the cutting edge of figuration's white flatness, often has to stay private and imaginary.

Of another work, *Swallow Hard* (2007), paintings of Black people on British ceramics, Himid says, 'The point I am often exploring *vis-à-vis* the Black experience is that of being so visible and different in the white Western everyday yet so very invisible and disregarded in the cultural, political or economic record or history.'[2] The ceramics themselves, the museum itself, should make Black people visible, because the museum and the ceramics were minted by the invention of blackness. But money is flat and disappears when turned on its side.

These are old problems. They circle around and go nowhere. The Black diasporic condition that Himid sees as characteristic is the loss of the dimension of time – perhaps this zero temporality fuels the cyclical nature of the art world's discovery, forgetting and rediscovery of Black artists.

At the Institute of Contemporary Arts (ICA) in London in 1985, Himid's exhibition 'The Thin Black Line' claimed and critiqued the art museum through the inclusion of a group of Black and Asian artists, all women. The transition from the first significant entries of Black women artists into European art spaces to the white dec-

1 *Naming the Money* was included in the exhibition 'Uncomfortable Truths: The Shadow of Slave Trading on Contemporary Art'.
2 Lubaina Himid in conversation with Jane Beckett, 'Diasporic Unwrappings', in Marsha Meskimmon and Dorothy C. Rowe (ed.), *Women, The Arts and Globalization: Eccentric Experience*, Manchester: Manchester University Press, 2013, p.194.

theguardian
weekend edition

£1.60
Saturday 20.12.08
Published
in London and
Manchester
guardian.co.uk

Gangs are getting younger and more violent, Met chief warns

Children killing each other over 'trivial' slights and girls increasingly involved

Christmas appeal Giving birth in Africa

Silence speaks louder than a flak-jacketed news hack

Anne Enright

A woman in Tiriri clinic lies on her side and labours in silence. It is early morning. Her husband, who sits beside her, looks worried, hopeful and forlorn. His wife's gaze has turned inwards, she is already in a different place. She doesn't seem frightened, as perhaps she should be. There is no pain relief here, and a week-old baby in the next room has just lost its mother to septicaemia.

I am astonished by the woman's silence. I am also worried that the look in her eyes seems so beautiful to me. Later I ask Brenda Acam, a student home from Kampala for the Christmas holidays, whether all the women of Katine give birth in silence. She laughs and says, 'You have children - did you not scream?' but yes, she agrees, 'Many of the women take their pain inside.'

It is the silences I find most disturbing in Katine. The children in the village are often hungry, but you do not hear that thin open cry of an unfed baby, or the outrage of a toddler surprised by the sudden emptiness of its belly. It seems

Continued on page 2 »

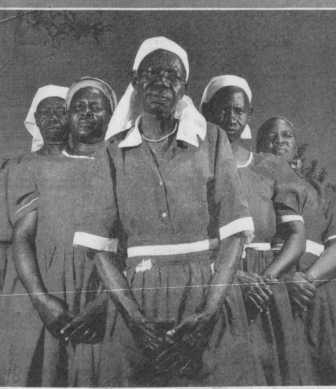

Sister Josephine Acen, centre, and her fellow traditional birth attendants in Katine Photograph: Dan Chung

12 A

C M K

Wednesday 20.08.14
Published in London
and Manchester
£1.60

theguardian.com

theguardian

winner of the Pulitzer prize 2014 | newspaper of the year

Second police killing fuels US racial tensions

Dunn does well

Isis releases video of US journalist's beheading

Spencer Ackerman New York

Jourdan Dunn is the first black Briton to enter the Forbes models rich list since it began in 2006, earning £2.4m over 12 months. Report, page 7 Photograph: Rex

Continued on page 2 »

Fifty stars express 'dismay' at lack of black and minority figures on screen – and back Lenny Henry's call for quotas

This section, page 7

laration of the post-racial is so fast it makes your head spin. Thirty years after 'The Thin Black Line', a similarly curated show would feel no less striking and fresh, which is as much a testament to the lie of the post-racial as it is to Himid's genius. The relentless othering of non-white artists requires constructing each individual as, paradoxically, either an extraordinary exception or a good example. Himid has resisted this tokenisa-

ists' (alienation) but with many overlaps. Most importantly, the prominence of US struggles in global Black politics has problematised political blackness to the point of no return, usefully redirecting attention towards the conditions in the colony rather than those at the colonial centre. As a result, it is impossible to make an equivalence between the political subjectivities of the colonised people whom the coloniser en-

tion by bringing her context into the gallery with her; by curating shows with other women of colour; by archiving, celebrating and showing their work. We have to go on doing this interesting and useful work for each other because we have a lot to say to each other. Representation is only reductive to the extent that its possibilities are reduced.

The publication created to accompany 'The Thin Black Line' refers to all the artists as Black, while a 2011 book published by Tate on this show (and two others) refers to 'Black and Asian women artists'.[3] In the decades since the exhibition, the meaning of British blackness has changed and also stayed the same – surveilled and marginalised. The conflation of Black and Asian diasporas into a unified Black identity, common in Britain up until recently, reflected their shared postcolonial status in the country.

Since then blackness and brownness have become pretexts for modes of policing, aimed at either 'gangs' (sociality) or 'terror-

counters in their homeland, amid their own historical forms and antagonisms, and of Black people removed forcibly from Africa and brought to unfamiliar islands as raw labour. The task of collapsing the struggles of all racialised peoples into a single category has now moved to the phrase 'people of colour', a term crafted by Black women as a collective indicator of solidarity across different experiences of race. This term is now itself under erasure, as indicated by increasingly popular phrases such as 'non-Black people of colour' and ubiquitous critiques of 'poc solidarity'. These are not mere intellectual or curatorial niceties: questions of what constitutes blackness and of the singularity of Black experience cannot be fully closed while anti-blackness persists – nor is it ethical to leave them entirely open.

Himid's work, her being, travels through different racial regimes separated in space and time, navigating by pattern: What is the same and what is different? Who is like me and who is unlike me? These

Previous spread: Lubaina Himid, *Guardian Paperworks: Negative Positives*, 2007-ongoing, acrylic and pencil on newspaper, 47 × 31.5cm. Courtesy Hollybush Gardens, London and the artist

3 See *Thin Black Line(s): Tate Britain 2011/12* (exh. cat.), Newcastle upon Tyne: University of Central Lancashire, 2011.

questions cannot be resolved because they are tools for navigating the world and the self. These artworks cannot be resolved: Himid talks often in interviews about continually revising old paintings so that they stay alive. Sometimes, in works like *Swallow Hard*, Himid condenses the question of a Black diaspora to its most simple expression – a reminder that Black people exist, have existed, will exist. This is still very hard for

tion of a ban on images, Himid's work is informed by the communicative possibilities of pattern - that play of abstract image and concrete life. Lives fall into patterns, too. That's what it means, to be living out a history, to be living out of history, to be living out of a suitcase that you like to refer to as history.

In Himid's series *Guardian Paperworks: Negative Positives* (2007–

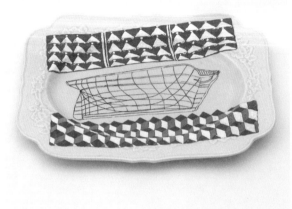

Above and opposite: Lubaina Himid, *Swallow Hard: The Lancaster Dinner Service*, 2007, acrylic on ceramic, dimensions variable, details. Courtesy Hollybush Gardens, London and the artist

people to understand. 'We must leave evidence that we were here, that we existed… Evidence of who we were, who we thought we were, who we never should have been', says the disability rights activist and writer Mia Mingus, of the oppressed in general.[4] The evidence is as much for ourselves as anyone else. For all the efforts of the modernists to keep the great ceiling of history intact, it falls down as dust, very slowly, over generations. Let's try to believe in this, and not be afraid.

Away (Ocean)

The ocean passages that obliterated time and family, all of that, that fragmented the world and joined it together, are braided through the incoherence of water. Everything we say about the void falls off into it. Now I'm looking at a floral-patterned plate with a black face on it (from *Swallow Hard*) and thinking of the ban on images of Auschwitz with which Adorno thought to bring the trash of memory/forgetting into the court of critique. As a way of leaping over the ques-

ongoing), images of Black people in *The Guardian* newspaper are framed by serenely patterned overpainting, lifting a part of the image up and out – a hand, an arrow – and repeating it until the epidermalised punctum of the celebrity skin is soothed away. An object's self-representation, which is a technological and not psychological matter, falls outside a ban on representation. For the European museum, Black art begins as a representation of absolute alterity, and everything else it strives to do (become ordinary, for example, like a plate) has to start from there.

The perversity of Europe is that only atop a pile of corpses, symbolic and real, can a person become banal. The Black artist in Europe is condemned to always be interesting. What is interesting about the idea of a Black artist in Europe is the idea of someone carrying around a terrible hurt and exonerating everyone of this terrible hurt by doing so. The Black artist in Europe is condemned to always have been a curiosity. What is curious about the idea of a Black artist in Europe

4 Mia Mingus, 'About', *Leaving Evidence*, available at https://leavingevidence.wordpress.com/about-2/ (last accessed on 13 December 2016).

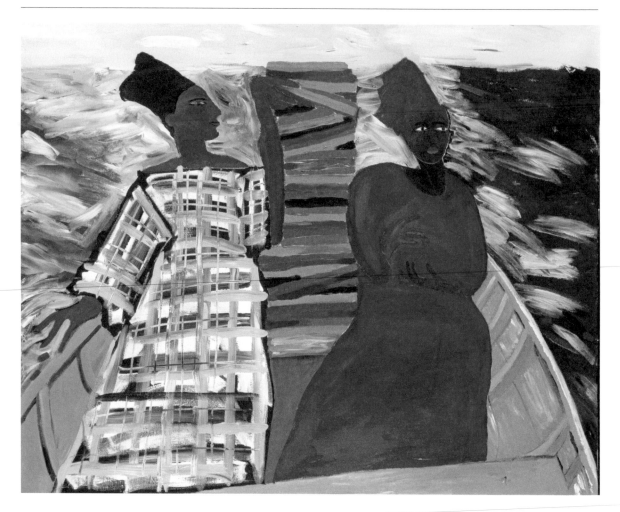

is the idea of someone carrying around a terrible hurt and insisting that we all look at it. There are two answers: forget yourself, or forget them. But you go on revising the answer because you are not sure if the question was right.

What caused this hurt? Asked in an interview about her paintings of the sea and water, Himid says: 'The fear of and obsession with the sea used to exactly mirror my life at the time of painting these works in which I could not navigate my way out of the dangerous places because they seemed safe. The strategy for escape seemed more frightening than the known danger.'[5] From Fred Moten's poem 'there is religious tattooing': 'it's simple / to stay furled where you can't live'.[6] I think he means it's not simple, but that the apparent simplicity of staying furled, contained within yourself, is an attempt to ignore the sea – 'furled' is a verb for a sail that currently doesn't know anything.

For all its mastery, all its serenity, Himid says her series *Plan B* (1999–2000)

was made 'at a time in my life when I was frightened a lot of the time'.[7] In *Plan B*, two adjacent painted views of the same thing – sometimes a thing transformed, sometimes just transposed – make a drama of the flat self-identity of mute objects. A popular anti-anxiety technique advises writing down your name and the date and place, then itemising what you can see in your surroundings (chair, screen, blanket, glass jar of oil, boots, phone…). The reality of objects is supposed to give contour and relief to the shapelessness of fear, but this technique feels lonely. It would be better to go inside the anxiety, inside the sea, than be confronted with the brute banality of oneself as an object amongst objects, picked up and put back down again wherever. But perhaps there is a process of becoming-thing, in art or life, that only then makes it possible to confront the fear of which the sea has become the object.

In her 2016 book *In the Wake*, Christina Sharpe refers to the afterlife of slavery as materialised in blackness, as pro-

5 L. Himid in conversation with J. Beckett, 'Diasporic Unwrappings', *op. cit.*, p.215.
6 Fred Moten 'there is religious tattooing', *Hughson's Tavern*, Southport: Leon Works, 2008.
7 L. Himid in conversation with J. Beckett, 'Diasporic Unwrappings', *op. cit.*, p.215.

Lubaina Himid,
*Between the Two My
Heart Is Balanced*,
1991, acrylic on
canvas, 122 × 152cm.
Courtesy Tate, London
and the artist

ducing a condition of 'non/being', alongside Black resistance to this foundational non/condition.[8] If Black culture is deployed all over the world as solace and excitement, sprinkled into the museum to keep things edgy and real or worthy and wholesome, it is not *despite* the positioning of blackness as the external edge of the human – as where the human blurs together with the commodity – but because of it. For Sharpe, living this impossible position of non/being requires something called 'wake work', a phrase implying alertness, mourning and the trail that a ship leaves on the water through which it passes.

Thinking of the ways people carry long-held hurt and neglect with them into their adult lives, the child psychologist D.W. Winnicot wrote: 'I can now state my main contention, and it turns out to be very simple. I contend that clinical fear of breakdown is the fear of a breakdown that has already been experienced.'[9] I suspect that

banality over generations. Two women sit on a boat, the wake trailing out behind them. A block of stripes between them is a stack of maps or something more energetic. Maps are no longer needed. The painting from which the title is borrowed, by a white man, depicts a white man sandwiched between two women, his mother and his wife. Just kidding – it's just two women. In Himid's version there are no white women, no white men. She says of the two women: 'The women take revenge; their revenge is that they are still here they are still artists, that their creativity is still political and committed to change, to change for the good.'[10] The original is revised to include its missing heart. *Revision* is a nice word because it implies we'll see each other differently; or one day see each other again.

The Black diasporic condition that Himid sees as characteristic is the loss of the dimension of time – perhaps this zero temporality fuels the cyclical nature of the art world's discovery, forgetting and rediscovery of Black artists.

Winnicot wasn't thinking of Black women, but here we are. The frightening possibility of escape-as-loss that the ocean once seemed to present is the reality that the loss, the escape, the great sea change already happened a long time ago, before the lines of experience were organised into something like an identity, when loss had no past or future.

Out of fear we make images of safety, and out of images of safety we make a world. Himid's painting *Between the Two My Heart Is Balanced* (1991) stages a meeting between two serene Black women on a frightening sea. The work is a Tate holding, bought with sugar money fattened into

8 See Christina Sharpe, *In the Wake: On Blackness and Being*, Durham, NC: Duke University Press, 2016.
9 D.W. Winnicot, 'Fear of Breakdown', in Donald Woods Winnicott, Clare Winnicott, Ray Shepherd, and Madeleine Davis (ed.), *Psycho-analytic Explorations*, Cambridge MA: Harvard University Press, 1989, p.90.
10 L. Himid, quoted in Maud Sulter, 'Without tides, no maps', in *Revenge: A Masque in Five Tableaux* (exh. cat.), Rochdale Art Gallery, 1992, p.32.

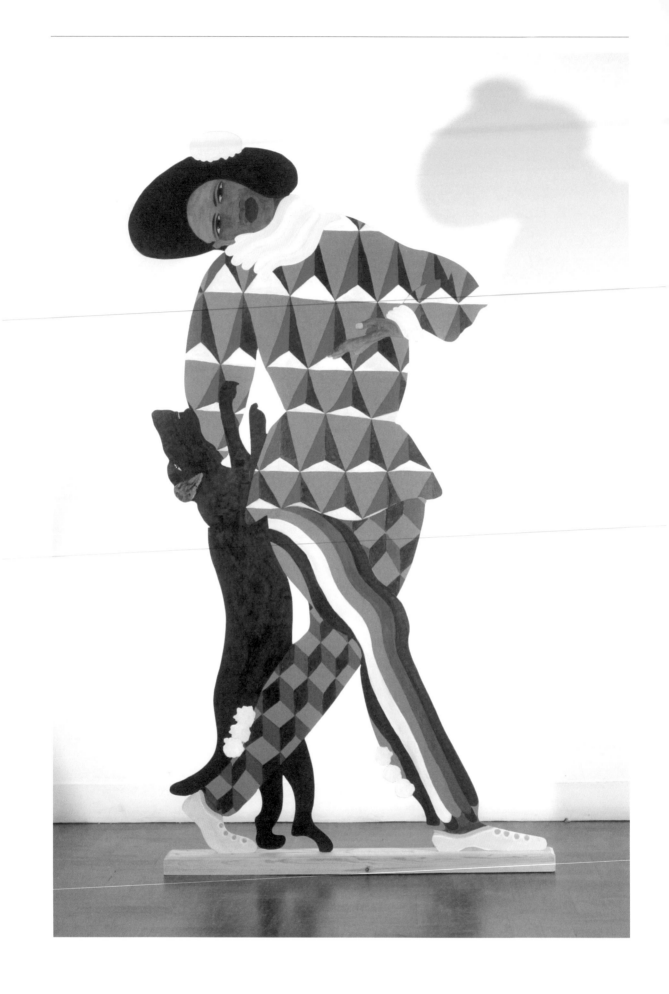

'How the political world crashes in on my personal everyday': Lubaina Himid's Conversations and Voices: Towards an Essay About *Cotton.com*

— Griselda Pollock

Patterns are not neutral. They are words, signals and whole sentences, signing different moods, saying different periods.
– Lubaina Himid, 2016[1]

The language of Lubaina Himid is a language of conversations, interventions, repositionings and patterns; negotiations of pasts and presents. Her work balances the mournful recognition of the annihilating force of racism in its everyday-but-relentless work of effacement and non-recognition, and the indomitable but tender evocations of the presence and agency of Black women. Himid entered my consciousness around

Griselda Pollock traces Lubaina Himid's creative trajectory as she articulates her presence and singularity as an artist.

1984–85, when Rozsika Parker and I were writing our book *Framing Feminism: Art and the Women's Movement 1970–85* (1987). She had just curated two exhibitions of contemporary British artists: 'Five Black Women' (Africa Centre, London, 1983) and 'Black Women Time Now' (Battersea Arts Centre, 1984–85). In 1985, the artist Sutapa Biswas, then a lone Indian fine art student at the University of Leeds, asked if I would invite Himid and Sonia Boyce to our Department for a talk, to thus succour her creativity in a postcolonial situation. Both artists came to Leeds and spoke to a packed room. At the time, Himid had been given a 'corridor' of the Institute of Contemporary Arts (ICA), London as the 'space' in which to present the work of her contemporaries. The show, 'The Thin Black Line' (1985), which included Biswas's work, laid down a thread that demanded I follow it.

Following Himid during the 1980s meant travelling a lot, to installations such as *A Fashionable Marriage* (Pentonville Gallery, London, 1986), *New Robes for Mashulan* (Rochdale Art Gallery, Greater Manchester, 1987) and *The Ballad of the Wing* (Chisenhale Gallery, London, 1989). *A Fashionable Marriage* drew upon the political imagination of William Hogarth to create a contemporary history painting, knowingly referencing Hogarth's place in the history of artists' struggle for visibility in the face of official gatekeeping.[2] With cardboard cut-outs of Margaret Thatcher entertaining Ronald Reagan in a deadly love-in that could lead to a third world war, on the political side, and the 'white feminist artist' taking the place of Hogarth's 'eager listener', seeking pearls of wisdom from the massive art critic (in place of Hogarth's castrato singer, while the Funder sits on the fence), on the art side, Himid reclaimed, across art and politics, the agency of the two African figures in Hogarth's paintings and prints.

Himid's *A Fashionable Marriage* choreographed the staging of the doubled scene of the politics of war and of art, with the artist using her signature cut-outs as both carved, semi-sculptural presences and flat, painted surfaces on which colour operated at its own doubled scale. Colour signified both the signature of the colonialist's imposition of a 'racial epidermal schema', in the words of Frantz Fanon, and the reclaimed language of a rich heritage of places, memories, cultures and a modernism that was renewed in Europe by its distorting discovery of Africa's multiple sculptural, performative and textile cultural-aesthetic resources.[3] The nine-foot-tall, six-foot-wide figure of the Black woman artist, made of the hardiest of building-quality birch plywood, loomed up as the central character of the work (no longer Hogarth's invisibilised African man serving hot chocolate in a cup, with a suggestively placed phallic biscuit).

1 Except where noted, quotations from Lubaina Himid are taken from my conversations with the artist in August 2016.
2 Hogarth painted a series of six pictures between 1743–45 titled *Marriage* à-la-mode (*A Fashionable Marriage*), depicting the upper classes during the eighteenth century.
3 Frantz Fanon, 'The Act of Blackness', *Black Skin: White Masks* (1952, trans. Charles Lam Markmann), London: Pluto Press, 1986, p.112.

She carried a bowl of limitless energy and ideas to revitalise the 'white feminist artist', inclined towards official acceptance, in need of this injection from the Black woman/ women artists to keep the feminist project moving forward. On the politicians' side, a young Black activist in the foreground replaced the boy-child with looted African sculptures; she knowingly opened the box of deadly weapons.

I did not get this when I first saw it. What I did see was what I was trained to home in on: me, or my alter ego in the form

Himid's extraordinary creativity over forty years has been a sustained battle to find her own forms, through which to speak in the first person; and more, to be seen and heard in that singularity as this artist.

of the 'white feminist artist' who seemed a composite figure of Susan Hiller, Mary Kelly and Judy Chicago. I had little experience to bring to understanding the urgency with which the reconfiguration of the two Black women in the work was speaking back as much to a feminist as to the dominant cultural establishment. I recently interviewed Himid about the work, prompted by an earlier discussion with her about the cloak of invisibility that had veiled from white eyes the prominent, tall, strong and clearly central figure of the Black woman artist who articulated the artist's own presence and singularity: I am here, I am an artist. She spoke of the tone of the piece and how, despite the massive force of the Black woman artist's presence, the citation of Hogarth kept *her* in the background – even the size and scale of her avatar could not interrupt the dominant field of meaning. Himid's created conversation, both with British art history and with the contemporary feminist scene, left the Black women in an oblique relation, isolated from each other as they both faced the viewer, questioning her, but not yet from their own space.

Revenge: A Masque in Five Tableaux (1991) marked a major strategic change.[4] It created the space for Black women to be

visible as the only subjects in the paintings, and, as importantly, pictured talking to each other. They were not a crowd, but two, each an individual in her own right while sharing a joint project of radical challenge and change. I bought *Five*, from this series, and placed it in the Leeds City Art Gallery on permanent loan.[5] I did so to make sure that *Lubaina Himid* was visible in a public gallery, in order to start conversations with those who might recognise themselves in the images of two Black women talking across a table about the future of the world and the dark histories they had inherited. Such viewers might come to feel at home in the gallery, and be inspired to be like the artist, to become an artist. The painting is often hung by the curators in conversation with abstract paintings, namely, *Winter Palace* (1996), by Bridget Riley, an artist with whom Himid feels herself to be in conversation, and *Helios* (1990), by Gillian Ayres. As a frame, such conversations work insofar as they acknowledge Himid's rightful place alongside her British contemporaries in painting, and specifically in terms of colour. The gallery itself, however, has not acquired further works by Himid and other Black women to extend the conversation between Black artists on its walls. As Sutapa Biswas was during her studies at Leeds, *Five* is lonely. It cannot speak all its languages, or mobilise all its concerns. The painting 'says' so much about its own situation, about the politics of the gallery space as much as of the condition of artists who are women and Black in contemporary Britain.

Himid's conversations have also been with place; with specific sites her work occupies. I travelled to St Ives specially to see *Plan B* (2000) installed at Tate there, with painter Alison Rowley and my daughter. Having stayed in a bed and breakfast from which I could see the famous lighthouse of Virginia Woolf's childhood (and her novel that mourns her mother), we walked to see *Plan B* by taking a path that led us around the coast and across the sandy flats with the tide out. As we turned back to look out to sea, we noticed the reflections of the sun on the rippled sand and trapped pools of water. We saw the colours. We saw a Bridget Riley there before us.

Plan B was a striking installation, without figures; full of rooms, waves, empty chairs, fabrics, objects and peepholes break-

4 First installed in Rochdale Art Gallery in 1992 and at the Southbank Centre in London.
5 It first came to Leeds in 1995, where it was the centrepiece of the first Feminist Arts and Histories Network Conference at the University of Leeds.

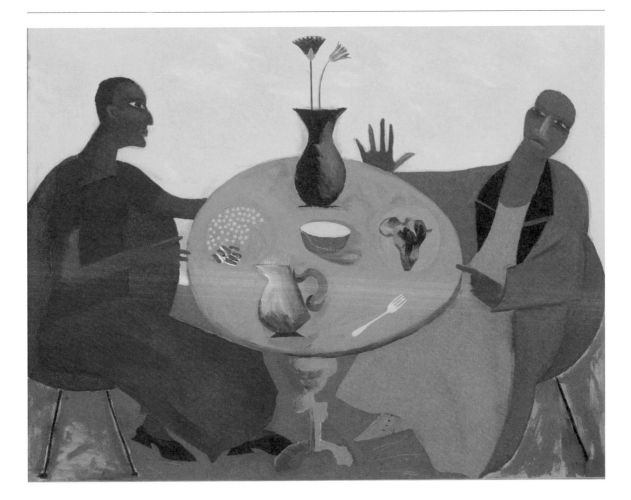

Lubaina Himid, *Five*, 1991, acrylic on canvas, 150 × 120cm, collection of Griselda Pollock on permanent loan to Leeds City Art Gallery. Photograph: Ben Westoby. Courtesy Modern Art Oxford, and Griselda Pollock

ing through blank walls to provide a glimpse of distant seas; and then 'a voice' created in painted writing that inscribed the terror of a group, of 'we' escaping to the safety of mountains. The installation placed the paintings in conversation with each other to form a rhythm of double canvases on the vertical axis and the horizontal. Both axes thus extended a severe and tall modernist white-cube gallery space lit overhead by natural light. In references to the sea and a coastline, to the echo of Zanzibar – and perhaps what I have called, in relation to my own formative memories of African space and place, 'natal memory'[6] – the historical voice of terror breaks through in one painting. Are these enslaved Africans who speak in and to this space of art, memory, war? Are they other kinds of refugees from violence? It is their fear that haunts this brilliant scene that knowingly claims its place in the history of British modernism and its 'spaces'.

❋

I want to jump now to *Naming the Money* (2004), a massive installation that reprised the cut-out after many years of painting. It comprised one hundred figures, each representing an activity undertaken by enslaved African men and women stolen from their own worlds and traded, renamed and reclothed to serve Europeans who did not see them as anything but instruments of types of required service and labour. Ceramicists, herbalists, toymakers, dog trainers, viola da gamba players, drummers, dancers, shoemakers, map-makers and painters formed a colourful and exuberantly creative company while music from different centuries – dating from the moment the first Europeans took people from the African continent – played throughout the space, marking four long centuries of servitude and oppression. On the back of each figure was a label-like bill of sale; in four lines the writing invoked the voice of the now reclothed and retrained personage by speaking of an original name, a given name, a former activity and a cur-

6 See my 'Back to Africa: From Natal to natal in the locations of Memory', *Journal of Visual Arts Practice*, vol.5, no.1-2, 2006, pp.49-72.

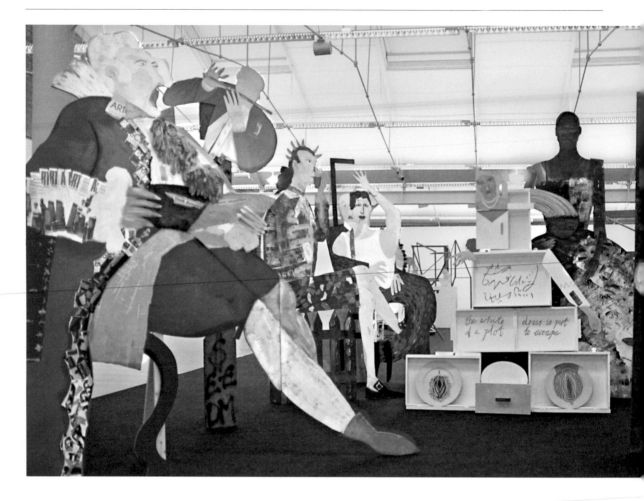

rent task. The back of the figure became the fragile space of each subject's individual memory and agency, the place where *I* speaks back to *they*, reclaiming *my* name from what *they* renamed *me*, remembering *my* skills back *there* and showing how even in *their* imposition of new tasks '*I*' keep a trace of *who I am*, still a person.

Conversations inside a single work, conversations between the figures in her installations, conversations between paintings and places, conversations between the artist and other painters, and now a chorus of voices speaking back *in the first person*. This last feature emerged in *Inside the Invisible* (2002), a site-specific installation in a former leprosy hospital, St Jørgen's in Bergen, Norway, of one hundred painted works on raw linen. The paintings, each five-inches-square on an eight-inch-square support, were placed in the small rooms the sufferers had once inhabited, cut off from the world by a disease that eats away at the body. To be a leper is to be cast out from a fearful, *abjecting* society, and to suffer unimaginable psychic anguish. Each painting had a small luggage label attached to it with string and

bearing a phrase written in Norwegian and English; each spoke of the person's past via an object ('I used this tureen on Sundays'), or of the precious objects that related to that past ('This is a special hook for mending nets'). Himid has written:

> I wanted to make a series of works that might give these people a voice. They were individuals, real, idiosyncratic, sexual, thinking people. They had memories, hopes, families. In the same way that slaves were more than slaves, lepers are more than just people with bits of their bodies missing through disease.[7]

This work reminded me of Himid's deep interest in workers, doers and makers, and in the rhythms of the daily lives of those who cooked, nursed, mended, washed, grew food, made babies, prayed, built and farmed. I also sensed a resonance she found in the sea people of Bergen, for many leprosy sufferers were fishermen. The sea has made its claim on her imagination again and again. One work that I had not known until

Lubaina Himid,
*A Fashionable
Marriage*, 1986.
Installation view,
'Keywords', Tate
Liverpool, 2014.
Courtesy Hollybush
Gardens, London
and the artist

7 See http://lubainahimid.uk/portfolio/inside-the-invisible/ (last accessed on 13 December 2016).

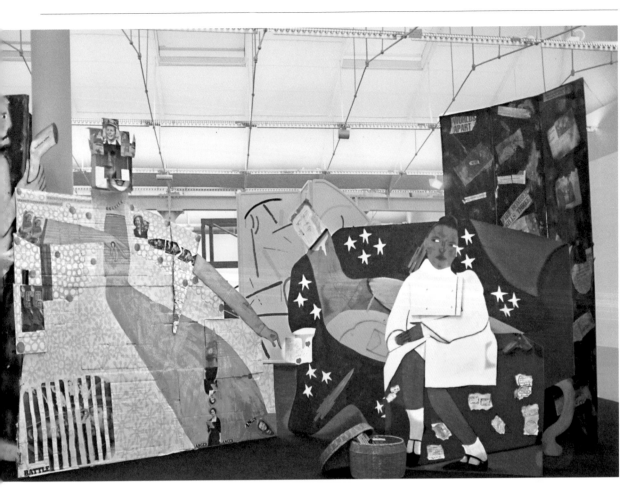

recently is *Zanzibar* (1999), shown at Oriel Mostyn Gallery, LLandudno in Wales. The most abstract of all the artist's works – fields of pulsating colour applied with a wide range of painterly processes, floating abstract patterns suggesting trace memories of buildings, shaded or highlighted facets evoking a brilliant sun reflecting off their surfaces – *Zanzibar* is a monument to the *natal memory* of place and of her journeys back to reconnect. The inchoate impressions of a first childhood home and feelings associated with its inexplicable loss now find a language in the processes of painting and the dance of lively pattern shapes in its worked surfaces.

The relay between *Inside the Invisible* and *Naming the Money* becomes apparent through pattern: the function of painting took over the colourfully personalised surfaces of the hundred later cut-outs, offering an evocation of a visual imagination. The word *pattern* has many meanings in English: 'repeated decorative design', 'a regular and intelligible form or sequence discernible in the way in which something happens or

is done', a 'model' and 'an excellent example for others to follow'.[8] It comes from the old French word *patron*. It was originally what was set out by those who were directing others to make things. Pattern thus has involved the imaginative project to make a form through which something becomes intelligible, to show that there is a form to the world. It is deep, structural and formal. *Repeated* and *decorative* are terms that acquired their negative connotations with regard to pattern-making and pattern-thinking at the moment of Western colonisation and as the gender hierarchy in early capitalist Western art established its hierarchies and codes. These terms become the negative of what is valued as original and singular as well as of whatever Western art has decided it wants to be when it is being tough, rigorous and *white-manly*.

It is, I would argue, Western art that should be understood as the brief aberration in world cultures because it does not delight in either the forms and shapes of living things in the world, or the capacity of our imaginations to create forms and to fill

8 'Pattern', *Oxford English Dictionary*, 2017, available at: https://en.oxforddictionaries.com/definition/pattern (last accessed on 31 January 2017).

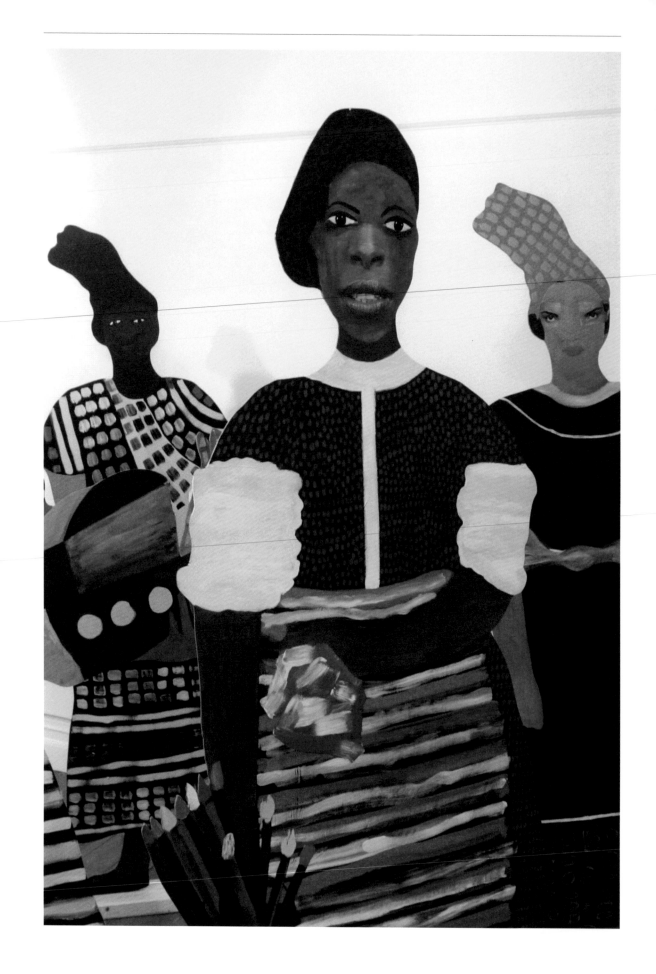

Lubaina Himid,
Naming the Money,
2004. Installation
view, Hatton Gallery,
Newcastle. Photo-
graph: Mark Pinder.
Courtesy Hatton
Gallery, Newcastle
University (Tyne
& Wear Archives &
Museums)

fields of colour that we wrap around our moving bodies, hang up to make walls and partitions, use to decorate and make vivid our living spaces, place beneath our feet, or make brilliant and awesome our sacred buildings. Pattern and its decorative use on surfaces and fabrics, in either its natural-istic joy or its symbolic abstract forms, is a worldwide language capable of as many layers of reference, association, symbolism and invention as any of the pictorial repre-sentationalism or human figuration that the West has so privileged even while remaining arrogantly dismissive of the deep fascination with pattern that has always exercised the imaginations of its own illuminators or stonemasons.

Pattern and painting have a long history in Himid's artistic language. *Inside the Invisible* went further. Her multiple paint-ings became objects. Not just images of cher-ished things that she imagined might reforge for the leprosy sufferers affecting links to the everyday social world from which their dis-ease had exiled them, her paintings on linen stood in for cloths and objects the inmates might have held close to their disintegrating bodies as talismans of healthier pasts. The borders of raw, undyed linen around the painted areas were also part of making a new form: a single entity composed of many elements, each one becoming a little world of memory and meaning, while combining to become a composite work of many utt-erances, some visual and others the loving traces of lost speech. *Inside the Invisible* speaks to the subjectivity of the unseen, the non-recognised. The work produces both an absence – the people whose incarceration because of disease made them feel disap-peared – and a presence – rehumanised, re-subjectivised persons to haunt these rooms in Bergen that are now a museum of ghosts.

❋

Between *Inside the Invisible* and *Naming the Money*, Himid made *Cotton.com* (2002), first shown in 'Fabrications' at CUBE (Centre for Understanding the Built Environment) in Manchester, in a building that had been part of the city's history as a capital of textile manufacturing and com-merce.[9] For *Cotton.com* the artist set herself the task of creating one hundred paintings at what she has called 'specimen' size – slightly smaller than those in *Inside the Invisible*. It was no mean feat to paint so many paint-ings while working full time as a university professor of fine art, to create one hundred visual events of varied internal rhythms and never repeating a motif. Himid told me that the labour involved in such detailed, close and careful painting performed a deep connection as a kind of physical mirroring to the piecework of the past, or the unpaid labour of enslaved workers. She does not image labour but performs it, in her own gestures and exhausted body. Its traces are her paintings.

The title *Cotton.com* combines a plant that is made into a fabric and an Internet handle, shorthand for commerce and busi-ness. As a result the former, a plant or a woven cloth becomes a commodity – as did those forced to pick cotton under specific historical conditions. It is against the human violence and violation inscribed in this brev-ity that a beautiful, elaborate and profound work unfurls.[10]

In the latter part of the nineteenth cen-tury, textile workers living in the north-west of England were affected by the American Civil War (1861–64) due to their links with the provision of slave-grown cotton. During that war, the Confederate States of America, seeking to hold on to slavery, thought to pres-sure European countries to enter the war on their side by cutting off the supply of cotton. The resulting cotton famine immiserated and starved the textile workers of the Man-chester region for a two-year period. At the point at which President Abraham Lincoln was about to deliver the Emancipation Proclamation of 1863, the Manchester trade unions held rallies and wrote to President Lincoln of the solidarity of the suffering fac-tory workers of the north in supporting the humanitarian project to end slavery in the United States. A bronze statue of Lincoln by

9 *Cotton.com* was commissioned by an academic group of historians of Manchester as part of an interdisci-plinary AHRC project on urban history and memory. The CUBE building had been a textile showroom, probably displaying rolls of fabric, hanging in great flows or broken into samples. That memory was invoked in the formation of Himid's installed paintings.

10 This work has been carefully and deeply studied in terms of its textiles' meanings and its visuality by Claire Pajaczkowska. Alan Rice has written fully on its complex relationship to the political and social history of Manchester, King Cotton and the suffering of the Manchester millworkers during the cotton famine. Both offer profound analyses which I will not rehearse here. See C. Pajaczkowska, 'Urban Memory/Suburban Oblivion', in Mark Crinson et al., *Urban Memory: History and Amnesia in the Modern City*, London: Routledge, 2005, pp.23–45; and A. Rice, 'The Cotton that Connects the Cloth that Binds: Memorialising Manchester's Civil War from Abe's statue to Lubaina Himid's *Cotton.com*', *Creating Memorials, Building Identities: The Politics of Memory in the Black Atlantic*, Liverpool: Liverpool University Press, 2010, pp.81–101.

Our entire food supply was devoured early on by a pack of stray animals. In desperation we tried to remember which mushrooms berries and bugs our grandmothers had once taught us were collected by their mothers years before. We were cautious and very afraid but the forest fed us well.

American sculptor George Grey Barnard created for London now stands in Manchester, bearing a plaque with the words of Lincoln's grateful reply to the Manchester unions, carefully edited to replace 'workingmen' with 'working people'. This too brief summary of an extraordinary episode sets the scene for a reading of Himid's reflection on two worlds and how they *touched* via the threads of raw and spun cotton.

Himid is interested neither in the trade union leaders nor Lincoln. In making *Cotton.com*, she wanted to make the everyday workers linked across the Atlantic by cotton touch via a very different gesture. She thought about the simple fact of the great bales of cotton coming into Manchester on barges from the seaport of Liverpool. She imagined the Manchester workers unloading, unpacking and sorting the compressed bolls; finding hairs, bits of fabric, fingernails, toenails, blood, skin and so many tangible traces of real bodies on the other side of the Atlantic. 'Cloth', she has noted, is not just a message from another set of workers. The cotton carried a *human* trace, from the set of bleeding hands that had picked it in scorching heat, to the hands that sorted it prior to its arrival in yet more hands – some children's – for spinning and weaving.

For *Cotton.com* colour played a rhetorical role. Himid installed black and white

Lubaina Himid, *Our Entire Food Supply*, 1999, acrylic on canvas, 122 × 305cm. Courtesy Hollybush Gardens, London and the artist

paintings – sometimes white motifs on black grounds, sometimes the reverse. Each was painted with detailed care, in small strokes, with fine marks; errors could not be covered up. Each movement of the brush had to be sure, clear, complete. The black and white avoids the literalness of direct historical reference to the transatlantic exchanges between union officials and the President of the United States. The artist had translated another kind of meeting mediated by materiality: cotton. That thread-talk was transformed into units of creative meaning in paintings that had the liveliness of both the symbolic-aesthetic practices of West African block-print fabrics and the energy and dynamic of European Wiener Werkstätte designs, pointing to the capital of Art Nouveau and a European design revolution at the beginning of the twentieth century. Looking at the works, I listed buttons, bows, stitches, combs, loops, stars, pears, apples, pineapples, shells, fishes, chains, birdcages, whales, tadpoles, cones, buttonholes, rays of light, wheels. On a brass plaque, set behind the viewer confronting the cascade of paintings, was a single monumental statement: 'He said I looked like a painting by [Bartolomé Esteban] Murillo as I carried water to the hoe-gang, just because I balanced the bucket on my head.' This was in reference to an inspector's report on the plantation system

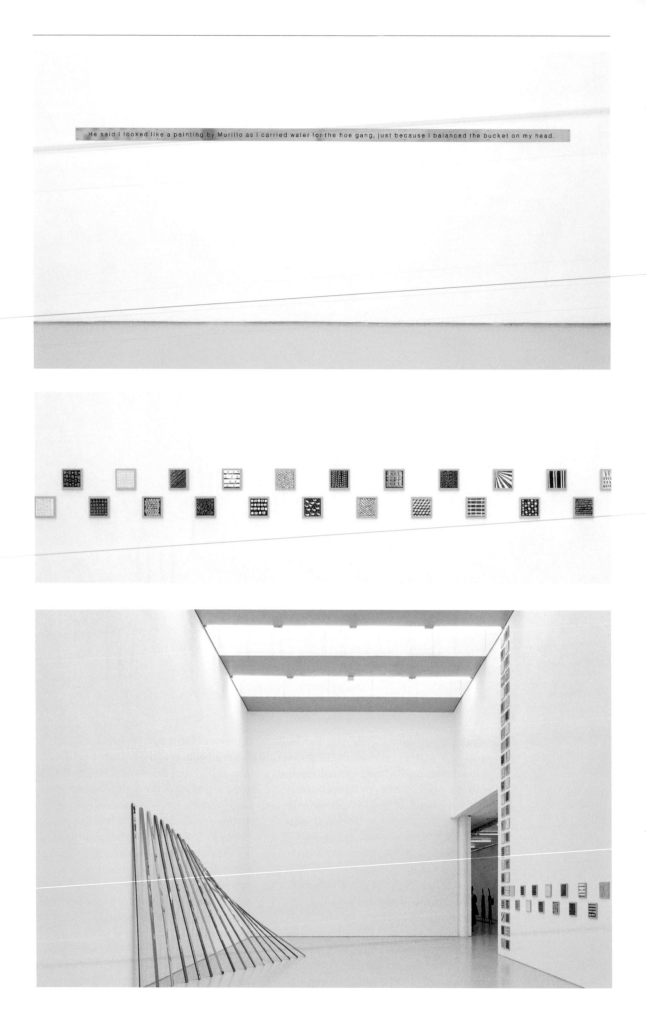

that noted how the workers slept and what they ate; the inspector included mention of an African woman carrying water to a gang of fieldworkers.

The art historian in me searches for the painting. I do not think such a Murillo actually exists. Murillo stands for the nineteenth-century British taste for bad Spanish art and for exoticism. Himid's plaque served to interrupt, undo and radically change the violence and the envy, the exoticisation and the blindness encoded in this passing comment. Consider the scene of the exchange: the Afri-

violence. She tells me that, nonetheless, the struggle to be seen as an agent of creative singularity as experienced by Black women today – the daily battle to be seen, to establish *who*, not *what*, you are – shares something with the distant woman who was glimpsed and *mis*-seen in a cold, factual report on the .com of plantation economies, built on the chattel enslavement of fellow human beings, on lives spent in the thankless and painful task of picking cotton.

When Himid says that her work touches again and again on the way the political

Opposite:
Lubaina Himid, *Cotton.com*, 2002. Installation views, 'Navigation Charts', Spike Island, Bristol, 2017. Photograph: Stuart Whipps. Courtesy Hollybush Gardens, London and the artist

Lubaina Himid, *Drowned Orchard: Secret Boatyard*, 2014. Installation view, 'Navigation Charts', Spike Island, Bristol, 2017. Photograph: Stuart Whipps. Courtesy Hollybush Gardens, London and the artist

Above: Lubaina Himid, *Sea: Wave Goodbye Say Hello (Zanzibar)*, 1999, acrylic on canvas, 101 × 304cm. Courtesy Hollybush Gardens, London and the artist

can woman is surprised, and worse, at being compared to a painting; the slave owners are astonished that anyone might imagine such a comparison. No longer disappeared as an enslaved worker or a momentarily eroticised image conjured by a passing white man making notes on systems of dehumanising labour, an African woman was brought forth by Himid's monumental plaque grammatically, from the page, as the subject of historical experience. Himid transformed history by making the African woman the speaker – neither a picture nor in the background, but written in words on hard shiny bronze. It was not enough to denounce the inspector's casually announced sexism and racism, his not seeing anything animate and human, just a pretty picture. His exoticism of 'her' was wiped out by Himid's 'He says *I...*', The use of the first person makes visible, and legible, that the African subject is not imprisoned in the gaze of the white man, and is not entirely abolished by his words. She is a subject. She speaks back. She articulates her astonishment but also her rebuke and her resistance.

Himid does not imagine she can – or certainly not that *we* can – enter into the subjectivity of the women and men deprived of their conditions of humanity while preserving it in the face of that daily, structural

world crashes in on her personal everyday, she refuses the split and speaks directly, in her own first person. Her extraordinary creativity over forty years has been a sustained battle to find her own forms, through which to speak in the first person; and more, to be seen and heard in that singularity as this artist. The power of her work resides, however, in the specific threads she weaves with the labour of the studio: the making, the painting, the poetic phrasing, the endless care with materials, all infused with the memories of places and a sense of a historical obligation to remember. Threaded through the dire histories delivered by political and economic violence is the counter force of the sheer brilliance of a sustained, resilient, inventive, incredibly knowledgeable, sharp and generous creativity. The dialectic of mournfulness and the relentless refusal to be effaced arises from her work's affective attunement to the human – to thinking, feeling, making, doing; to being ever-vulnerable and always resisting – dimensions of the places, stories and histories of Black experience. Even this journey to see *Cotton.com* has revealed the aesthetic and historical complexity this artist creates, work by work, making space and giving voice.

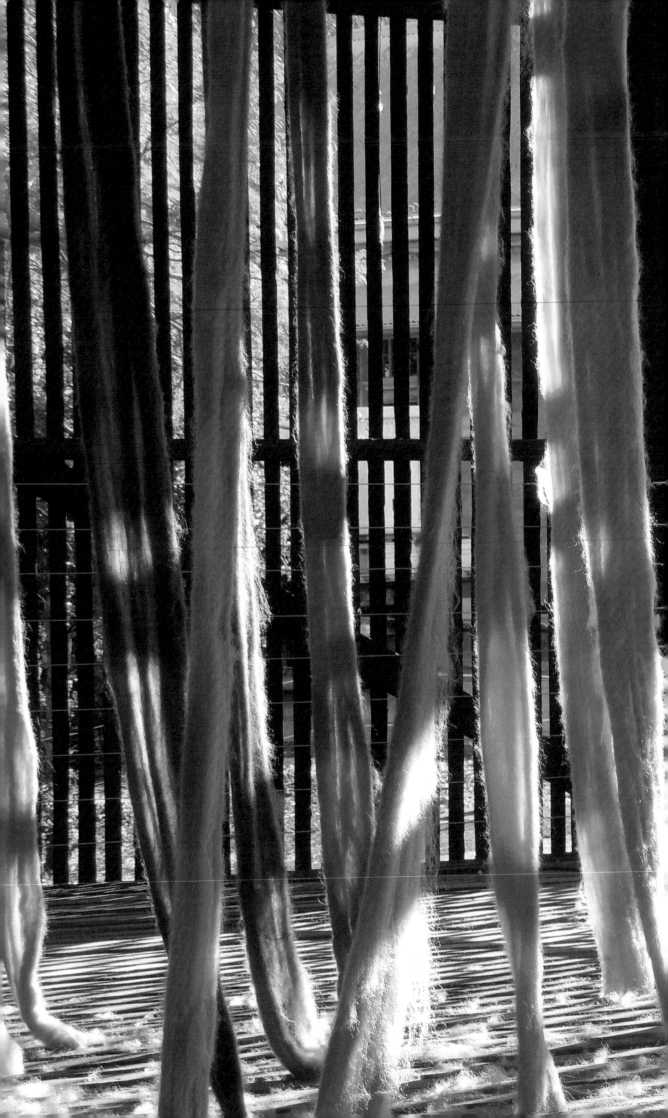

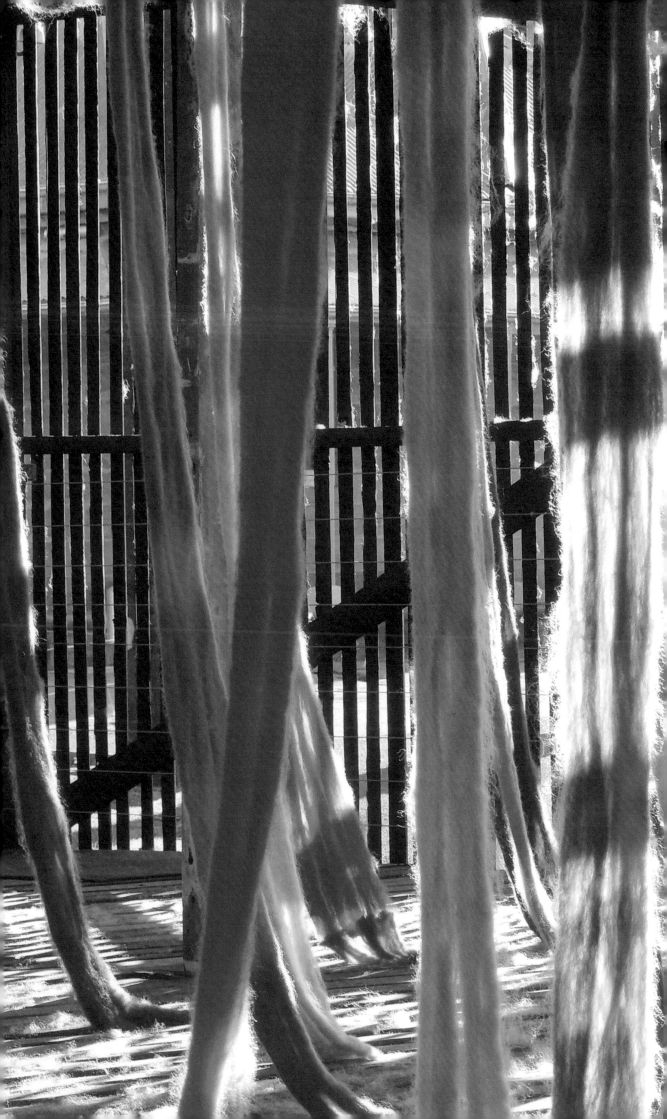

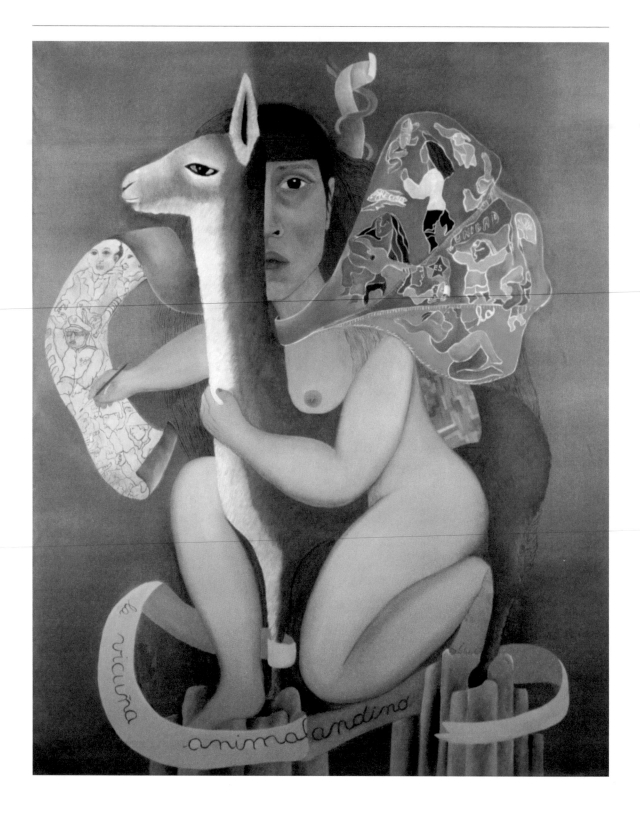

Previous spread:
Cecilia Vicuña,
Quipu Austral, 2012,
unspun wool,
string and sound.
Installation view,
18th Biennale of
Sydney, 2012.
Courtesy England &
Co. Gallery, London
and the artist

Opposite:
Cecilia Vicuña,
La Vicuña, 1977,
oil on canvas, 120 ×
139cm. Courtesy the
artist

Floating Between Past and Future:
The Indigenisation of Environmental Politics

— Lucy R. Lippard

Words are acts.
- Octavio Paz

Although Cecilia Vicuña's art is thoroughly ensconced in the present, she is also an 'old soul'. Her ancestry may include the indigenous Diaguita from northern Chile, as well as Basque, Irish and a Spanish family that goes back to seventeenth-century Chile, which could well mean an early mestizo (mixed) line in all of the southern Americas, up through Nuevo Mexico, as Spanish colonials propagated with local peoples. Vicuña has identified with Andeans since she was a child. When she was six, the Inca mummy

Lucy R. Lippard considers the poetic and ecological urgencies expressed through the work of Cecilia Vicuña.

of a sacrificed boy was found high in the Andes and schoolchildren were taken to see it at the Museum of Natural History in Santiago. She recalls that 'they had turned him into an "exhibit", an "object", but I saw it was me, exactly like me, and I believe that's when my identification with the ancestral world began'.

In Basque, *vicuña* means mountain goat, and she began to think of herself as an Andean animal when her friends in Colombia converted her name into a verb: *ahi viene La Vicuña a Vicuñar* (here comes the Vicuña to do her Vicuña thing). In 1977, she painted *La Vicuña*, a nude self-portrait locked in an embrace with her namesake, sharing a pair of eyes. In 1990, she titled a poetry book *La Wik'uña*, using the Quechua spelling.[1] *Vicuñas* live at almost celestial heights and are said to be born at the sources of springs. Their wool was sacred fibre, woven into the source of all Andean wealth. Thus the artist's family name, her very identity, evokes weaving and water – two of her major themes.

As Peter Skafish has written about Eduardo Viveiros de Castro's theories, Amerindians

who live in intense proximity and interrelatedness with other animal and plant species see these nonhumans not as other species belonging to nature, but as PERSONS, human persons in fact, who are distinct from 'human' humans not from lacking consciousness, language and culture – these they have abundantly – but because their bodies are different, and endow them with a specific subjective 'cultural' perspective.... Thus the idea that culture is universal to human beings and distinguishes them from the rest of nature falls apart.[2]

Years later, Vicuña discovered that the child mummy that had so impressed her had died with red threads in his hands[3] and had been buried alive next to the glacier that is the source of the Río Mapocho. The artist was born in a clinic in downtown Santiago, by that same river. Water, red threads and the Río Mapocho are constant presences in her art – connective tissues binding and bonding present, past and future, as well as the varied landscapes in which she has lived and worked. Threads are not only connective – textiles or texts, as she has often noted – but they were inspired by quipus, the Incan narrative and accounting devices consisting of a central line (a kind of horizon), with threads below and above. Vicuña has likened the quipu to a palindrome. It can change, knotted and tied over and over, transforming in place, like her own fragile and temporary artworks. Her piece in the upcoming documenta is 'the story of the read thread'[4] – a *Quipu Mapocho* following the entire course of the river, a project initiated in March 2016 at its mouth, *la desembocadura*, which is currently threatened by a MegaPort

1 Cecilia Vicuña believes that the similarity of Basque and Quechua was probably a 'phonetic coincidence. The two names are not connected linguistically or historically. Since Quechua was not a written language, the Spaniards "heard" the word "vicuña" in the Andes, and they wrote it in Basque.' Communication with the author, 24 May 2016.
2 Peter Skafish, 'Introduction', in Eduardo Vivieros de Castro, *Cannibal Metaphysics* (trans. P. Skafish), Minneapolis: Univocal, 2014, p.12.
3 Vicuña's sculptural installation *Aural* (2012) was dedicated to this child.
4 'Read' instead of 'red' began as a typo, but it kept 'repeating itself', so Vicuña decided to keep it.

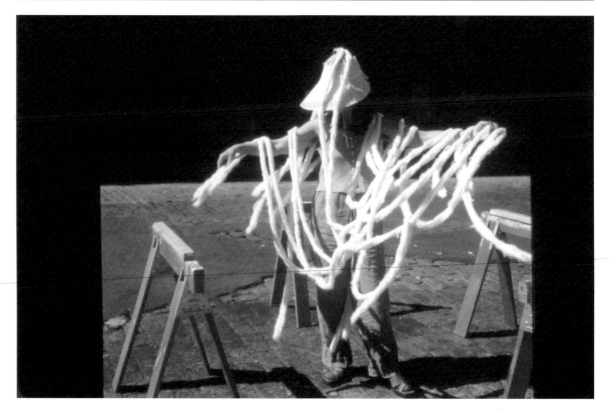

development that is dumping chemicals and destroying the beach. The piece will culminate in a performance at the glacier.

In 2014, Vicuña and her partner, poet Jim O'Hern, created a video with the goal of recovering collective memory and environmental responsibility through oral traditions. It is titled *We Are All Indigenous*, though, Vicuña adds, 'some have forgotten' (that would be most of the US population). For all its welcome sense of unity, this notion is problematic amongst the tribes native to the United States, where commercially driven wannabes and Asian imports plague North American Native artists. (The 'my-great-grandmother-was-a-Cherokee-princess' syndrome is cause for snickering in Native circles.) Pan-Indian movements notwithstanding, North American tribes have struggled for centuries to maintain their cultural individuality and sovereignty in the face of forced assimilation. Non-Native artists trying to pass, and appropriating indigenous symbol and image, have come in for some ferocious criticism. There are current coalitions of Latin American and North American indigenous activists, for instance, Idle No More, founded by four women in Canada and now a vast global movement to protect land and water from fracking, pipelines and nationalist and corporate greed.

Latin American indigenous communities, for all the crimes against them, are often more culturally autonomous than those further north, and their political situations vary from nation to nation. The survival of indigenous peoples in the face of incredible odds may have created a model, of sorts, for those desperately trying to raise consciousness about impending environmental disasters.

Candice Hopkins, a Native Canadian curator, writes that there is a 'growing interest in Indigenous art internationally. We know, from experience, that these interests emerge at times when Western culture and ideologies are in a state of crisis. Right now that crisis is environmental and, somehow, it is the latent recognition of indigenous knowledges and cosmologies that might save it.' But, she reminds us, 'There also needs to be a responsibility to not just borrow these forms, but to consider how what you do might enable the very people from whose practices you are borrowing from … the perspective that everyone is indigenous can be harmful, as it erases or speaks over the voices of those who have been quite radically dispossessed. Is it the same as the call for Black Lives Matter being met with "all lives matter"?'[5]

But Vicuña's notion that we are all indigenous goes back into deep time. In 1989, she wrote a poem that accompanied a *precario* sculpture at Lake Titicaca:

5 Candice Hopkins, communication with the author, May 2016.

*The Inca is about to be
and the ruins of the past
are the model for the future
being created by our
remembering.*[6]

There is nothing specific about her appropriations, if that is what they are. Her works 'look indigenous' not only because of her profound sense of communion with Chilean Native cultures – even as she decries the poverty imposed by colonialism and its consequences – but also because most non-Natives are so ignorant about what really is indigenous. Just as her poems take language apart to discover new and restore old meanings, her objects evoke rather than imitate. As Surpik Angelini has written, she 'avoids both mimetic and exotic representations of Amerindian culture…. Her voice, breath, accent, gestures, signs, traces and marks show us how these elements conforming the "aural" dimensions in her aesthetics, far from being abstracted from reality, vividly evoke the artist's actual experiences with Andean people.'[7]

Vicuña often works at the confluences of waterways, a metaphor for her connective aesthetic. She has woven her threads under water and tied rocks together in streams, paying homage to their endless movement and transformational qualities, reflected in a poetry book titled *Unravelling Words and the Weaving of Water* (1992). She often finds the cross form unintentionally appearing in her art, and notes that it is the essence of weaving, of crossing cultures, or national boundaries, or art world categories. An installation at Exit Art in New York in 1997 – *The Water Wants to Be Heard* – was about the circulation of water in the city, offerings to the rivers, the gutters, the puddles. It was also about listening to nature. The phrase has become a slogan for environmental actions. Her friend Sabra Moore recalls small shrines next to hydrants in the city streets, 'paying homage to a life source that most of us took for granted'.[8] The *Agua de Nueva York* project included tiny 'rafts' braving trash and commercial vessels, recalling the crossing of seas and cultures by the Kon-Tiki. She also warns that water was privatised in Chile by the Pinochet dictatorship, while 'mining corporations and private enter-prises have appropriated the rivers', evicting indigenous fishermen whose ancestors have been there for millennia. Combined with global warming, this has 'created havoc, drought/floods, disaster after disaster, the latest one at the Río Mapocho'.

She cites 'these old stories that keep coming back in one form or the other … my poetics have always been indigenous, performed in the Andean spirit that embraces wisdom from all corners of the world. I discovered Taoism as a teenager, and that philosophy

Vicuña often works at the confluences of waterways, a metaphor for her connective aesthetic.

increased my passion for indigenous thinking, which in time I expanded to include Dada and Surrealism, which always brought me back to ancient knowledge.'[9] Respectfully sharing a spiritual approach with her indigenous sources, Vicuña sees herself as the receptacle of ancient knowledge, which she then translates into a very contemporary idiom. Her art is not easily categorised. She's neither a poet who makes art, nor an artist who writes poetry. Her art is a naturally fused amalgam of word and act in which she not only translates but becomes an archaeologist of language – excavating, dissecting, recreating meaning and communicating it to the inhabitants of today. Her 'performances' or 'eco art actions', which date from the 1960s, have been called 'conceptual' and 'dematerialised'. In the 1970s, involuntarily exiled from Pinochet's Chile in London, then Bogotá, and finally New York, she organised and participated in any number of protests – both political and aesthetic – against the fascist regime. This confluence of ancient beliefs and current politics is typical of Vicuña's art, which she sees as an homage to the 'despised peasant ideas' that secretly fuelled centuries of resistance against colonialism. One aspect of her work that is unique in the realm of so-called 'conceptualism' is its emphasis on connective communication. Vicuña bemoans the fact that 'complex public conversation' is disappearing. She identifies with 'marginal people – children, the insane, the uneducated', often incorporating their voices into

6 Quoted in Lucy R. Lippard, 'Spinning the Common Thread', in M. Catherine de Zegher (ed.), *The Precarious/QUIPOem: The Art and Poetry of Cecilia Vicuña*, Hanover, NH: University Press of New England, 1997, p.15.
7 Surpik Angelini, 'Cecilia Vicuña: The Aural Dimension/La Dimension Aural', *Artlies*, Fall 2000, p.54.
8 Sabra Moore, communication with the author, May 2016.
9 C. Vicuña, communication with the author, May 2016.

Cecilia Vicuña, stills
from *We Are All
Indigenous*, 2014.
Courtesy the artist

her work. She leads children's workshops, and constantly engages her 'audience' (in this case the word is accurate for art as much as for music). In her 1980 film, *What Is Poetry to You?*, she interviewed prostitutes, workers and residents of the poorest barrios, receiving responses that inspired her to keep asking, keep listening.

Precariousness is increasingly a description of human life on the planet, and precariousness is Vicuña's element. Her art balances on the littoral or liminal edge, where land and water meet[10] – places like New Orleans, where the devastation by Hurricane Katrina and the BP Gulf oil spill, five years later, is ongoing.[11] The history of water in Louisiana, forever entwined with the Mississippi River, the Gulf of Mexico and the hidden bayous, provided fertile ground for Vicuña's work in this exhibition ['Cecilia Vicuña: About to Happen', at the Contemporary Arts Center New Orleans, 2017]. *La Noche de las especies, la mar herida nos mira* (*The Night of the Species, the Wounded Sea Watches Us*) recapitulates an earlier drawing, 120 feet long, executed in Chile in 2009. It is based on the death of the ocean, and its rebirth: 'The poems at the bottom of the sea are bacteria dreaming the sea back to life.'[12] The rapidly eroding Louisiana coastline predicts the water's triumph over human engineering, suggesting another beginning, birthing a new species less arrogant than ours... or perhaps a recreation of 'us' so the cycles can begin again. Vicuña dedicates her new site-specific installation – *A Balsa Snake Raft to Escape the Flood*, constructed of *basuritas* (detritus)[13] from the coast – to the climate refugees in and on the Gulf, especially the indigenous communities.

If we are all indigenous, we are also all immigrants. Displacement from original lands is an integral part of modern indigeneity. Vicuña has said that 'language is migrant', and in one of her *palabrarmas* she imaginatively parses the word 'migrant' into the Latin *mei* (to move) and Germanic *kerd* (heart), arriving at 'changed heart, a heart in pain, changing the heart of the earth. The word immigrant really says "grant me life".' Then she adds the Proto-Indo-European root of 'grant' – *dhe* – meaning 'allowed to have', which she connects to the roots of law and deed, and sacred rites.[14]

In the arid Southwest where I live, the history of the land and its indigenous peoples are far more visible than in most parts of the United States, more like Latin America. As we attend the dances for rain that remain part of Pueblo cultures, we are constantly reminded of the millennia of successive droughts that formed our landscape, and the desperate urban and rural planning that is surfacing in Southwestern and coastal cities, and in agricultural communities. Vicuña's *Cloud Net* (1998) evoked the eternal safety net necessary to survival, recalling the cloud terraces in Pueblo rock and kiva art, and shrines in the landscape to clouds and the deities, called *kachinas*, who live there. Of course, water is life all over the globe, as inhabitants of non-arid regions are finally beginning to realise.[15] With the increasingly dire effects of climate change breathing down our necks, our national sense of invulnerability and exceptionalism is eroding along with our coasts. The nearing upheavals are made visible by artists whose ecological consciousness and social consciences have led them into deep water. As rivers join the sea, so Cecilia Vicuña and her peers hope to reunite society and nature on an indigenous model, joining Native peoples all over the world.

10 For a theoretical artist's ideas relatable to Vicuña's work, see Bruce Barber, *Littoral Art and Communicative Action*, Champaign, IL: Common Ground, 2013.
11 I lived in New Orleans in the late 1940s and recall plunging tropical rains that flooded the streets with an abandon unfamiliar to a Yankee, as well as snakes, gravestones, wild oaks and Cajun talk on the Bayou Barataria. For the past 23 years I have lived in New Mexico, where *agua es vida* (water is life) is a constant refrain. These extremes inform my ecological consciousness as Latin America and New York have informed Vicuña's.
12 C. Vicuña, communication with the author, May 2016.
13 Over the years Vicuña has often called her ephemeral sculptures *basuritas*, or 'little garbages, little rubbish'.
14 See C. Vicuña, 'Language Is Migrant', *Harriet*, 18 April 2016, available at http://www.poetryfoundation. org/harriet/2016/04/language-is-migrant (last accessed on 25 January 2017).
15 Florida ran out of water a few years ago in a massive drought, bringing home the extent of a crisis often confined to the West, and today sea water is infiltrating the aquifers in the Everglades as seas rise.

This essay was realised in conjunction with the exhibition 'Cecilia Vicuña: About to Happen', organised by the Contemporary Arts Center New Orleans, 16 March-18 June 2017, and travelling to the Institute of Contemporary Art, Philadelphia; the Berkeley Art Museum, University of California, Berkeley; and the Henry Art Gallery at the University of Washington, Seattle. It was originally published in *Cecilia Vicuña: About to Happen* (exh. cat.), New Orleans and New York: Contemporary Arts Center New Orleans and Siglio, 2017.

Coloniality Is Far from Over, and So Must Be Decoloniality

– Walter D. Mignolo

I

When I received the letter from *Afterall* inviting me to participate in this issue, the following paragraph both captured my attention and oriented what I wanted to write:

> The impetus for this issue stems from two distinct, though not unrelated, contexts. On the one hand, the appalling rise of xenophobia and racism in Europe and the United States in the wake of divisive populist politics (read Trump, Brexit, etc.), which has exposed the colonial matrix as the untouched structure of power and knowledge – and the attendant nostalgia for empire. On the other, this issue has stemmed from conversations with Canadian Indigenous artists, curators and organisers and their insistence in emphasising indigeneity over decoloniality – that is, that the gesture of decentring and delinking must be accompanied by a process of recentring aesthetic and political indigenous structures. In this issue, then, we would like to consider to what extent these two processes of 'delinking' and 'relinking', if you will, overlap, clash or complement each other.[1]

Both issues seem, at first sight, to be unrelated. Racism and xenophobia in Europe are manifestations of the European indigenous peoples feeling menaced by the foreigners or non-indigenous. You may be surprised at my referring to 'European indigenous peoples', and assume I made a mistake, or that I've lost my mind. This is a specific case of the virus of *coloniality* and how it infects our minds and makes us 'see' what the rhetoric of Western modernity wants us to see: that 'indigenous peoples' are somewhere over there and not here. However, if you look at the meaning of *indigenous* in modern European imperial languages grounded in Greek and Latin

Walter D. Mignolo describes the necessary work of delinking from Western narratives in order to relink and affirm the modes of existence we want to preserve.

(Italian, Spanish, Portuguese, French, German and English), you will find that the word is an adjective referring to those 'born or originating in a particular place'. It comes from the late Latin *indigenus*, which means 'born in a country, native'.[2] So, if Europeans are not indigenous, where did they come from?

The problem with coloniality of knowledge, and of existing within its realm (knowing, sensing and believing), is that it makes us believe in the ontology of what the North Atlantic's 'universal fictions' have convinced us to believe.[3] In this case, that Europeans are nationals in Europe, that people of European descent in the Americas must be people of European indigenous descent (natives born in the New World), and that the people who inhabited the land before European intervention are referred to as 'indigenous' to that land and not to Europe's land. In purely etymological terms, *indigeneity* is derived from *indigenous*, and, in purely semantic terms, refers to the identity of indigenous peoples. Clear enough.[4] Now, the problem appears when signs – in this case, the adjective *indigenous* and the noun *indigeneity* – refer to people. Who decides that the indigenous are somehow of the 'national' – which is who actually counts, since Western Europeans and their Southern counterparts (in Italy, Spain and Portugal, with modern Greece falling almost out of the South of Europe) have defined themselves as 'nationals'?

With the emergence of the idea of the nation-state and the definition of the 'Rights of Man and of the Citizen', doors were closed for lesser-Man and non-citizens, that is, 'non-nationals'. Then came the significant problem of the modern, secular and bourgeois Euro-

1 Email to the author, 21 July 2016.
2 'Indigenous', *Online Etymology Dictionary* [website], available at http://www.etymonline.com/index. php?term=indigenous&allowed_in_frame=0 (last accessed on 23 January 2017)
3 See Michel-Rolph Trouillt, 'North Atlantic Universals: Analytical Fictions, 1492-1945', *South Atlantic Quarterly*, vol.101, no.4, Fall 2002, pp.839-58.

pean nation-state that propagated all over the world. What *is* the problem of the nation-state? That the nation-state cares (in practice but not in theory) for nationals and not for human beings. Non-nationals are lesser human beings; they are foreigners, immigrants, refugees, and for colonial settlers, indigenous from the land they settled in are second class nationals.

II

Before going further with this line of reasoning, I consider it necessary to be more explicit about *coloniality*. This term – in short – refers to the Colonial Matrix of Power. I understand the CMP as a structure of management (composed of domains, levels and flows)[5] that controls and touches upon all aspects and trajectories of our lives. If one looks at the transformations of the CMP since its formation in the sixteenth century, one sees mutations (rather than changes) within the continuity of the discursive or narrative orientation of Western modernity and Western civilisation: from, in the nineteenth and twentieth centuries, Christianity (Catholic or Protestant) to secularism, liberalism and Marxism (in other words, from the Christian to the civilising mission); and from 'progress' in the nineteenth century to 'development' in the second half of the twentieth.

The global westernising project collapsed at the beginning of the twenty-first century. This did not mean the end of the West. It only meant the end of westernisation in its last attempt: neoliberal globalism. The westernisation of the world is no longer possible because more and more people are resisting being subsumed in it. Contrarily, people begin to re-exist. This means to figure out how to live their/our own lives instead of giving our time and bodies to corporations, our attention and intelligence to the unbearable mainstream media, and our energy to the banks, which are constantly harassing us to obtain credits and pay high interests. Reponses of different kinds and levels have become visible, including the emergence of projects of de-westernisation, amongst them: China's political re-emergence due to economic affirmation; Russia's recovery from the humiliation of the end of the Soviet Union and attempt to prevent westernisation in Ukraine and Syria; and Iran's cooperation with China and Russia. These projects have paralleled the growth of *decoloniality* following the Bandung Conference in 1955. This means that decoloniality emerged after the collapse of the Soviet Union, demarcating itself from decolonisation due to its wider impact. The collapse of the Soviet Union was a Russian event – yet it had significant global implications.[6]

Global history was no longer steered by Western actors and institutions, and this was manifested in general conflicts between dewesternisation and rewesternisation. We could see growing decolonial forces delinking from the state, corporations, banks and inter-state institutions. Delinking, then, means doing so from the domains of the CMP. This could not – or should not – be done all at once, in one week, given all the complicated tentacles of the CMP. It is a long process, at different levels and with different needs and preferences. It took more than 500 years for the current global bourgeoisie to control the organisation of the planet. This has generated all kinds of conflict, discontent, humiliation, anger and dehumanisation. Moreover, it opened colonial wounds.

Decoloniality, which was no longer decolonisation as it was during the Cold War, became a proliferating project and organisation of *disobedient conservatism*. Decolonial disobedient conservatism is the energy that engenders dignified anger and decolonial healing, and its main goals are to delink in order to re-exist, which implies relinking with the legacies one wants

4 To open up the conversation, I recommend Mexika.org, which digs into the memories of ancient Mexican civilisation: 'Next, let us look at "indigeneity." If it sounds like an academic construction, that is because it is. In simple terms, "indigeneity" is the combination of the words indigenous and identity – hence, indigeneity. Seems obvious enough, what else is there to say about it? Well, what is indigenous identity? Who defines it; a government, a group of people, an authoritative individual? This term is a little harder to apply because of the long settler-colonial legacy of denying indigenous people their Native ethnicity in North America, particularly in the United States with its blood quantum policies. For our purposes here, we will say that "indigeneity" is an indigenous identity particular to an individual who sees him/herself as belonging to a specific group with roots dating prior to the so-called "great encounter" of 1492. That is an extremely wide net that encompasses a diverse array of peoples, cultures and societies stretching the northern and southern American continents.' Tlakatekatl, 'Towards a "Yankwik Mexikayotl": A Definitional Essay; Part I', *Mexika.org* [blog], available at https://mexika.org/2014/07/18/a-new-mexikayotl-its-time-to-purge-the-nonsense/ (last accessed on 23 January 2017).
5 See Walter D. Mignolo, 'Global Coloniality and the World Disorder', *World Public Forum*, November 2015, available at http://wpfdc.org/images/2016_blog/W.Mignolo_Decoloniality_after_Decolonization_Dewesternization_after_the_Cold_War.pdf (last accessed on 23 January 2017).
6 What was attempted in the Obama era was to re-bump westernisation. Obama's foreign policy was marked by a consistent effort to re-westernise the planet. It has been stopped, but the US and the Pentagon, with the core of the EU, would persist in preserving their own values (which is fine, everybody has the right to do so) and in imposing their values all over the world (which is an aberration).

to preserve in order to engage in modes of existence with which one wants to engage. Thus, re-existing depends on the place of the individual in the local histories disavowed, diminished and demonised in the narratives of Western modernity. This is not to suggest that decoloniality calls for delinquency. On the contrary, it calls for both civil and epistemic disobedience, which could be enacted at different levels and in different spheres. (Mahatma Gandhi, for instance, showed the way to the Indian people.) Needless to say, the state, the corporations and banks would not be in favour of people taking control of their own destinies.

However, and this is crucial, there cannot be one and only one decolonial master plan – that would be far too modern, too Eurocentric, too provincial, too limited and still too universal. Decoloniality operates on pluri-versality and truth and not in uni-versality and truth. As mentioned above, decoloniality's first moves should be those of delinking. Secondly, it should strive for re-existence. Re-existing is something other than resisting. If you resist, you are trapped in the rules of the game others created, specifically the narrative and promises of modernity and the necessary implementation of coloniality. There cannot be only one model of re-existence.

Projects of resistance have emerged from very specific geopolitical and corpo-political local histories confronting global designs. For instance, the Bandung Conference was a crucial moment that ignited the fire of the Third World that Frantz Fanon theorised in his celebrated *Les Damnés de la Terre* (*The Wretched of the Earth*, 1961). Decolonial geopolitics refer to state politics struggling to liberate themselves from economic and political dependency. Body politics are also articulated in Fanon's response to Western racism: 'O my body, make of me always a man who questions!'[7] Where Fanon said 'man' we should read 'human beings'. Where Descartes said 'mind' Fanon said 'body'. But the body invoked by Fanon is not the body of Leonardo da Vinci's Vitruvian Man, a singular Roman body modelled as universal Man/Human. It is a black body in the middle of the twentieth century; it is a racialised body; it is a humiliated body; it is the despised body that he contested and rejected all through *Peau noire, masques blancs* (*Black Skin, White Masks*, 1952). This is a different kind of geopolitics: the geopolitics of the body, which does not operate in the sphere of the state, but in the geopolitics of racialised and sexualised bodies.

Gloria Anzaldúa's influential *Borderlands/La Frontera: The New Mestiza* (1987), made a similar point from the experience of a lesbian *Chicana*.[8] For Anzaldúa, *la frontera* (the border) is geopolitical. The border between the US and Mexico, with all the power it embodies, is also a sexually racialised *frontera*: 'the new mestiza' is both ethnically mestiza (Mexican-American or Chicana) and sexually mestiza (a lesbian of colour).[9] This reading is not necessarily ethnographic, as these readings are frequently categorised, but political. It is an example of decolonial disobedient conservatism – wanting to preserve the legacies that secure what it means to be a lesbian of colour or a Mexican-American alongside the modes of existence that they potentially embody. Both Fanon's and Anzaldúa's analyses are necessary to thinking about delinking to re-exist by preserving the legacies that Afro-Caribbeans and lesbians of colour in the US want to preserve. Both arguments are analytic, coherent and of paraxial empowerment. Both embody decolonial disobedient conservatism: they propose to *preserve* what each community needs in order to be able to re-exist, and not to *change* following the rhetorical trap of Western modernity.

III.1

Where does this excursus on modernity/coloniality/decoloniality take us in confronting issues such as the refugee crisis in Europe?

In the current situation in Europe, human beings who are identified as immigrants or refugees not only do not have room in the media or university to make their argument, they also do not have the energy: their main concern is survival. A fragment of the civil society in European countries considers that they have been affected by the arrival of these individuals, but there are extreme limitations in what civil society can do when state politics portray refugees as a burden that obstructs their priorities, specifically domestic economic growth and inter-state relations to preserve the inter-state economic and political hierarchy. I take this opportunity to bring back the modus operandi of the CMP. It is not my intention, however, to apply the CMP structure of management in order to analyse the complex issues of

7 Frantz Fanon, *Black Skin, White Masks* (trans. Charles Lam Markmann), London: Pluto Books, 2008, p.181.
8 See Gloria Anzaldúa, *Borderlands/La Frontera: The New Mestiza*, San Francisco: Aunt Lute Books, 1987.
9 Google doesn't recognise the term *mestiza*; it only recognises *mestizo*, which is masculine.

immigration, the refugee crisis or indigeneity. It is also not my intention to use these issues as illustrations of the CMP. Instead, I am attempting to articulate harmonic relationships between them. For instance, the CMP unfolds in the analysis of immigration, the refugee crisis and indigeneity, yet at the same time it impacts our way of understanding these issues in a particular way: the decolonial way of thinking.

Decolonial thinking strives to delink itself from the imposed dichotomies articulated in the West, namely the knower and the known, the subject and the object, theory and praxis. This means that decolonial thinking exists in the exteriority (the outside invented by and from the inside to build itself as inside). It exists in the borderland/on the borderlines of the principles of Western epistemology, of knowing and *knowledge-making*. The inside (Western epistemology) fears losing its status of rational mastery by promoting the importance of emotions over reason. For instance, what would happen if we articulated our decisions and our scientific premises (assumptions) as irrational and emotional? We would perhaps be considered heretics, or a similar medical or legal category used to keep people in the exteriority. Well, that is what disobedient conservatism means: to disobey 'scientific' classifications of human beings and to conserve the fundamental role of sensing (*aesthesis*) and *emotioning* in our everyday life, as well as in the high decisions by the actors leading states, corporations and banks and the production of knowledge.

The Berlin Conference of 1884–85 was a turning point in the history of the CMP. If from the sixteenth to eighteenth centuries the Americas were the battlefield amongst Europe's Atlantic imperial states (Spain, Portugal, Holland, France and Britain), the conference turned the scenario to Africa. When you look at a map of Africa around 1900, what do you see? You see not one single corner of Africa that was not possessed, managed and controlled by a European state.[9] When several African countries gained independence during the Cold War, immigration to Europe started. (It continues to this day.) Decolonisation in Asia and Africa and the intervention of the US in Central America since the 1960s have escalated immigration also to the US, where traditionally immigrants had been white Europeans. The 'melting pot' narrative was conceived to highlight the proudness of a nation-state where immigrants were welcomed. By the 1970s, when non-white immigrants were arriving, the narrative of the melting pot mutated into the narrative of multiculturalism, and of Richard Nixon's ethno-racial pentagon, which asked the immigrant to identify him/herself in one of five categories: White, Asian-America, African-American, Hispanic or Native American (a situation that continues today).

This brief history of migration to Europe and the US is another chapter in the history of Western imperial expansion, in which the nation-state has nevertheless maintained its status.[10] The nation-state form emerged at a crucial moment of the first mutation of the history of the CMP. Historically founded in the sixteenth century, the form of governance was then monarchic, supported by the Church. The governing elites were the aristocracy in each of the forming European countries and the elites of the Roman Papacy. The criteria for preferred people as 'nationals' did not yet exist in concept in Western hegemonic narratives (and even less in narratives of non-Western civilisations). The outcasts were all kinds of 'unbelievers'. For three centuries, the main 'victims' of the Western narratives were *Pueblos Originarios* in the Americas (from Southern Chile to Canada and Alaska) and enslaved Africans. The latter were more demonised than Africans themselves at that point – for Europe, Africa was the provider of enslaved human beings. With the advent of the modern-secular and bourgeois nation-state in Europe, which displaced from governance the European monarchies and the Church, the narrative of national citizens displaced the narrative of Christian believers. The logic was the same (the logic of coloniality) but the rhetoric changed (nation-states, citizens, 'Rights of Man and of the Citizen'). As mentioned above, the nation-state form of governance is today an encumbrance because it favours nationals over humans: by its logic, non-nationals are lesser humans. As a consequence, a global atmosphere of racism is ingrained in the formation, transformation and management of the CMP. This indicates how racism is created by an epistemic classification, and not by the representation of existing racial differences between human beings. Non-nationals (immigrants and refugees) fall prey to racism due to epistemic classifications.[11]

10 In 1900, Belgium was also in the imperialist family, possessing the territory that would become the Belgian Congo.
11 Frantz Fanon understood it clearly: he knew of course that he had black skin. He did not know he was a 'Negro'. He learned he was a 'Negro' in France: walking along the street, a child pointed at him and told her mother, 'Look, a Negro.' Black skin is a matter of fact. Being a 'Negro' is a racial epistemic classification. That is racism. F. Fanon, *Black Skin, White Masks*, *op. cit.*, pp.111-12.

III. 2

The next question is, where does this excursus on modernity/coloniality/decoloniality take us in confronting issues such as indigeneity? Further, how can decoloniality be conceived and enacted (for those who are interested in conceiving and enacting it) by 'indigenous' former Western Europeans and by 'Anglo-natives'? (By the former, I mean people born in the in the US of European descent.[122])

The *Pueblos Originarios*, also referred to as 'Indians', and translated as 'indigenous',[133] is a term now common in Spanish and accepted by many of these communities in the Americas. People belonging to *Pueblos Originarios* are neither immigrants nor refugees. They were on the land when *European immigrants* arrived without invitation – and without passport – and settled on the land. Histories of rebellion and discontent amongst *Pueblos Originarios* have been written by the settlers, and memories of discontent have never been forgotten in the hearts and minds of the *Pueblos Originarios* themselves. Resistance and re-existence have never stopped since the sixteenth century. Without constant re-existing, we wouldn't be able to understand the continental resurgence of *Pueblos Originarios*: their reclaiming the land and dignity that belongs to them; their affirmation of their own humanity; and their confronting the barbarism of 'Western humanism', which made them lesser humans.

Human and *humanism* are keywords in Western narratives that articulate concepts of both the human and humanity. These concepts corresponded with the image that those who asserted and reproduced these narratives had of themselves. Racial classifications were necessary to be able to identify and distinguish what being human (looks, origins, practices, etc.) entailed. Humanism became the project that strived to humanise people on the planet who were previously understood as lesser humans (indigenous, immigrants, refugees). Now the fiction has been disclosed. The hegemonic narratives that made a vast portion of the planet's population lesser humans (because of ethnicity, skin colour, blood, gender and sexual preference, language, nationality or religion) are seen in today's narratives of barbarism: not because there are ontological barbarians but because the authors of the narratives are indeed barbarians in the act of inventing difference to classify equal living organisms as lesser humans.

III.3

There are, then, good reasons why indigeneity may be preferred over decoloniality. Indigeneity, like national or religious identifications (French, German, American, British, Christian, Muslim, etc.), is a heterogeneous identification. There are debates, positions, conflicts in each identification. Christians may be Catholic or Protestant, but still they see themselves as Christian. Muslims could be Sunni or Shia, they still they see themselves as Muslims. There is a line, however, that cannot be crossed: no Christian would see herself as Muslim unless she converts. No Muslim would see herself as Christian unless she converts.[144] I have been learning myself from the struggles of indigenous peoples in the Americas – from the Mapuche in Chile, the Aymara in Bolivia, the Quichua in Ecuador, the Maya-Quiché in Guatemala, the Osage in the US and Nishnaabeg in Canada, to name a few. In each nation and project, there are thinkers and activists from all walks of life, including curators, artists and scholar-intellectuals. I am learning from their arguments: oral, written, visual and aural. I am not an anthropologist who 'studies the other'. I am learning from them as I once learned from Aristotle, Kant or Marx. Being myself neither Greek nor German I was then indeed learning from 'my others'. I am attentive to how indigenous people carry their fight in order to orient my own in the racialised ethnic and sexual spheres I am fighting. What is common to all the diverse indigenous inhabitants of the world is the need for affirmation to resist the imperial/colonial powers. Author, educator and activist Taiaiake Alfred captures this idea as follows:

12 Such as Hillary Clinton or Donald Trump.
13 The denomination 'Indian' honoured Christopher Columbus's mistake – he originally thought he was travelling to India. The denomination *indigenous* was created later on, when the word entered Western classifying vocabulary. Following their own definition, as I mentioned before, Europeans are also indigenous. However, the word was invented and used to classify the difference. If they recognised themselves as indigenous, then indigenous could not be different.
14 As a Third World intellectual and immigrant in Argentina, France and the US, I have the immigrant consciousness in common with immigrants around the world – the experience of dwelling and thinking in the borderland/borderline.

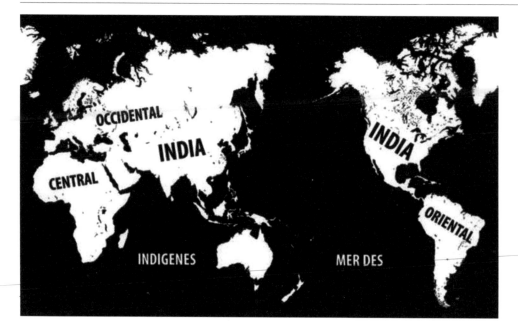

Under colonisation, hundreds of indigenous nations that were previously autono-mous and self-governing suffered a loss of freedom. Even today, the lives of their people are controlled by others.[155] The problems faced by social workers, political scientists, physicians and teachers can be all traced to this power relationship, to the control of Native lives by a foreign power. In the midst of Western societies that pride themselves on their respect for freedom, the freedom of indigenous people to realise their own goals has been extinguished by the state in law and, to a great degree, in practice. Above all, indigenous nationhood is about reconstructing a power base for the assertion of control over Native land and life. This should be the primary objective of Native politics.[166]

What Alfred describes corresponds to what I have called the Colonial Matrix of Power. Delinking from foreign powers' control over lives goes hand in hand with rebuilding and re-existing under new conditions and modes of existences that are your own.

Whereas it is true that decoloniality does not equal indigenous struggle (thus I under-stand that for some people indigeneity has priority over decoloniality), the act of rebuilding indigeneity implies decolonial delinking from settlers' control of lives. Decoloniality is not an ethnic, national or religious identification. It is a political project, and as such, indigenous people may inhabit it differently from other non-indigenous communities (be they immi-grants, Muslims, members of the LGTB community, transnational queers of colour, Third World women, Latinas and Latinos, indigenous people from the Urals or Black Africans in South Africa) and at the same time may inhabit it differently from each other. Since I am not indigenous myself, I have neither the right nor the authority to decide what indigenous people themselves should do to protect their interests and advance their struggle for affirmation and

Decolonial thinking strives to delink itself from the imposed dichotomies articulated in the West, namely the knower and the known, the subject and the object, theory and praxis.

re-emergence, to re-exist and liberate themselves from centuries of settler colonialism. What is relevant is an understanding of the trust of diverse projects around the world that are not initiated by the state, corporations, banks or by Nobel Prize nominations but by people themselves. People organising themselves all over the world to delink from the fictions of modernity and the logic of coloniality find the vocabulary and the narratives that afford

15 Notice that Alfred is indigenous himself, and he, like Fanon, uses the third person in talking about the first.
16 Taiaiake Alfred, *Peace, Power, Righteousness: An Indigenous Manifesto*, Oxford: Oxford University Press, 2009, pp.70—71. Emphasis mine. A similar argument in the South American Andes has been made, see Fernando Huanacuni Mamani, *Vivir Bien/Buen Vivir: Filosofía, polítias, estrategias y experiencias de los pueblos ancestrales*, La Paz: Instituto Internacional de Integración, 2015.

Pedro Lasch, *The Indianization of Globalization*, 2009. Courtesy the artist. This map merges English, Spanish, and French to produce a new cartography based on the meanings of the words *Indian* and *Indigenous*. Providing the foundation for our current processes of globalisation, the map returns to the image of extreme ignorance and confusion experienced by Europeans during their arrival to the Americas. As a future or contemporary world order implied by the renaming of the continents, however, the map also registers the epic growth of cultural and political power accomplished by the very populations who have been accurately and mistakenly defined by the idea of the *Indian* and the *Indigenous*. Often presented in books and other publications, the map also exists in the form of ephemeral large-scale paintings for walls of community centres, schools, social organisations, art galleries, museums and other sites for which the map's content might seem relevant. Scale and colours are adaptable to the context.

them affirmation; they are delinking from modernity/coloniality to relink with their own memories and legacies, thereby securing modes of existence that satisfy them. These modes of existing cannot be thought of as uni-global, uni-form, homo-geneous. All these claims are modern imperial claims: uniformity according to global designs intending to homogenise the planet. That is over. Decoloniality is neither a 'new' nor a 'better' global design that will supersede previous ones.

To conclude, Western civilisation, the visible narrative sustained by the invisibility of the CMP, has affirmed itself during the past five hundred years of global histories and extended its tentacles all over the world. Although the West is not homogeneous, there is something that holds it together and distinguishes it from other civilisations: the narratives and rhetoric of modernity, including the variation of postmodern narratives and the logic of coloniality (e.g. the modus operandi of Western expansion and management). Consequently, the westernisation of the world touched upon many different histories and memories. Each local history and memory was disturbed by the intervention and domination of Western civilisation, with the collaboration of elites in each local history. The process of coloniality decayed from the emergence of decolonial responses, that is, responses from people who were not happy to be told what to do and who they are. Today decoloniality is everywhere, it is a connector between hundreds, perhaps thousands of organised responses delinking from modernity and Western civilisation and relinking with the legacies that people want to preserve in view of the affirming modes of existence they want to live.

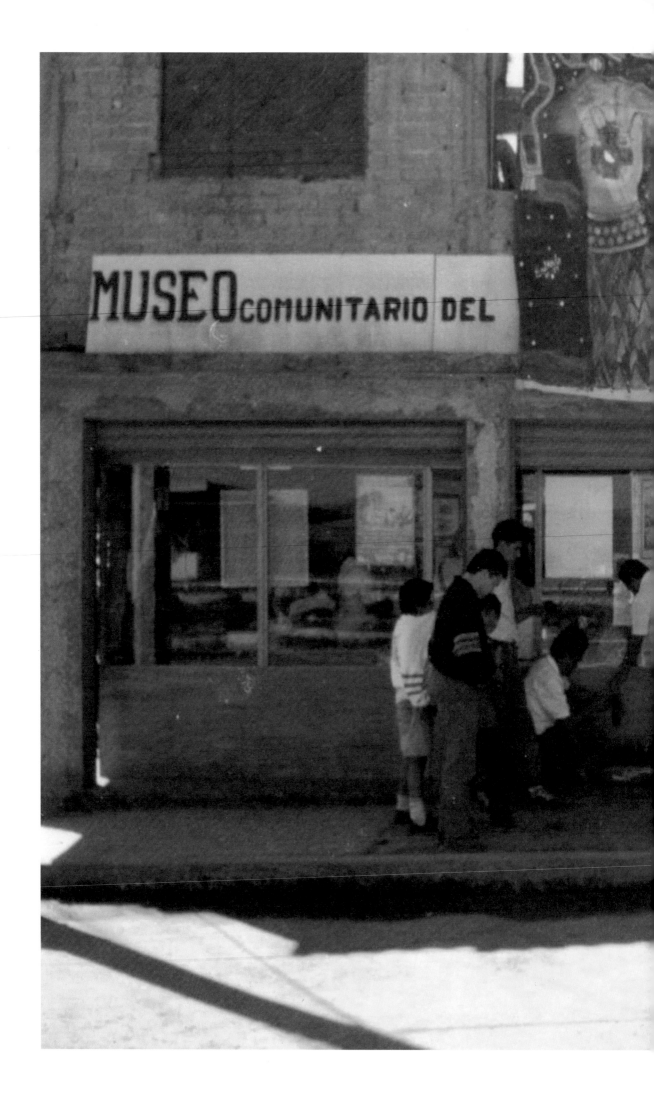

Previous spread:
First headquarters
of the Museo
Comunitario del
Valle de Xico,
Estado de México,
1996. Courtesy
Museo Comunitario
del Valle de Xico

Opposite: Museo
Comunitario del
Valle de Xico, Estado
de México, 2013-16.
Courtesy Pablo
Lafuente and
Michelle Sommer

Chronicle of a Visit to the Museo Comunitario del Valle de Xico, Or: Cultural Solidarity in the Globalised Neoliberal Age

— Irmgard Emmelhainz

Eventually, I believe, he comes to believe in the world, which is to say the other world, where we inhabit and maybe even cultivate this absence, this place which shows up here and now, in the sovereign's space and time, as absence, darkness, death, things which are not.
- Stefano Harney and Fred Moten[1]

On a voulu crier 'victoire' à leur place.
- Jean-Luc Godard[2]

In his 1993 novella, *La leyenda de los soles* (*The Legend of the Suns*), Homero Aridjis paints a sunken, deforested Mexico City: dead vegetation, a destroyed volcano-scape, trash everywhere. He describes a city scourged by crime, corruption and pollution, a 'boundless and foreign world' that underwent 'gradual loss of soil, air and water ... the loss of its own self'.[3] The environ-

Irmgard Emmelhainz sees the Museo Comunitario de Xico's paradigm of care, reciprocity and communality as a model for life at the margins of capitalist markets and neoliberal states.

ment imagined by Aridjis for Mexico City in 2027 is dysfunctional and violent, the dictatorship exacerbated by indescribable forms of control and violence. In the background of Aridjis's apocalyptic vision of a ruined earth – akin to that of the Hollywood film *Elysium* (2013) – are the neoliberal reforms promised in the 1990s: the road of prosperity for all, the answer to the 70s and 80s problems of the corruption of public service, of bureaucracy and the dysfunctional state. The 'transition to democracy' heralded in 2000, when the Partido Acción

Nacional (National Action Party, PAN) took power after the seventy-year-long reign of the Partido Revolucionario Institucional (Institutional Revolutionary Party, PRI) assured the end of the perfect dictatorship and the beginning of alternation, citizen participation and an antagonistic struggle for consensus.

More than twenty years after Aridjis's novel was published, I live in 'CDMX', a branded Mexico City and a key location in the economic and cultural map of globalisation.[4] With most public services privatised, it has become an archipelago of sophistication and wealth, where the quality of the gasoline blues the sky. We enjoy 'First World' infrastructure and services: there are police officers on every corner (including occasional checkpoints); the cleansing of informal vendors and beggars has taken place in public spaces; and beautiful green areas are flourishing, many kept by neighbours, corporations or private businesses. Far from the dry, dark desert of violence that Aridjis imagined, after twenty years of privatisation, concessions and the implementation of a logic of 'zonification' (every one of Mexico City's delegations or boroughs has been oriented toward its optimal economic vocations), privileged territories coexist side by side with misery belts and slums – as in many Latin American cities (and increasingly, all over the world). That is to say, privileged areas in which the state is present, protecting and applying an array of neoliberal governance techniques coexist with zones of sacrifice or environmental devastation inhabited by populations that have been made redundant by neoliberal reforms, resulting in relationships of injurious interdependency between both sorts of populations.[5]

1 Stefano Harney and Fred Moten, *The Undercommons: Fugitive Planning & Black Study*, New York: Minor Compositions, 2013, p.137.
2 'We had wanted to claim victory on their behalf' from *Ici et ailleurs* (*Here and Elsewhere*), dir. Jean-Luc Godard and Anne-Marie Miéville, France, Société des Etablissements L. Gaumont, 1951 [videocassette].
3 Homero Aridjis, *La leyenda de los soles*, Ciudad de Mexico: Fondo de Cultura Economica, 1993, p.7.
4 In 2016, the official name of the megalopolis was changed from Distrito Federal (Federal District) to Mexico City, the name by which the city has long been known worldwide.

View of the Hacienda
de Xico before it
collapsed, early
1900s. Estado de
México. Courtesy
Museo Comunitario
del Valle de Xico

❋

In January 2017, I drove away from the
Museo Comunitario del Valle de Xico,
through the outskirts of Mexico City, feeling
overwhelmed, humbled, disquieted. I had in
my mind the seemingly endless landscape
of cement and pollution unfolding from
the museum's courtyard, and the image of
a sculpture that hung there from a tree: an
anthropomorphic figure suspended from
an egg-shaped cage, made out of wire and
branches and standing on top of random,
discarded objects, like a pile of trash. A sun,
also made of wire, was suspended on top of
the faceless figure. I could not help but think
of the sculpture as a metaphor for the people
of the Valle de Chalco.

A century ago, the valley was farming
land that had been artificially fabricated
through the desiccation of Lake Chalco.[6] In
the 1970s, immigrants from the country-
side, looking for opportunities and for mod-
ern subjectivities, began to settle there on
stolen, bought or appropriated land; gradu-

ally urbanising the farmland, this migration
gave way to the incommensurable urban
sprawl named, under Carlos Salinas de
Gortari's regime in the 90s, Valle de Chalco
Solidaridad (Valley of Chalco Solidarity).
Valle de Chalco gathers thirteen municipali-
ties within a larger urban conglomeration[7]
that has been described as the 'biggest slum
in the world'.[8] Most of its inhabitants work
in precarious conditions in the informal ser-
vice economy of Mexico City. This means
exhausting daily commutes on deficient
public transportation; absolutely no labour
rights; and only minimum access to low-
quality credit, infrastructure, housing, com-
modities, healthcare, education and food
(cancer and diabetes abound).

Xico, once the bigger of the two islands
in Lake Chalco, is one of the thirteen mu-
nicipal seats of Valle de Chalco. It harbours
traces of Mexico's pre-Hispanic and modern
eras. Most of Xico lacks basic services such
as water, education, work, electricity and
healthcare,[9] but corporate chains includ-
ing pharmacies, supermarkets, shops and

5 See Irmgard Emmelhainz, 'Injurious forms of dependency: toward a decolonizing resurgence of
 indigenous peoples?', *Clima.com* [online journal], 2016, available at http://climacom.mudancasclimaticas.
 net.br/?p=6399 (last accessed on 17 January 2017); and 'The Mexican Neoliberal Conversion: Differentiated,
 Homogenous Lives', *Scapegoat Journal*, no.6, January 2014, available at http://www.scapegoatjournal.
 org/docs/06/Scapegoat_06_Emmelhainz_The%20Mexican%20Neoliberal%20Conversion.pdf (last
 accessed on 24 January 2017).
6 This project began in the sixteenth century and materialised in subsequent efforts by the Spanish colony
 to dry out and channel the lakes upon which the Aztec City of Tenochtitlan and adjacent cities were built
 (which comprised five interconnected lakes: Zumpango, Xaltocan, Texcoco, Xochimilco and Chalco).
7 Along with Ciudad Nezahualcóyotl and Iztapalapa.
8 See Michael Waldrep, 'Scenes from Neza: Mexico's Self-Made City', *Fulbright National Geographic Stories*
 [blog], 26 March 2015, available at http://voices.nationalgeographic.com/2015/03/26/scenes-from-
 neza-mexico-citys-self-made-city/ (last accessed on 18 January 2017).

Christian temples have a strong presence. Since the 1990s, the state has made itself strategically present in Xico, 'investing' in the area through reforms mostly geared at favouring the interests of private real estate projects, water concessions and other forms of territorial exploitation. In contrast, Xico's inhabitants have developed a complex network of grass-roots councils led by originary peoples, neighborhood representatives, *núcleos ejidales*,[10] NGOs, educators and various other political organisations.[11]

In this context, the Museo Comunitario de Xico was created roughly twenty years ago. In contrast to state-run or private museums, community museums in Mexico are developed in consultation with the specific community in which they are located, in response to its needs. Such museums were formalised by the Instituto Nacional de Antropología e Historia (National Institute of Anthropology and History, INAH) during the 1990s, and are geared at strengthening communal action, organisation and identity through endogenous knowledge and interpretation of local culture. In practice, these museums generate projects to ameliorate a community's quality of life: they offer courses and training to cover an array of needs, revive cultural traditions, develop new forms of expression and generate tourism that is controlled by the community itself. They also serve as bridges for cultural exchanges with other communities, and for alliances, integrated networks and joint projects.[12] In the states of Oaxaca, Yucatán, Veracruz, Morelos, Tlaxcala, Hidalgo, Guerrero, Querétaro and Puebla, there are about fifty community museums supported by the INAH, while hundreds exist in Mexico City with no institutional support. INAH provides community museums with workshop spaces, small budgets for select projects and support for conservation and archival measures.[13]

That cold January morning in 2017, I had arrived at the Museo Comunitario de Xico with my daughter, where we were greeted by the museum's team: Mariana Huerta Páez, art workshops coordinator; Giovanni Veracruz del Angel and Juan José Ayala Fonseca, librarians; Ana Laura Lira Huerta, tourism liaison; Diana Ivete Espinosa Hernández, cultural promoter; Juan Neri, in charge of design and social networking; and Don Genaro Amaro Altamirano, the museum's director and Xico's official chronicler. Over a *rosca de reyes*[14] and coffee, they generously discussed their projects and described the museum's collection and programmes.

The Museo Comunitario de Xico was created by the Comisión Local para la Preservavación del Patrimonio Cultural del Valle de Chalco (Neighbourhood Council for the Preservation of Cultural Heritage of Valle de Chalco) for the upkeep and preservation of the vestiges of Xico's archaeological site. It opened in July 1996 in a small venue with an exhibition of its founding collection, donated by the inhabitants of the valley. The museum holds five thousand pre-Hispanic artefacts, a thousand of which are currently on display. Aside from preserving and documenting the collection, the museum organises community-related activities such as Dia de los Muertos (Day of the Dead) celebrations, *posadas*,[15] *tertulias*[16] and other festivities. It has also served as a catalyst for initiatives such as the reactivation of a *chinampa*, or human-made lake, in Tláhuac, in addition to resistance against real estate projects in the area. The museum, moreover, is known for lodging the Zapatista Caravan every time it passes through, and for having hosted meetings of the recently dismantled (because of privatisation) Sindicato de la Comisión Federal de Electricidad (Federal Electricity Commission Union) and of the Guerrero Policía Comunitaria (community police). Along with art workshops, the museum has a project to write and teach the history of Xico from its

9 See Gustavo Magallanes, Atzin Bahena, Amanda Ramos and Fiorella Fenoglio, 'La rebeldía del Valle de Chalco: la lucha contra las aguas negras y el mal gobierno', *Revista Rebeldía*, vol.8, no.70, April 2010, pp.18-29, available at: http://revistarebeldia.org/revistas/numero70/06chalco.pdf (last accessed on 18 January 2017).

10 An *ejido* is a piece of land farmed communally under a system supported by the state.

11 A few kilometres away is the town of San Salvador Atenco, where resistance against the construction of a new airport in 2006 received much media attention after an unprecedented degree of state violence was applied by then-governor Enrique Peña Nieto (now president of Mexico).

12 See the '¿Qué es un museo comunitario?' page of the Museos Comunitarios's website: http://www.museoscomunitarios.org/que-es (last accessed on 18 January 2017).

13 See 'Museos comunitarios preservan la memoria e identidad', on the INAH's website: http://www.inah.gob.mx/es/boletines/4434-museos-comunitarios-preservan-la-memoria-e-identidad (last accessed on 18 January 2017).

14 *Rosca de reyes* (king's ring) is a cake traditionally eaten on 6 January in Spain and Latin America to commemorate the arrival of the Magi.

15 Parties and celebrations that take place from 12-24 December in Latin American countries in anticipation of Christmas.

16 An informal, typically bohemian gathering or party.

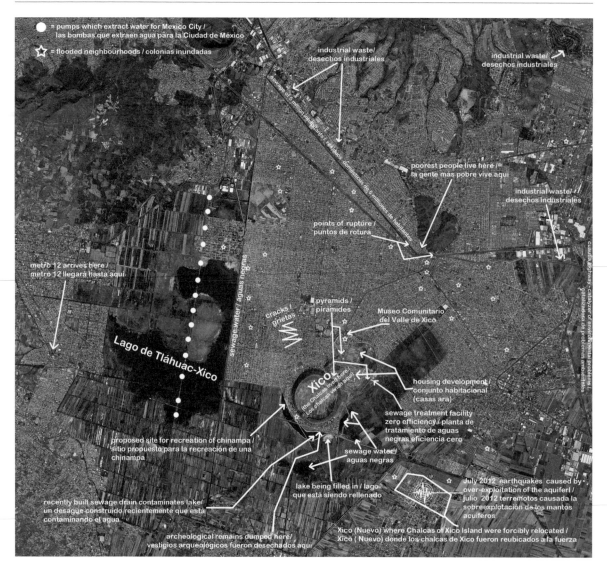

○ = pumps which extract water for Mexico City /
las bombas que extraen agua para la Ciudad de México

☆ = flooded neighbourhoods / colonias inundadas

industrial waste/ desechos industriales

industrial waste/ desechos industriales

poorest people live here / la gente más pobre vive aquí

points of rupture / puntos de rotura

industrial waste/ desechos industriales

metró 12 arrives here / metro 12 llegará hasta aquí

sewage water / aguas negras

cracks grietas

pyramids / pirámides

Museo Comunitario del Valle de Xico

Lago de Tláhuac-Xico

Xico (the Chalcas live here/ Los chalcas viven aqui)

housing development/ conjunto habitacional (casas ara)

sewage treatment facility zero efficiency / planta de tratamiento de aguas negras eficiencia cero

proposed site for recreation of chinampa / sitio propuesto para la recreación de una chinampa

sewage water/ aguas negras

recently built sewage drain contaminates lake/ un desagüe construido recientemente que está contaminando el agua

lake being filled in / lago que está siendo rellenado

July 2012 earthquakes caused by over-exploitation of the aquifer! / julio 2012 terremotos causada la sobreexplotación de los mantos acuíferos

archeological remains dumped here/ vestigios arqueológicos fueron desechados aquí

Xico (Nuevo) where Chalcas of Xico Island were forcibly relocated / Xico (Nuevo) donde los chalcas de Xico fueron reubicados a la fuerza

inhabitants' point of view. A grant from a Finnish NGO has guaranteed training and salaries for three historians to teach in public schools throughout the valley and to hold workshops for children at the museum. The museum's staff have produced a series of 35 booklets, which are taught and distributed in the region's public schools. The first Saturday of every month a gathering for the art, literature and music of the people of Xico is hosted on-site. Recently, a considerable portion of the exhibition space has been devoted to showing local contemporary art; when I visited, artist Stephanie Bringas was having a solo show.

In a collective effort of care, and following the values of reciprocity and communality, the Museo Comunitario de Xico has resisted ongoing threats including eviction, relocation, lack of funding and private interests' and government organisms' efforts of appropriation. In 1997, the museum relocated to the Hacienda de Xico,[17] built on a pre-Hispanic platform from the Teotihuacán era and beside a pair of extinct volcanoes and the vestiges of a sixteenth-century ranch owned by the Spanish conquistador Hernán Cortés.[18] The hacienda is the symbol and site for Xico's identity and history: it is a complex, if not unique, palimpsest of Mexico's history of colonisation, dispossession and dreams of modernity. Between 1885 and 1903, with the support of the dictator Porfirio Díaz, Spanish entrepreneur Iñigo Noriega Laso embarked on a mega-project to dry out the lake with the purpose of transforming it into arable land. During this period, thousands of the valley's inhabitants were violently removed by Noriega's private army or forced

17 Historically haciendas were large land holdings that served as farms, factories, mines and/or plantations and that included a dwelling house.
18 The building suffered partial damage during the Mexican Revolution (1910–20) in addition to further modifications later in the twentieth century; it is presently being restored.

Maria Thereza Alves,
*El retorno de un lago
(On the Return of a
Lake)*, 2012, Ciudad
de México. Courtesy
Museo Universitario
Arte Contemporáneo
(MUAC)

into labour.[19] In 1913, Noriega's hacienda was occupied and the lands transformed into *ejidos*.[20] In the 1980s, an aquifer began to emerge, which is now a considerable lake named Tláhuac-Xico.[21] As a matter of fact, every rain season the lake floods the valley; on display at the museum is a dead refrigerator bearing the muddy watermarks of a devastating flood in 2000.

The desiccation project of Chalco and the current environmental precarity of its inhabitants exemplify the relationship between colonial dispossession and environmental devastation. In the recent book *Erasure: The Conflict Shoreline* (2016), Eyal Weizman connects climate change with colonialism: climate change should not be viewed as an unintentional effect of modernity, or as collateral damage, but as declared goal. For instance, Weizman explains how the Negev desert is a movable frontier that advances in response to agriculture, colonisation, displacement, urbanisation and climate change, and that all of these are tied to dispossession. Like Iñigo Noriega, who sought to expand arable lands during Porfirio Díaz's regime, the government of Israel has sought to expand the arable area of Negev and to place nomads under state control.[22] In Chalco, as in the Negev, climate change and the displacement of populations has gone hand in hand. The lens that Weizman provides to understand colonisation in the Negev is key in understanding land degradation, the destruction of fields and forests, and pollution and water diversion in its reciprocal interaction with sociopolitical conflict in Chalco.

Aside from periodical flooding,[23] the region has been affected by the lowering of the lakebed: water drainage, combined with the pumping of groundwater, has caused the water table to drop, resulting in topographic changes. As the lakebed sinks, it grows closer to the sinking water table – a sort of chasing downwards. But unlike the sunken topography, the water table can rise again; during the rainy season, the water table rises and the first point at which it hits the topography is at the base of the former Lake Chalco, which it fills once again.[24] The pumping of the water is not only polluting the aquifer's clean water but also causing the land to sink: by 2013, the ground level was twelve metres lower than twenty years previous. The valley's gradual sinking has also contributed to the continuing collapse of the Hacienda de Xico.

The history and current challenges faced by the inhabitants of the Valle de Chalco have given this territory a special status. For the past decade, an array of architects, urban planners, cultural producers, transnational think tanks, environmentalists, government officials, doctoral students, biologists, civil rights organisations, activists and experts of every kind have proposed policies, projects, symbolic histories and plans to bring the water back, to make the area sustainable and to provide infrastructure (for instance, the much needed drainage systems and culverts).[25]

Against this background, and within the context of global solidarity and environmental justice furthered by cultural initiatives, the Museo Comunitario de Xico was recently the subject of an international controversy. In 2012, artist Maria Thereza Alves exhibited at dOCUMENTA (13) a project developed in collaboration with the Xico museum. The exhibition showed dioramas describing the history of the place and included a portrait of Iñigo Noriega burning in flames – symbolising past and

19 The hacienda was considered to be the epitome of modernity and progress in pre-revolutionary Mexico, with a train that went from Xico to Atlixco, in the adjacent state of Puebla, connecting all of Noriega's properties.
20 See G. Magallanes, A. Bahena, A. Ramos and F. Fenoglio, 'La rebeldía del Valle de Chalco', *op. cit.*
21 According to theorist and researcher Seth Denizen, Lake Chalco and the aquifer need to be carefully distinguished here because they are not necessarily connected. For instance, it is possible for the lake to re-emerge and the aquifer to be depleted at the same time; the dense clays of the lakebed can prevent water from moving into subterranean aquifers.
22 See Eyal Weizman, *Erasure: The Conflict Shoreline*, Göttingen: Steidl Verlag, 2016.
23 This is also caused by the overflow of the La Compañía Channel, which carries much of the former lake's water.
24 As explained to me by Seth Denizen in an email, 14 January 2017.
25 For instance, in 2011 the urban development department of the Comisión Hidrológica del Valle de México (Hydrologic Commision of Mexico's Valley) made a plan to identify the region's problems, amongst them the lack of clean water, pollution, drought, floods, sinking and soil erosion. There is also the Water Caravan, a study to implement a master plan to rescue the Chalco Lake and Xochimilco basins, and Vuelta a la ciudad lacustre (Return to the Lake City), an ambitious ecological and urban project by a team of architects, biologists, philosophers, engineers and politicians (gathered under the aegis of architects Teodoro González de León, Alberto Kalach, Gustavo Lipkau and Juan Cordero) to bring the lake back by building water treatment plants and by creating new public spaces and solutions to the irregular urban sprawl. This initiative has a precedent in the 1964 project at Lake Texcoco (adjacent to Chalco) by Mexican engineers Nabor Carrillo and Gerardo Cruickshank. These plans remain unrealised. Some proposals have been utopian, others are transient palliatives or struggles for water rights and land use disputes. Many are tied to infrastructure and real estate projects (such as privatised social housing projects) backed up by corporate and state neoliberal interests.

ongoing dispossession and the destruction and exploitation of Chalco. There was also a section about the historical 'heroes' of the region, and another one about the axolotl, a near-extinct amphibian made famous in a short story by Julio Cortázar as well as by Roger Bartra Murià's positing of the creature as a metaphor for modern Mexico (not a tadpole, not a reptile, forever caught in between evolution and stasis).[26] The project included an invitation to Don Genaro Amaro Altamirano to visit La Fundación Archivo de Indianos-Museo de la Emigración (Indianos Archive Foundation-Museum of Emmigration) in Colombres, Spain – lodged in Noriega's estate – to deliver a history book written from the point of view of the people of Xico. Alves's project, in its weaving of a net of memories from the nineteenth century in relationship to the neoliberal politics of accumulation, was a much-needed exercise of counter-history and restitution. Evidently, memory is a crucial part of the war being waged against mega-projects and resource extraction everywhere today.

In Mexico City in 2014, the Museo Universitario Arte Contemporáneo (University Museum of Contemporary Art, MUAC) at the Universidad Nacional Autonoma de Mexico (National Autonomous University of Mexico, UNAM) exhibited a second edition of Alves's *El retorno de un lago* (*On the return of a lake*) in collaboration with the Museo Comunitario de Xico. A selection by Don Genaro from the museum's collection was shown at MUAC, and a series of round tables held in which representatives from Chalco's thirteen municipalities were able to discuss their local environmental, political and economic problems. In turn, MUAC organised workshops, lectures and tours engaging Xico's community in the valley.

Two years ago, a few months after the MUAC exhibition, the Xico municipality began to restore the hacienda with a budget of twenty million Mexican pesos[27] – but failed to provide proper temporary storage for the collection, or provisional headquarters for the museum itself. The museum had to relocate to the Hacienda's adjacent barn, which had no water, electricity or ventilation. The barn was filthy, invaded by doves and their excrement; its ceiling had both asbestos and holes in it. The municipality agreed to clean out half of the barn as well as to build provisional walls to separate the storage area from the exhibition area. They also committed to installing a net and sealing part of the ceiling to keep doves out. When Don Genaro told me this story, I suspected that the restoration project was an effort on the part of the municipality to take over the hacienda. By now, the restoration funds have 'run out'. Don Genaro has subtly hinted that, as an act of reappropriation, the community will get copies of the keys to the hacienda. This way they can regularly use it to teach their history workshops – despite the fact that the building remains without roof, windows, electricity or finished floors.

According to Don Genaro, he and the community looked in desperation for proper storage for the collection. In their attempts to gain financial and institutional support from MUAC as well as other arts contacts and institutions, the administrators of the Museo Comunitario de Xico were kindly discouraged from directly contacting MUAC's highest level staff. When Don Genaro requested the 'voluntary cooperation' of MUAC's employees,[28] Cecilia Delgado Masse, former MUAC curator and the person in charge of Maria Thereza Alves's project in MUAC, collected money from the museum's employees. This money together with a donation from Jorge Satorre and the Kurimanzutto Gallery in Mexico City (a total of $42,000 Mexican pesos) enabled them to minimally rehabilitate the building adjacent to the hacienda, where the Museo Comunitario de Xico is currently located. In a phone interview, Delgado Masse explained to me how for her, as the main person from MUAC involved with the Museo Comunitario de Xico, she developed an extra-institutional relationship with them. This is the place from which she supported them, offering the money collected as well as materials to rehabilitate the barn as museum space.[29]

In the light of the eviction from the hacienda and the Mexico City art community's lacklustre response and lack of solidarity, art historian and critic Paloma

26 See Julio Cortázar, *Final del juego*, Ciudad de México: Los Presentes, 1956; and Roger Bartra, *La jaula de la melancolía. Identidad y metamorfosis del mexicano*, Ciudad de México: Grijalbo, 1996.
27 Ignacio Ramírez, 'Arrumban Museo Xico por obra', *Mural*, 21 November 2015, available at http://www.mural.com/aplicacioneslibre/articulo/default.aspx?id=700468&md5=515eeade89137366d264175b58af69d2&ta=0dfdbac11765226904c16cb9ad1b2efe (last accessed on 24 January 2017).
28 Information in email exchanges between the Museo Comunitario de Xico and Don Genaro Amaro Altamirano. This information was kindly provided by Cecilia Delgado Masse via email, 24 January 2017.
29 Telephone conversation with C. Delgado Masse, 22 January 2017.

Checa-Gismero has questioned the ethics and politics of MUAC's and Alves's intervention/collaboration with the Museo Comunitario de Xico.[30] Checa-Gismero's argument is that collaborations such as this tend to bring together 'dispositives' whose

In a collective effort of care and following the values of reciprocity and communality, the Museo Comunitario de Xico has resisted ongoing threats including eviction, relocation, lack of funding and private interests' and government organisms' efforts of appropriation.

publics and actors are worlds apart, thus '[activating] an aesthetic and ideological torsion that alienates publics from the real problematic originally addressed by Alves: an environmental and social crisis in a Mexican town'.[31] While MUAC was interested in fostering an artistic project that referred to a pressing social issue at its headquarters, its lack of interest *as an institution* in fully supporting the smaller-scale museum is evidence that the power relations created in these exchanges are never at stake. Structural inequality remained untouched and restitution could only happen at the symbolic level, shedding light on the dissymmetry in publics and executors that characterises intervention work.[32]

In Xico, after two years of work on the hacienda, the date of the collection's relocation to the renovated headquarters is nowhere in sight. The building where the museum is currently located is a former industrial trash deposit, and a third of the space is occupied by an enormous pile of rubble that the museum's team have been patiently cleaning out for the past two years. The building has thin metal sheets and canvas for its ceiling; even more than the humidity and dust felt inside the space, the carefully mounted pieces on discrete styrofoam plinths and wobbly wooden vitrines speak loudly about the precarity and poverty despite which the Museo Comunitario de Xico survives. Thanks to a provision given by the INAH, Don Genaro has been able to fend off threats of eviction and destruction. It has become evident that all efforts to maintain the museum's autonomy and social initiatives pose a threat to and are also prey to appropriation by foreign agents of cultural capitalisation. In this context, the museum resists by surviving – through different modes of being and belonging; through the enactment of new economies of giving; and through the practices of exchange, obligation and reciprocity at work in the museum's programme and objectives as well as in Don Genaro's ethical stance. For instance, in his guidelines for directing the museum, he states that the museum is for and by the community and that the staff's goal is to work in reciprocity for the community as opposed to for themselves.[33]

This space is part of a vulnerable network of *instituent* efforts to build counter-histories and autonomous identitarian narratives and initiatives for sustaining traditional forms of communal life. There are indeed contradictions operating at the

30 It must be noted that Don Genaro Amaro and the rest of the museum's team consider Maria Thereza Alves, Jimmie Durham and Catalina Lozano as invaluable allies who have provided support to the Xico Museum in helping them conceptualise their activities toward socially engaged art struggling against capitalism. Although their institution moves within the structures of control and domination of the neoliberal system, they promote and exhibit art that questions, proposes and builds its own ways to conceive a new world through art, as committed art on the side of the marginalised. The museum's team wishes that Alves and their art world supporters not be minimised or disqualified, as for them their collaboration has been invaluable. Don Genaro and Mariana Huerta kindly provided this information in an email exchange, 28 January 2017.

31 Paloma Checa-Gismero, 'On The Return of a Lake', *FIELD: A Journal of Socially-Engaged Art Criticism*, issue 1, Spring 2015, pp.281–88, available at http://field-journal.com/wp-content/uploads/2015/05/FIELD-01-Checa-Gismero-ReturnOfALake.pdf (last accessed on 18 January 2017).

32 In response to the urgency of addressing this kind of asymmetry and in a radical exercise of decolonial institutional repurposing, the project *Wood Land School: Kahatènhston tsi na'tetiátere ne Iotohrkó:wa tánon Iotohrha* will take place starting this January 2017 in Montreal, Canada. Following curator Cheyanne Turion's description, for a year the institutional identity and resources of SBC Gallery of Contemporary Art, which is directed by Pip Day, will function wholly in support of the Wood Land School. Theirs is an experiment in relation to what it means for settler-colonial infrastructures to work in service of indigenous imperatives, and an exploration of power relations and their possible reconfiguration from an initial perspective of indigenous self-determination. See C. Turions, 'Wood Land School *Kahatènhston tsi na'tetiátere ne Iotohrkó: wa tánon Iotohrha*', *Cheyanne Turions: Dialogues Around Curatorial Practice* [blog], available at https://cheyanneturions.wordpress.com/ (last accessed on 22 January 2017).

33 Don Genaro kindly showed me these guidelines in January 2017 in a PowerPoint presentation he has delivered at community museum gatherings in Oaxaca and Guerrero.

heart of these projects – one of their main tasks is to decolonise the very structures of knowledge, categorisation, classification, periodisation and the very concept of the *museum*. This will be the work of generations to come, but the Museo Comunitario de Xico is exemplary as an inspiring start.

We ('we' on the side of privilege) should reconsider the ways in which we think about these initiatives and the role they have in our political imaginaries. We should begin to learn from their experiments and experiences in self-determination and collectivity, acknowledging that they are situated and impacted upon by destructive forces in which we participate. Art historian T.J. Demos has posited Alves's project as serving a socioenvironmental politics of justice, comparing 'its struggle for local self-determination, return to subsistence, greater autonomy, community solidarity and ecological sustainability' to the Zapatista movement – although, in his condescending view, 'the museum is no revolutionary withdrawal from the state'.[34] It is evident that for now it is impossible to go beyond the state or its institutions as a means to do politics: the museum would not

exist without the INAH provision and thus, without institutional validation. But what is actually being done is the building of an autonomous historical horizon, which takes into consideration the contradictions and ambiguities of the relations of domination within the capitalist system. Furthermore, *we* should no longer deny the way in which underprivileged populations are being negated by the kind of social relations imposed by capital and bureaucracy in operating their interests through betterment and restitution projects. It should be made clear that such interventions are neither neutral nor horizontal and that exogenous reforms and interventions of all kinds have nothing to do with autonomy, solidarity or democracy. This is because current forms of power are embedded not in what we do, know, talk about or see, but in what infrastructures we operate within and how we do so.

A question remains: can a project such as the Museo Comunitario de Xico be emancipatory? Beyond uprisings and mobilisation, exercises in autonomy open up perspectives to think about 'other' means to organise, preserve, self-preserve, reproduce.

34 T.J. Demos, '*Return of a Lake*: Contemporary Art and Political Ecology in Mexico', *Rufián Revista*, no.17, January 2014, pp.50–63, available at https://tjdemos.sites.ucsc.edu/wp-content/uploads/sites/374/2016/08/Demos-Alves-MUAC-copy.pdf (last accessed on 18 January 2017).

View of an event
with the Zapatista
Army, 2001, Xico,
Estado de México.
Courtesy Museo
Comunitario del
Valle de Xico

The Wood Land School project in Montreal, Canada is exemplary here for working within a framework of tenets by which mutual accountability, reciprocity, relocation across difference and stewardship of resources can take place. They envision their project as a space of critical reflection and reimagination, where indigenous thought and theory, beyond identity, can be centred, enacted and embodied, honouring specific expressions of inheritance and becoming with awareness of the presence of the various forms of settler colonialism.[35] In the context of indigenous Latin America, the common horizon of communal emancipation is not a series of explicit and systematic objectives to be achieved; rather, as Raquel Gutiérrez Aguilar has argued, it is an ambivalent and open process, a trajectory by multiple groups, by men and women. Bearing this in mind, the relationship between state-centred politics and autonomous politics is not one of opposition but one of disjunction, of the confrontation of incompatible differences and perspectives.[36]

The Museo Comunitario de Xico's efforts at autonomy and links to a national network of community museums have further global resonance in Mark Fisher and Nina Möntmann's proposal to enable small-scale institutions throughout Europe to build a transnational network that would combine an autonomist emphasis on autonomy with the Gramscian emphasis on institutions. They envision a cluster containing hubs of activation with the task of building publics and collectivities pitted against market interests. The cluster would serve, organisationally and aesthetically, as an international infrastructure combining aspects of exchange and the mutual support of small-scale institutions with a debate on decentralised internationalism.[37] The Museo Comunitario de Xico and the Wood Land School would be nodes in this international hub, adding perspective towards decolonising cultural spaces and practices, and bringing awareness that knowledge and cultural infrastructures have been built upon the negation and silencing of originary peoples.

Moreover, the Museo Comunitario de Xico is an instance of a new paradigm of politics emerging at the surface of the social throughout indigenous and underprivileged communities in Latin America. These exercises are building the possibility of living in dignity at the margins of capitalist markets and neoliberal states, enabling subjects to begin to recognise themselves as autonomous entities that resist by surviving, conscious of the appropriation of their own political practice. They are characterised first by dignified and gracious distrust of anything that hints at the disciplinary, at subjection or at foreign capitalisation, and second by elegant suspicion of prescriptive and universal statements that speak from the site of the imposition of power. What is needed is the projection of a road in common, displacing thought and debate, pitting reform and revolution against emancipation, in awareness that social relationships cannot be transformed because they occur within the very system that denies that anything was ever broken – and is still being broken – by (neo) colonialism. It is that structure, the standpoint from which colonialism makes sense, that is limiting our ability to find each other. After Stefano Harney and Fred Moten, today it is neither useful to speak truth to power, nor to recognise the other. It is pressing that we 'inhabit' the language of the other, which has been rendered as nonentity by colonialism; that we show the sovereign's 'space and time', which makes itself present 'as absence, death, things which are not'.[38]

35 See C. Turions, 'Wood Land School *Kahatènhston tsi na'tetiátere ne Iotohrkó: wa tánon Iotohrha*', *op. cit.*
36 See Raquel Gutiérrez Aguilar, 'Los ritmos del Pachakuti. Reflexiones breves en torno a cómo conocemos las luchas de emancipación y a su relación con la política de la autonomía', *Desacatos*, no.37, September-December 2011, pp.19-32.
37 Mark Fisher and Nina Möntmann, 'Peripheral Proposals', in Emily Pethick (ed.), *Cluster: On a Network of Visual Arts Organizations*, Berlin: Sternberg Press, 2014, pp.171-82.
38 S. Harney and F. Moten, *The Undercommons*, *op. cit.*, p.137.

The author would like to thank Paloma Checa-Gismero and Seth Denizen for their valuable feedback and comments. She is also grateful to Cecilia Delgado Masse for sharing her experiences working with the Museo Comunitario de Xico and the exchanges that ensued at the time of the museum's relocation from its main building to the barn.

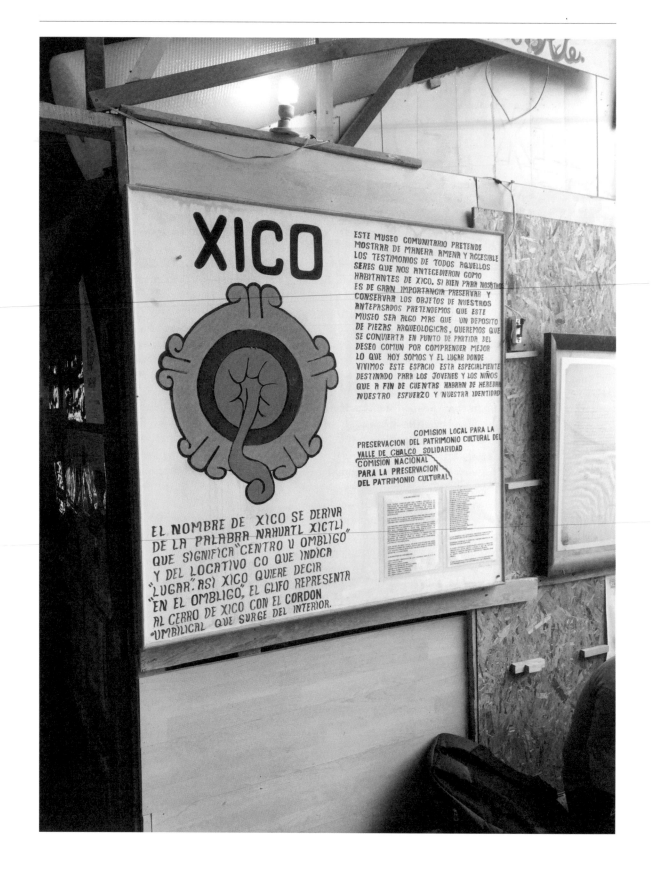

Museo Comunitario
del Valle de Xico,
Estado de México,
2013–16. Courtesy
Pablo Lafuente and
Michelle Sommer

'History is made by the people':[1] Fragments on the Museo Comunitario del Valle de Xico

— Pablo Lafuente and Michelle Sommer

Surface level: The archaeological site of Xico, Xico Station, Old Xico, San Miguel Xico, Xico hill… The name Xico comes from *Nahuatl Xictli*, which means 'centre' or 'belly button', and from the suffix *co* that signifies location. Therefore, *Xico* could be translated as 'in the belly button'. Its glyph, its pictogram, represents the Xico hill, seen from above, from the sky, with an umbilical cord that emerges from its centre.

❊

Layer A: Located in the south-east of Mexico City, on flatlands that used to be a lake, the municipality, officially referred to Valle de Chalco Solidaridad (Valley of Chalco Solidarity), is home to around 400,000 registered inhabitants. The destruction of the place and its history begins with the violent occupation of México-Tenochtitlán by the Spanish in 1519–21.

After the Mexican Revolution in 1910, the lands of the Xico estate are expropriated and transformed into several plots of land

Through a series of fragments, Pablo Lafuente and Michelle Sommer present a picture of the Museo Comunitario de Xico via histories of anti-colonial resistance, collectivity and the museum as a social tool.

for communal exploitation. When labour begins, and with it the movement of earth and stone, many ceramic pieces that were under the earth are destroyed, but some are also saved. Small vases, pots, human or animal faces, tiny spheres, beads of different materials.

❊

Layer B: 'As part of the valorisation proposal of popular manifestations, the potsherds, vases, pots, ceremonial vessels, crockery and ceramic pieces representing deities, men or animals are vestiges of what the ancient peoples used in their daily life and in numerous rituals and ceremonies. In these ceramic objects, many of them made right here, others brought from afar by merchants, they expressed plastically their spiritual and artistic experiences, as well as a way of thinking, feeling and interpreting the world. The ceramic that is stepped on, destroyed or subtracted surreptitiously has an incalculable value: it is the only source, in the absence of writing, for the study of Xico's past, before the conquest.'[1]

❊

Surface Level: 'Archaeological wealth is so dense and diverse that people from other locations arrive and begin digging to look for little monkey figures and vases. Gringos also arrive – we call them moneros – to buy archaeological pieces.'[2] As a response, in 2004 a project to save the archaeological heritage of Xico began, with demands for the pieces to remain where they were found, so that they could serve as pedagogical tools within the cultural dynamics of the place. The Instituto Nacional de Antropología e Historia (National Institute of Anthropology and History, INAH) recognised the community as the legal custodian of the collection, and an intensive education project about the relevance of the objects that were found began within municipal schools and community organisations in order to generate a relationship of respect and valorisation of the cultural heritage. But not only that.

1 Anonymous, 'La cerámica de Xico: El barro hecho arte', *Cuadernos de historia del Valle de Xico*, no.5, date unknown. All translations are by the authors unless specified.
2 G. Amaro, 'La destrucción del patrimonio arqueológico de Xico', *Cuadernos de historia del Valle de Xico*, no.19, date unknown. The term *gringos* is used in Mexico to refer to citizens from the United States. It is also used more broadly in Spanish-speaking and Portuguese-speaking countries to refer to foreigners.

※

Layer D: The Museo Comunitario del Valle del Xico is a radical, ambitious and unpretentious experiment, one grounded in popular culture, and which produces value with and from subjects. It works towards the defence, study, knowledge and dissemination of cultural heritage and it is integrated within the life and dynamics of the place by means of revitalising and refunctionalising ancient cultural forms and connecting them to new ones. Sometimes spontaneously, sometimes not, but always with a creative aim: to recognise the contribution of local artists, and of a practice that persists despite the lack of support and opportunities.

※

Layer C: 'To popular manifestations of art, the Museo Comunitario opens its doors in order to feed from the knowledge of the artistic past and yesterday's struggles, so their art becomes part of the education and social consciousness in order to strengthen the aspiration to end the social and economic inequalities that divide the peoples between poor and rich, remembering that the artist is the chronicler of her time and that her work must perpetuate the struggles and aspirations of the people she belongs to – the working people.'[3]

※

Layer D: The operational mode is analogical, a network that works through one-to-one contact. Eye-to-eye in the physical and verbal interactions, in the horizontal mediations, in the pedagogical exchanges. There is no reduction to context of the archaeological pieces donated by the community that itself identifies them as valuable. On the contrary: the(ir) place is contextualised to create possible relations beyond the obvious. The interactions – sensitive – emerge from an analogical and dialogical relationship that shapes plural narratives, heard and told. Intertwined.

Like Xico's glyph, the umbilical cord is ready for new connections. Community engagement – organic, organised and also spontaneous. It is activated through continuous actions that don't solely depend on the museum's initiative, but rather on the network that grounds it, which is in constant change. Change that happens through consultation with the community: with the schools the team visits, with those who live around it or frequent it. They chose its location: the former Hacienda de Xico, constructed in the late nineteenth century by Spanish colonial landowner

Communitas, *in the spirit of a community operating through a self-managed cultural organisation, is interested in social interaction, in shared experience, and not in 'objects' or 'exhibitions'. And thus hints at what the museum's social function could be.*

Iñigo Noriega Laso, and taken over by the revolutionaries in 1914, who distributed its riches to the local population in insufficient compensation for the theft and abuse inflicted on them by the previous 'owner'. The museum, an act of rewriting history housed by the building's own history, is another act of compensation – still insufficient, but...

※

Surface Level: In 1994, the Centro de Desarrollo Comunitario Juan Diego (Centre for Community Development Juan Diego) initiated a project called *Cuadernos de historia* (History Notebooks), with the aim of promoting the recovery of historical memory and the oral tradition of the valley, as well as of contributing to the formation of the Museo Comunitario del Valle de Xico. It is a response to what the community perceives as its own needs: its desire to learn about the location's history, and to preserve both its archaeological and cultural heritage. The first edition is from 1995. In 1996 the community organised the Comisión Local para la Preservación del Patrimonio Cultural de Valle de Chalco Solidaridad (Neighbourhood Council for the Preservation of the Cultural Heritage of Valle de Chalco), which in turn created the Museo Comunitario del Valle de Xico.

3 Anonymous, 'Los murales del Museo Comunitario del Valle de Xico', *Cuadernos de historia del Valle de Xico*, no.25, February 2013.

View of Fernando Palma's and Nuria Montiel's workshop *Caminata por nuestro maíz (Walking Through Our Corn)*, from Xico to Teuhtli, Estado de México, 2015. Courtesy the Museo Comunitario del Valle de Xico and Fernando Palma and Nuria Montiel

In twenty years, more than forty notebooks have been published. They discuss the arts and the conservation of archaeological pieces, crafts and history, food, traditions, representations...

❋

Layer A: When an object is donated to the museum, the donor receives a certificate, confirming her engagement and contribution. The story goes that some years ago, a young boy, after a pedagogical visit by the museum to a school, donated a small object that made it into the collection. Years later, a young man, accompanied by his partner, appeared in the museum requesting a new certificate, as the original had been damaged in the flood.

❋

Layer D: Distant from the utopian horizon of global interconnectivity found in cultural industry museums, the 'communitarian' aspect of the Museo Comunitario de Xico works according to a triad: common-unity-local. *Communitas*, in the spirit of a community operating through a self-managed cultural organisation, is interested in social interaction, in shared experience,

and not in 'objects' or 'exhibitions'. And thus hints at what the museum's social function could be.

The 'newness' according to which the communitarian museum operates does not aim to integrate it within a network of cultural global tourism, in which institutions simultaneously belong to everyone and no one. In contrast to the mega-hyper-expansionism of large-scale museums, for which everything is monumental, the communitarian museum's bet is on the valorisation and strengthening of the local base. Both in the way of exhibiting – with museological supports built on-site by members of the community – and the operational modes – the museum is a 'social' tool, incorporated rather than built apart, in its own domain.

The museum belongs to and in the community. It hosts the community and is hosted by it. It is not sitting still, waiting for the 'public'; it moves to meet those around it, through history workshops in the schools in which participants 'are able to develop their feelings and vision of past history in relation to their current situation and the facts that build the history of their present'.[4] Mobilised by affect, through local history locals become involved in the museum and come to its encounter.

4 G. Amaro, 'Imágenes Zapatistas: La Revolución Mexicana en Xico', *Cronica Xicotecatl: Relatos de la gente del linaje de Xico*, 28 March 2016.

In what is shared – the common – lays the museum's largest 'capital': those living in the Valle de Chalco Solidaridad who build a museum of things made by and for people, where solidarity is more than a name.

❁

Friday, 12 February 2016

*To my dearest friend
(Emiliano Zapata)
Well, Emiliano, before anything, how
are you doing? We are grateful that
you fought with the indigenous to
save the houses they owned, also what
you did was not in vain because if
nobody had done it we would remain
in that same situation. And thanks
to your courage you freed us from
those troubles, even though I think we
are in a similar or worse situation
because of Peña [Nieto][5], he brought
us down, because there is a lot of
corruption and I would love you to be
the president and that you were
still alive.
Bye, my little friend.*

*P.S. I like your moustache.
Alan Ornar Navarrete Vázquez
3D Sec. Belisario Domínguez[6]*

❁

Layer E: Like the museum, this essay is put together collectively, based on feelings of respect and curiosity, and through fragments that are not assessed hierarchically. Unlike the museum, it is not consistent; but like the museum, it might be, amongst other things, a provocation.

❁

Surface Level: The pieces that after being found are not included in the collection display are reburied in the grounds surrounding the museum. They return, then, to the earth (the womb, through the belly button?), where they were expelled from, or extracted from after years of shelter. They may, perhaps, re-emerge later as something different: protected for longer from observers, from study, from use, from circulation until they are needed, or until they decide to emerge anew.

Above and opposite: Museo Comunitario del Valle de Xico, Estado de México, 2013–16. Courtesy Pablo Lafuente and Michelle Sommer

5 Enrique Peña Nieto is the current president of Mexico (2012–present).
6 G. Amaro, 'Imágenes Zapatistas: La Revolución Mexicana en Xico', *op. cit.*

✻

Surface Level, and beyond: One of the pieces in the collection they refer to as the 'sky gazer', a stone piece from some time between 1200–1520 BCE that shows what seems to be a man (a pre-Hispanic astronomer, perhaps?) looking into the sky. Not back into the past, or down into the layers of archaeological history, but up and forward, grounded and light at the same time.

'Life goes on and the world goes round, but there is always something that remains among all the things that disappear.'[7]

7 G. Amaro, 'La isla de Xico: Un volcán que se extingue', *Cuadernos de historia del Valle de Xico*, no.17, date unknown.

What Is to Be Learned?
On Athens and documenta 14 So Far

— Stavros Stavrides

The choice of the artistic director of documenta 14, Adam Szymczyk, to focus this internationally acclaimed exhibition on crisis-ridden Athens has indeed been controversial. It was not only the choice to split the exhibition and its programme between Kassel, the event's traditional base, and Athens that has fuelled the debate, but also a widespread view that Germany and Greece are in a continuous state of friction, if not hostility, concerning the handling of the Greek public debt. True, documenta 14 explicitly attempts to build bridges through art between the two countries. Yet what is perhaps most interesting in this approach is how it problematises crisis as an opportunity for artistic creativity. 'Despite the chaotic and dramatic situation we are still in Athens and we intend to stay, learning from whatever comes', Szymczyk noted in 2015. 'But ... we don't want to illustrate the crisis. We believe that the real image of the crisis *doesn't exist and it perhaps should not be imposed*. We just try to exist in this state of crisis, every single day – in Germany and in Greece.'[1]

Stavros Stavrides considers documenta 14 and 'Learning from Athens' in light of the city's local cultures of solidarity.

How can one learn from Athens? How can one understand Athens as a site that supports and engenders experiences that are meaningful for its inhabitants? And what do these inhabitants see and feel when they are actually enveloped by prevalent mythologies connected to their city's history? What seems to be crucially important in this process is to realise that Athens is not only the result of various layers of inhabiting practices but also the product of ideologies of urban identity construction violently imposed by dominant elites in their effort to literally shape the city. Neoclassicism, for example, became the prevailing aesthetic and organisational narrative that actually shaped the city plan in the nineteenth century and legitimised interventions in emblematic monuments (such as the Acropolis complex); vestiges of epochs unworthy of remembering (or those 'insultingly vulgar' compared to the 'ancient glory') were thus destroyed.

It is important to remember that Athens, although now a more multicultural city than it used to be, has a very strong identity within the dominant narrative of Western civilisation, and this identity is propelling tourist-oriented consumption. Caught in the web of this identity-imposing narrative, some Athenians even resort to its glory in their attempt to preserve a kind of collective self-respect as they experience blows to their 'national pride'. This feeling of collective humiliation is largely connected to the results of policies imposed by 'outside' agents, such as the International Monetary Fund and the European Union, that have dictated devastating measures – immense salary and pension cuts, the sale of public assets, and the dismantling of rights and of the welfare state – together with a growing loss of national sovereignty.

To learn from Athens, then, one has to understand first the concrete and lived ideologies permeating today's Athenian *everydayness*. True, lots of people feel themselves to be foreigners in this context – perhaps because they came to the city during the last decade hoping to find work, or because, in attempting to escape war and destruction in their own countries, they tried to reach through Greece a kind of illusionary promised land in Northern Europe. And although these people are not really trapped by the humiliation-pride syndrome of Greek-born Athenians, they live in a city that is permeated by its convolutions and jolts. Immigrants and refugees may be presented as obstacles to overcoming national humiliation, or even as the very cause of it – having allegedly destroyed the Greek economy, or the purity of Greeks' European descent, and so on. If one wants to learn from Athens, one needs to look for exchanges amongst the city's current inhabitants beyond the hostilities connected to this

1 Adam Szymczyk, quoted in Alanna Martinez, 'Documenta Still On For Germany and Greece... Despite That Whole Debt Thing', *The Observer*, 23 July 2015, available at http://observer.com/2015/07/documenta-will-still-be-jointly-hosted-by-germany-and-greece-despite-debt-mess/ (last accessed on 13 December 2016). Emphasis mine.

syndrome. Such exchanges, which so often unfold under the radar of the dominant media, are primarily connected to cultural and ethical cross-fertilisations. These gestures of support and mutual aid need to be understood in the context of the particular potentialities and antinomies of Athenian (and Greek) identity.

Despite hostilities based on well-known schemas of racist delineation, of 'unpolluted identities', Athenian identity is a recent and precarious construction. (Perhaps this is one way that Athenians are particularly suited to understanding the needs and aspirations of refugees.) Athens owes its identity to an imported (or rather, imposed) Bavarian prince, who applied a neoclassical lens of 'ancient-glory'. Through both archaeological investigation and infrastructural development – universities, libraries, schools and hospitals – Otto Friedrich Ludwig's reign (1832–62) sought to formulate both a modern state and a national identity for Greece's inhabitants. Despite its small size, Athens became the capital city. Many Athenians today are also newcomers to this city; their fathers or grandfathers having been born in villages spread all over Greece. Contemporary Athens is essentially the result of a huge 'internal immigration' that unfolded after the Second World War and culminated in the 1960s and 70s. Athenians thus don't exactly identify with the city they live in. Most of them regularly visit the villages or small towns of their ancestry. So, for Athenians *autochthony* as a mythology rests on very precarious foundations.

> *How can one learn from Athens? How can one understand Athens as a site that supports and engenders experiences that are meaningful for its inhabitants? And what do these inhabitants see and feel when they are actually enveloped by prevalent mythologies connected to their city's history?*

This complicates the notion of community in Athens today. On the one hand, memories and fragmented experiences of rural or non-metropolitan communities (rehearsed mostly in vacation periods) shape the imaginary of today's Athenians of Greek origin. On the other, immigrants and refugees also carry strong memories of community life, and often reinforce those memories by building local networks of mutual support. Solidarity and collaboration in the current period of crisis emerge at the intersection of such shared imaginaries of community (although their history may differ greatly). Notably, encounters of such kinds acquire their meaning and momentum by being connected to the realities and dreams of community support as distinct from the lost support of the welfare state. The Greek state is not considered by most Greeks – and even less so by immigrants – as a benign and protecting force, something to be trusted (a mythology that is probably stronger in Northern Europe).

What is perhaps distinctive about Athenian society's response to crisis is not the proliferation of differences in identity and life values, but the re-emergence of community values and practices beyond state-regulated relationships and institutions. In various dispersed initiatives throughout the city, people rediscover forms of mutual aid and collaboration buried under a collapsing social safety net, supposedly effective during the previous era of collective 'well-being'.[2] There is an expanding network of social health clinics which are self-managed and based on the voluntary contribution of doctors, pharmacists and municipal employers. And there are self-sustained neighbourhood centres, which provide educational and cultural support to those who can't afford to pay relevant private or public institutions. For example, one could refer here to the Lampidona Social and Cultural Center, established by local activists in the Vyronas neighborhood. Lampidona is housed in an occupied building that belongs to the municipality and has developed programmes of mutual help, language programmes, dance and philosophy lessons, music and theatre festivals and collective cooking and refugee support initiatives. Another very successful example is a social club run by leftist activists in a rented building in the Nea Smyrni neighborhood, which organises, for example, language lessons and cultural events along with political discussions.

2 Before the crisis, especially during the Panhellenic Socialist Movement (PASOK – nominally socialist, actually social-democratic) administrations (1981–89; 1993–2004), populist policies connected with a consumption-oriented economy created a welfare state that was becoming more and more indebted. Public debt, of course, is one of many reasons for today's socio-economic crisis. Greek society is actually trapped in the restructuring mechanisms of the EU, which create a new geometry of power within the 'union', resulting in new neocolonial relationships.

'Torture and Freedom
Tour of Athens',
2016, Opening of the
documenta 14, Athens
Muncipality Arts
Centre, Parko
Eleftherias.
Photograph: Stathis
Mamalakis. Courtesy
documenta

There are social kitchens that cook for the most vulnerable victims of austerity and there
are expanding bartering networks. And there are ongoing efforts to organise food-focussed
trading 'without intermediaries' – that is, by bypassing the big supermarket chains that
control the food market and make products more and more expensive. This form of trade
became visible nationwide when potato cultivators in Northern Greece decided to organise
their own open-air market in an effort to lower the prices imposed by in-between traders and
to secure decent returns for their own hard work. Soon various local markets became organ-
ised and, in certain cases, local municipal authorities tolerated or even encouraged them.
Declared 'illegal' and closed down by police raids, many of these informal markets have
nevertheless survived. There is also a tendency towards collaborative projects that treat work
and the economy as areas of collective mutual support and action (e.g. coffee shops, computer
and courier services, small alternative trade shops). All these initiatives give new meaning to
communitarian relations, which are not circumscribed within closed communities. Expand-
ing practices of sharing, of urban commoning, are indeed establishing communities of soli-
darity in the making.[3]

So, how can an international art exhibition promote a process of learning from Athens?
Is it a precarious experiment for contemporary artists, a gesture of support for artistic pro-
duction in a country devastated by crisis; is it an opportunity for artistically exploring new
experiences (being there, 'existing' in crisis)? Is it an exoticising gesture, which sees Athens as
the most intriguing place to explore – a site of unprecedented socio-economic crisis bound to
fuel cultural crises? Or could documenta 14 indeed be a process of observing, even encourag-
ing, practices of freedom?

This last idea has been embodied in some of the programming leading up to the opening
of the mega-exhibition. Between October 2016 and February 2017, the Athens Municipality
Arts Centre at Parko Eleftherias became the venue for the public programme 'The Parlia-
ment of Bodies', in which activists, musicians, artists, critics, theorists and writers were
invited to 'exercise freedom' in different manners and formats within the building. Parko
Eleftherias (Freedom Park) originally served as the military police headquarters during the
years of the right-wing dictatorship (1967–74) of the anti-communist Greek military junta.
The aim of documenta's public programme was to reclaim the building as 'an experimental
public sphere, a setting for the exercise of freedom through acts of speech, movement and

3 See Stavros Stavrides, *Common Space: The City as Commons*, London: Zed Books, 2016.

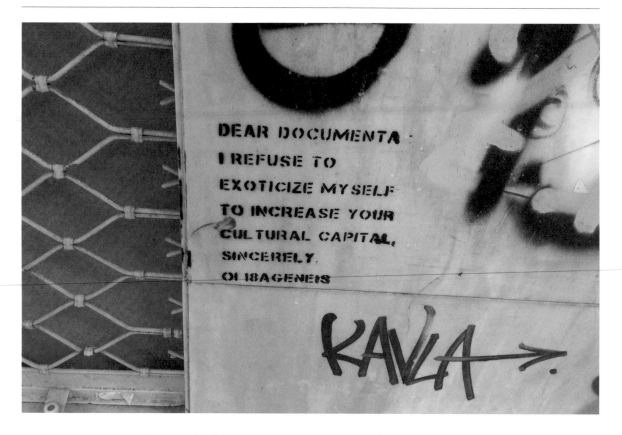

living presence, inspired by Foucault's definition of freedom as practice'.[4] Does this indicate a possible lesson to be learned in Athens? Isn't this rhetoric on freedom rather something that pre-exists any visit to Athens, a rhetoric strongly rooted in the individualist imaginary of a politically correct version of liberal values?

True, on the level of rhetoric, the 'exercises of freedom' appear to be oriented towards a confrontation with prevailing ideas of freedom and democratic consensus: 'Might it be possible to think the Greek notion of *eleftheria* (freedom) against the capitalist notion of freedom?'[5] However, by not distinguishing between collective and individual practices, or between different levels of struggle, this approach risks promoting a strange patchwork of examples that equate personal radical identity choices with contemporary insurrectionary events. There is a huge difference between struggles for collective freedom and self-determination and individual radical actors. Combining the two makes it easy for almost everybody to agree that freedom is obviously the highest and noblest value. But to do so is to escape the stakes at issue: freedom for whom? In what social context and against which rules that may confront, limit, subvert, distort or even hijack practices seeking social emancipation?

In the current crisis in Athens, it is above all collective rights and the shared freedom of groups and communities that are being harshly suppressed. Collective rights connected to work, to the crossing of borders in search of a more decent life, to public health, to education, to rights of access to the urban commons (which are being privatised and sold). This is why it is meaningless to refer to the brutalities of the 1967–73 dictatorship as a way of reinforcing the rhetoric of freedom-based democracy – then as now, collective freedoms are those most at stake. Even the installation by Andreas Angelidak in the Parko Eleftherias building, *DEMOS* (2016) – a collection of foam blocks providing the 'soft architecture' for the 'Parliament of Bodies' events, to be rearranged and used as seating by visitors – seems to reflect this ambivalence: the recasting of the democratic imaginary in the form of abstract, differentiated presences in an abstract space 'for all' is also presented as a 'democracy in ruins'.

It is not that a confrontation with the most conservative attitudes concerning individual rights is without meaning today. In both Germany and Greece aggressive racism and xenophobia need to be urgently challenged by political activism and cultural and artistic performances. This is perhaps why certain Greek politically engaged art groups (such as the

Graffiti that appeared in Athens during the first days of documenta 14's public programme, 2016. Courtesy Stavros Stavrides

4 '34 Exercises of Freedom', documenta 14 website, available at http://www.documenta14.de/en/public-programs/928/34-exercises-of-freedom (last accessed on 30 January 2017).

5 *Ibid*. One might also question this reference to a distinctively Greek version of freedom.

Adespotes Skyles theatre group) chose to be part of documenta's programme. Yet one needs to study the many different kinds of recent movements (including urban, social and workers') to see if there is indeed something to be learned from Greek society's recent struggles. And surely this does not happen if one simply assembles an ever-expanding mosaic of thinkers, actors, projects and views. The unfolding programme of different 'societies' (such as 'The Apatride Society of the Political Others', 'The Society for the End of Necropolitics', 'The Society for Collective Hallucination', 'The Cooperativist Society', 'The Society of Friends of Ulises Carrión', etc.) is indicative of a kind of pastiche approach that potentially neutralises any radical discourse.

At the centre of Athens's inventiveness and its agonies today is the problem of survival, the problem of reweaving the social fabric that has been so violently damaged by austerity politics – policies that separate, victimise and destroy increasing numbers of individuals and devour collective rights. If one can learn something from Athens, it is that disempowered and exploited people may only resist collectively. According to Gustavo Esteva, *comunalidad* (commonality) can be considered 'a collection of practices formed as creative adaptations of old traditions to resist old and new colonialisms, and a mental space, a horizon of intelligibility: how you see and experience the world as a We'.[6]

One such formation emerged in Athens during the Syntagma Square occupation in 2011, which attracted thousands of participants: a renewed awareness of the meaning of democracy was expressed in concrete acts. This was not a parliament of bodies. It was actually a dense network of micro-communities protesting in front of the Parliament Building and in direct confrontation with a discredited and simulated democratic representation. Syntagma Square epitomised collective aspirations for justice and everyday sociality – both devastated by dominant austerity policies. The right to speak, for example, was re-established in and through this democracy of bodies by rules invented in order to block narcissistic soliloquys and the dictates of 'enlightened' leaders. This right was given a renewed momentum by the collective decision to draw lots among potential speakers – a reinvention of an ancient democratic ethos which, following Jacques Rancière, is based on the conviction that everybody has the right to have an opinion and thus the right to participate in governing.[7]

During the occupation, as well as in neighbourhood assemblies and self-managed initiatives, bodies arranged themselves in patterns that gave shape to democratic space, to space as democracy. Those were and still are events and processes of urban commoning based on efforts of egalitarian coordination and on the creation of a common ground on which common struggles may grow. Whether all local protagonists advocating for documenta 14 are interested in furthering such a struggle is rather doubtful, however. A small case in point would be Giorgos Kaminis, the mayor of Athens, who has always been against mobilisations such as Syntagma Square, and who was invited to give a supporting speech to documenta 14. Not surprisingly, it was he who linked the documenta events with a much-welcomed boost to the city's tourist industry.[8]

The lesson of Athens lies not in the reinvention of individual freedom. Instead, one needs to study carefully the multifarious networks of solidarity that expand in, against and hopefully beyond crisis. It is possible that art will profit from such a lesson by becoming more modest. Artists may learn how to listen and how to nourish imaginaries of social emancipation. Will the forthcoming exhibition support such an attitude? Will the institutional, economic and cultural affinities of the documenta organisation encourage such approaches to art? We need to wait and see: looking perhaps most keenly for art practices inspired and triggered by the collective inventiveness of people in search of survival-through-sharing. Because it is through such everyday collective practices that dreams of a more just future society develop.

6 Gustavo Esteva, 'Hope from the Margins', in David Bollier and Silke Helfrich (ed.), *The Wealth of the Commons: A World Beyond Market and State*, Amherst, MA: Levellers Press, 2012.
7 See Jacques Rancière, *Dissensus: On Politics and Aesthetics* (trans. Steven Corcoran), London: Continuum, 2010.
8 The mayor was also one of only a few politicians to support the EU's austerity blackmails in 2015, which resulted in a brave majoritarian 'no' in the public referendum.

Afterall will publish a retrospective response to documenta 14 in Athens in 2018.

How to Eat a Forest

– Ntone Edjabe

Over the past two centuries the visible, material and symbolic boundaries of Africa have constantly expanded and contracted.... New forms of territoriality and unexpected forms of locality have appeared. Their limits do not necessarily intersect with the official limits, norms or language of states.
– Achille Mbembe[1]

History is the science of the state, while memory is the art of the stateless.
– Wendell Hassan Marsh[2]

It has often been said that cartography is the tool of the colonial project. But it is rarely acknowledged that mapping has remained a major instrument of political and economic interests beyond the colonial project. A few years ago writer Billy Kahora travelled to a region on the southern edge of the Great Rift Valley in Kenya that forms part of the Mau Forest Complex, the largest forest area in East Africa.[3] The complex is a water catchment of more than ten rivers and numerous lakes in both East and Central Africa. It was once said to occupy 273,300 hectares, three times the size of Nairobi's administrative district. Kahora was there to write about the eviction of what were being described as 'encroachers', or landless peasants from neighbouring tribes; he noted the buzzword, which proved as unyielding as the claims of the people being described thus. 'Squatter' had always been the term of choice in such circumstances, and Kahora became curious about this relatively new term, encroacher, and its connotations. The difference, in the context of the Mau, is simply that an encroacher is seen to be a 'foreign invader', and a squatter is a propertyless individual from within. The squatter is considered to be relatively harmless, while the encroacher seizes and intrudes on property that has been clearly mapped and is already owned. There is a primordial hatred towards encroachers by locals, while some impatient tolerance seems to exist for the squatter. At the heart of all this was an attempt by the encroachers to change the map. Encroachers seize territory, change maps to their advantages. Squatters do not threaten the cartographical status quo.

This seemingly harmless distinction completely changed things in the Mau scenario. These so-called encroachers were the tip of an attempt at one of the largest land grabs in Kenya's history: they were the most visible manifestation of the attempted abuse of one of two instruments that govern the process of land ownership, cartography, which in this context can be described using the less grand term 'survey'.

Survey, like encroachment, was a ubiquitous term in the Mau saga, used invariably by both the communal owners of the land and the encroachers. This modern word had entered the lingo to justify illegal actions – 'survey this' and 'survey that' – and

Ntone Edjabe describes processes of mapping as resistance in his introduction to an artists' insert by Chimurenga.

had also been appropriated by the victims into something that was itself illegal, hostile to the old ways. So, as Kahora discovered in the depths of the Mau, one of the biggest untold stories about our continent is the abuse of the technical aspects of the land survey. What is measured point by point on the ground, and the representation that tallies this exact measurement, can be changed arbitrarily if no one is fighting for a neutral and epic-sized territory such as the natural space of a forest. A land surveyor might be instructed by powerful political and economic interests to redraw a map of the original piece of land, to eat up a forest. This disregard of natural boundaries in favour of new and recreated boundaries is at the heart of the problems of our knowledge of self, of our spaces and of our territories. But a contestation of who the land belongs to and who is new, who is local and who is an

1 Achille Mbembe, 'At the Edge of the World: Boundaries, Territoriality, and Sovereignty in Africa' (trans. Steven Rendall), *Public Culture*, vol.12, no.1, 2000, p.261.
2 Wendell Hassan Marsh, 'Re-Membering the Name of God', *Chronic*, March 2015, p.19, available at http://chimurengachronic.co.za/re-membering-the-name-of-god/ (last accessed on 25 January 2017).
3 See Billy Kahora, 'How to Eat a Forest', *Chronic*, March 2015, pp.28–31 and 34–35, available at http://chimurengachronic.co.za/how-to-eat-a-forest/ (last accessed on 25 January 2017).

encroacher, is at the heart of the struggles against our official atlas.

More than the abuse of law, especially as regards land, it is this disregard for preexisting boundaries and organically emerging ones that has given lie to what our territories really are and what they mean. And so, lately, the primary entity of how we understand our spaces, the nation-state – the result of the colonial survey, accepted by the independent African nation – is for this exact reason coming under extreme duress. In the context of the colonial instrument of the land survey and its counterpart, the land legislation regime, our continent seems to be reverting to its earlier knowledges of territory against the more recent colonial and postcolonial instrument of cartography – against 'survey' – while also exerting newly emerging knowledges and ways of thinking against the same instrument.

Our atlas is therefore now being reshaped into territories of new religious ecumenisms that are related to Christianity, Islam and African religions; sexual and pleasure territories; contemporary migratory phenomena manifested in refugee camps that produce armies without a state, making war a phenomenon that is disconnected from the state; and resource-based territorialities where water is especially key (issues around the Nile indicate this phenomenon).

So, we ask: What were the precolonial visible, material and symbolic boundaries and what is their relationship with official state boundaries today? What are the new forms of territoriality and unexpected forms of locality? How does one now represent Greater Somalia? What of the Swahili Coast that extends from Kenya through Tanzania and Northern Mozambique, of its reluctance to be integrated into any national project other than its own, which goes back to the fourteenth century? What of the transnational identity of the Tuareg across the Sahel belt, who are at the core of several conflicts in that region, from Libya to Mali and Chad? What are the African names of the Indian Ocean? And as a site of world-making, what role did this ocean-territory play in the emergence of Third World politics? What are the new divisions of the world and how do they affect our continent – from the war on terror to the Sahara-Mediterranean as boundary? Who are the neo-pats and re-pats (new and returning migrants), and where do they come from? What are the new capitals – for the church-industrial complex of Anglophone West

Africa, for example? Or for the drug trade in East Africa?

So, we ask: What if maps were made by Africans for their own use, to understand and make visible their own realities or imaginaries? How do we, on the continent, create a cartography that is so exactingly representative of our fluidities, complexities and material realities?

Jorge Luis Borges's fable 'Del rigor en la ciencia' ('On Exactitude in Science', 1946) might be a good start for such work. An exacting representation, cartography or series of maps can only start with an attempt to understand every inch, foot, unit of measurement of the thing we claim to stand on as our own, our continent. The territory we claim as collectively ours. The reality we all take on. The knowledge we herald as our own. This approach suggests that the optimal way to real ownership is to map one's reality; to make an exacting representation, point for point, centimetre for centimetre, whether it is land, water, dreams. Then, after possibly understanding one's reality in its minutiae, to earn the right to work on a replication, to create real understanding and knowledge. If this is done right, the representation should be directly proportional to the confidence of one's knowledge.

This work requires that we reaffirm lived experience, improvisation and imagination as forms of knowledge. It calls for a knowing-through-seeking and a constant transforming and renewing of our image of the world.

This is important because over time the few and powerful on our continent have excelled, to their advantage, in creating an atlas without exactitude. Therefore, our knowledge of the territory is never ours. At the same time, a too exacting knowledge would be useless; a too representative approach would distance us from the real. We also need our own modes of representation on our own terms, our own materialities and needs.

The task is to develop maps that are based on a multiplicity of scales and projections, and a multiplicity of symbolisation – a river can be a body of water and can be a sacred being. Scales, set squares and compasses alone will not work; we also require hands, feet and hearts. And memory.

The following maps are part of an atlas of our discontent at misrepresentations, an ongoing attempt to represent our knowledge of our spaces with some exactitude. It is also an attempt to balance exactitude and representation.

AFRICAN NAMES OF THE INDIAN OCEAN

"The poet Haji Gora Haji drew us, his listeners, to 'see' that the geography of the oceanic imagination is boundary-less; that lived memories are platforms upon which we can glimpse the shape of past and future destinations; that lines between sky, land and sea blur – it is only a matter of perspective; that human maps are mere suggestions.
'You are looking for a map?' Haji Gora asked. 'The sea is the map.'
He explained that environments are created out of which a desired destination emerges; and that no culture intending a robust presence in the world has done so without laying claim to its seas or its oceanic imagination."
—Yvonne A. Owuor, 'Imagined Waters', Chimurenga Chronic 5

KOLKATA

CHITTAGONG

SITTWE

WOODY ISLAND

BANGKOK

MOULMEIN

SRI LANKA

COLOMBO

>50% of the world's maritime oil trade is found in the Indian Ocean region.

THAILAND

HAINAN ISLAND

the world post 9/11

MALAYSIA

KUALA LAMPUR

SINGAPORE

STRAITS OF MALACCA

BANDUNG 1955

AIR MALAYSIA

MH370 SEARCH AREA

UK/US SEAS

DIEGO GARCIA

INDONESIA

JAKARTA

a nnazama bahari nina ghariki
Ona mramana bado huyasadiki
itazama kuniafu hudiriki
nnazama kuniokoa hutaki
huoni huruma waniacha nahiliki

Taraab song, lyrics by Hemed Hadi

AUSTRALIA

PERTH

FREEMANTLE

Legend

String of Pearls
China's rising geopolitical influence through access to ports, airfields and military force.

...Dau trade route
Dau is the Swahili term for "Dhow", usually misattributed to Arabs or Indians. The dau trade route links all major port cities in East Africa, the Middle East and South Asia through trade in spice, ivory, gum copal, textile and slaves.

Taarab Sega Zither Cricket Islam Migration patterns

Choke points
Narrow maritime channels that are critical to world oil trade.

Bandung Afro-Asian Conference, 18-24 April 1955
The Bandung Conference was a large-scale meeting of newly independent Asian and African states and an important step toward the Non-Aligned Movement.

US military bases (including Diego Garcia)
Diego Garcia is a US Navy and Air Force base at the centre of the Indian Ocean. It played a key role in the Gulf War, the war in Iraq, Afghanistan, Syria and the ongoing War on Terror.

Port cities

Sources:
Yvonne A. Owuor, 'Imagined Waters', Chimurenga Chronic 5
Yvonne A. Owuor, 'Dragonfly Monsoon and imagined oceans: in search of poem-maps of the Swahili seas', 2019, MPhil Thesis, School of Communication and Arts, The University of Queensland
Lindsay Bremner, Folded ocean: The spatial transformation of the Indian Ocean world', 2014, Journal of the Indian Ocean Region, 10:1, 18-46
Lindsay Bremner, 'Fluid ontologies in the search for MH370', 2015, Journal of the Indian Ocean Region, 11:1, 8-29
Françoise Vergès, 'Utopias and Oceans: Liquid Alchimis', presentation at the 2014 JWTC, https://www.youtube.com/watch?v=8oGLOFB7DZc
Françoise Vergès, 'Writing on Water: Peripheries, Flows, Capital, and Struggles in the Indian Ocean', 2003, positions: east asia cultures critique, Volume 11, Number 1, 2003, pp. 241-257
Devleena Ghosh and Stephen Muecke (eds), 'Cultures of Trade: Indian Ocean Exchanges', 2007, Cambridge Scholars Publishing

Nisreen Kaj, 'It Can Only Go Up From Here', Chimurenga Chronic 6
Edward A. Alpers, 'The Indian Ocean in world history', 2013, Oxford University Press
Gaurav Desai, 'Commerce with the Universe: Africa, India, and the Afrasian Imagination', 2013, Columbia University Press
Top End Sports, 'Popularity of Cricket Around the World', http://www.topendsports.com/world/lists/popular-sport/sport/cricket.htm
Hasan Kiel, 'Travel and song: the roots of Zanzibar 'taarab'', 2012, African Music Journal
Roger Blench, 'Using diverse sources of evidence for reconstructing the prehistory of musical exchanges in the Indian Ocean and their broader significance for cultural prehistory', 2012, Submitted for a special number of African Archaeological Review printed by Pundit West and
Nuruddin Farah, 'Crossbones', 2012, Penguin Books
Mwambao Shores, 'Taraab', http://www.mwambao.com/taraab.htm
Tamilnation.org, www.tamilnation.co

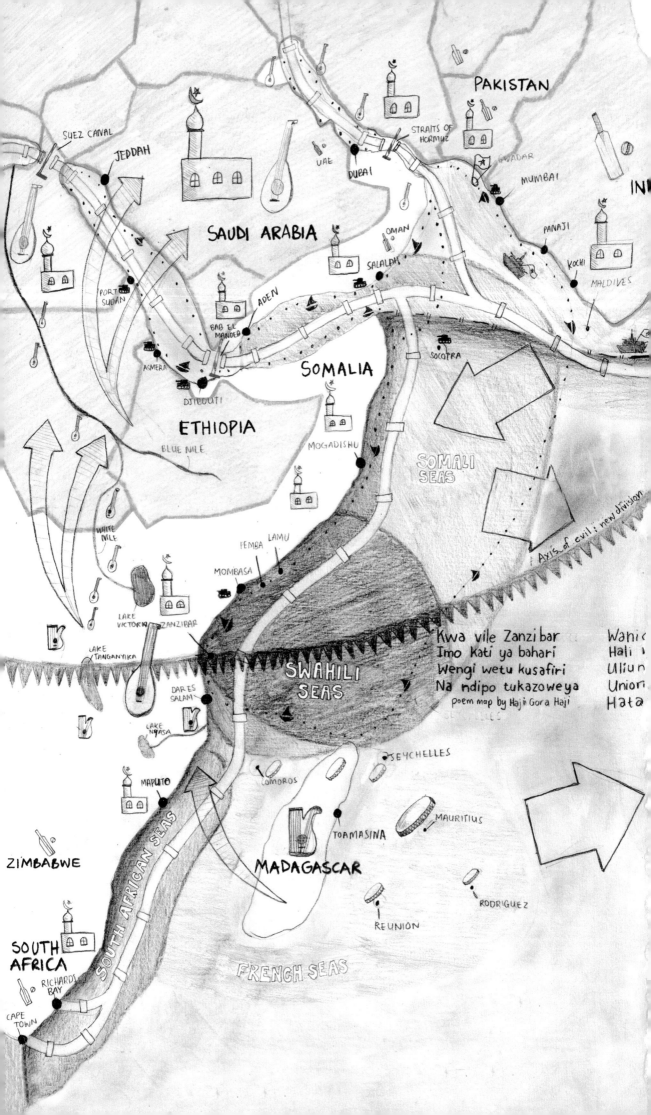

SOFT POWER DESIRE MACHINES AND

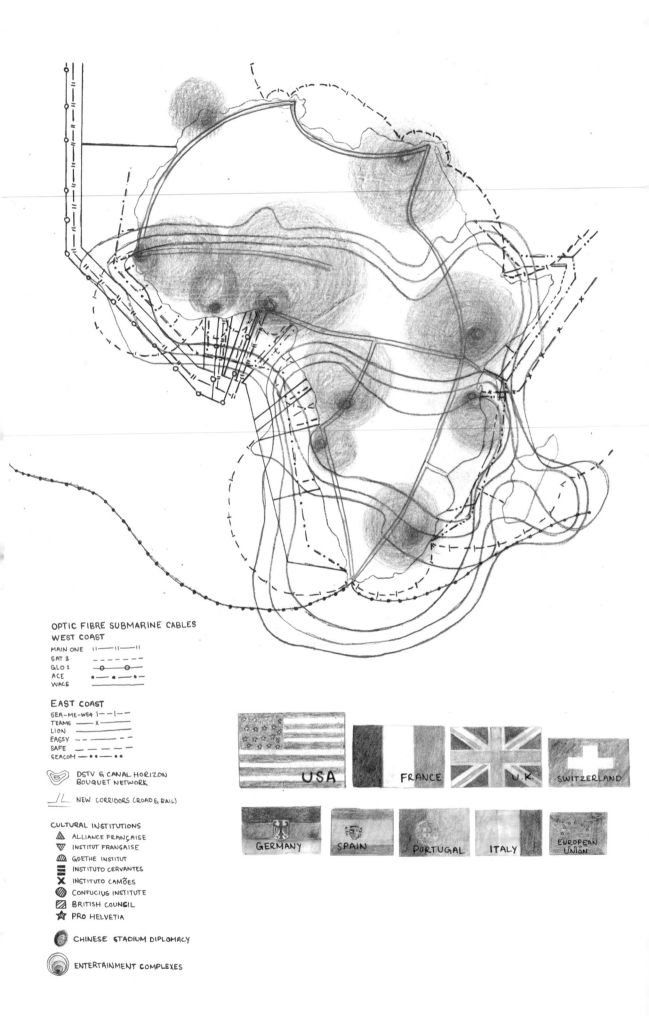

OPTIC FIBRE SUBMARINE CABLES
WEST COAST

MAIN ONE ||——||——||
SAT 3 – – – – –
GLO 1 ——o——o——
ACE •–•——•–•
WACS

EAST COAST
SEA~ME~WE4 |——|——||
TEAMS ——X——
LION
EAGSY – – – – –
SAFE — — — —
SEACOM — •• —— ••

DSTV & CANAL HORIZON
BOUQUET NETWORK

NEW CORRIDORS (ROAD & RAIL)

CULTURAL INSTITUTIONS
⬟ ALLIANCE FRANÇAISE
▽ INSTITUT FRANÇAISE
◖ GOETHE INSTITUT
≡ INSTITUTO CERVANTES
X INSTITUTO CAMÕES
◉ CONFUCIUS INSTITUTE
▨ BRITISH COUNCIL
☆ PRO HELVETIA

⬤ CHINESE STADIUM DIPLOMACY

◎ ENTERTAINMENT COMPLEXES

USA FRANCE U.K. SWITZERLAND

GERMANY SPAIN PORTUGAL ITALY EUROPEAN UNION

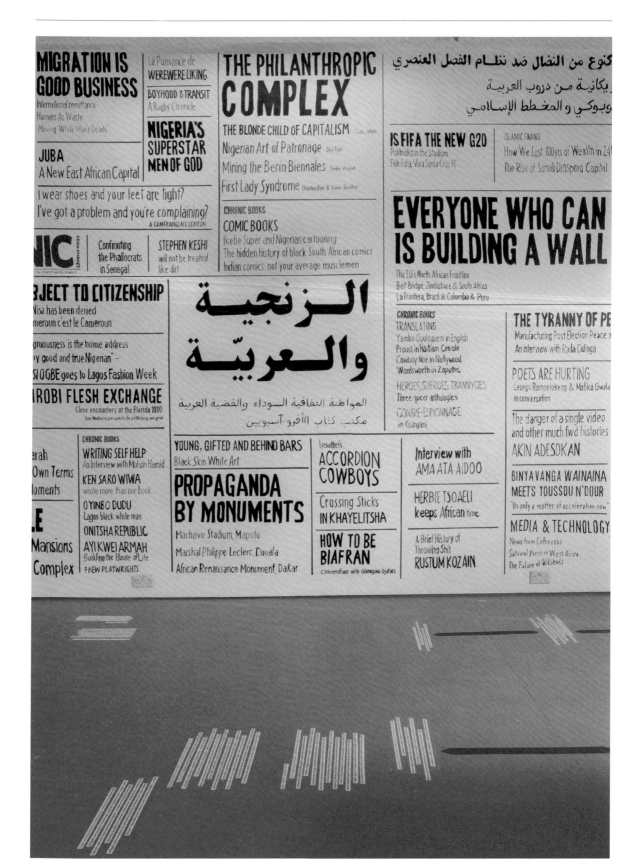

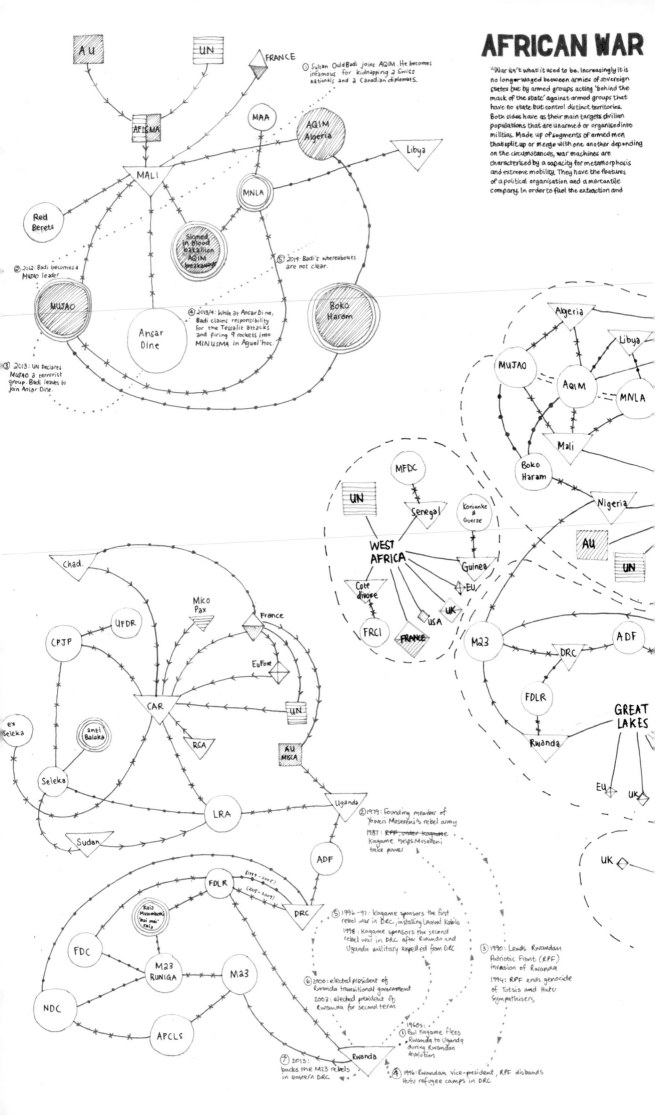

AFRICAN WAR

"War isn't what it used to be. Increasingly it is no longer waged between armies of sovereign states but by armed groups acting 'behind the mask of the state' against armed groups that have no state but control distinct territories. Both sides have as their main targets civilian populations that are unarmed or organised into militias. Made up of segments of armed men that split up or merge with one another depending on the circumstances, war machines are characterised by a capacity for metamorphosis and extreme mobility. They have the features of a political organisation and a mercantile company. In order to fuel the extraction and

① Sultan Ould Badi joins AQIM. He becomes infamous for kidnapping 2 Swiss nationals and 2 Canadian diplomats.

② 2012: Badi becomes a MUJAO leader

④ 2013/4: While at Ansar Dine, Badi claims responsibility for the Tessalit attacks and firing 9 rockets into MINUSMA in Aguel'hoc.

⑤ 2014: Badi's whereabouts are not clear.

③ 2013: UN Declares MUJAO a terrorist group. Badi leaves to join Ansar Dine.

② 1979: Founding member of Yoweri Museveni's rebel army

1987: RPF, under ~~Kagame~~ Kagame helps Museveni take power

⑤ 1996-97: Kagame sponsors the first rebel war in DRC, installing Laurent Kabila
1998: Kagame sponsors the second rebel war in DRC after Rwanda and Uganda military expelled from DRC

⑥ 2000: elected president of Rwanda transitional government
2003: elected president of Rwanda for second term

③ 1990: Leads Rwandan Patriotic Front (RPF) invasion of Rwanda
1994: RPF ends genocide of Tutsis and Hutu sympathisers

① 1960s: Paul Kagame flees Rwanda to Uganda during Rwandan revolution

④ 1996: Rwandan vice-president, RPF disbands Hutu refugee camps in DRC

⑦ 2013: backs the M23 rebels in eastern DRC

MACHINES

export of natural resources in the territories they control, war machines forge direct connections with transnational networks. At the same time, this extraction and looting goes hand in hand with brutal attempts to manage the multitudes, either by immobilising or confining them. An extreme manifestation of necropower, war machines are less concerned with controlling bodies by inscribing them within disciplinary apparatuses than with incapacitating them with mutilation or simply massacre."

Stacy Hardy, "Achille Mbembe Idiolect", Chimurenga 15

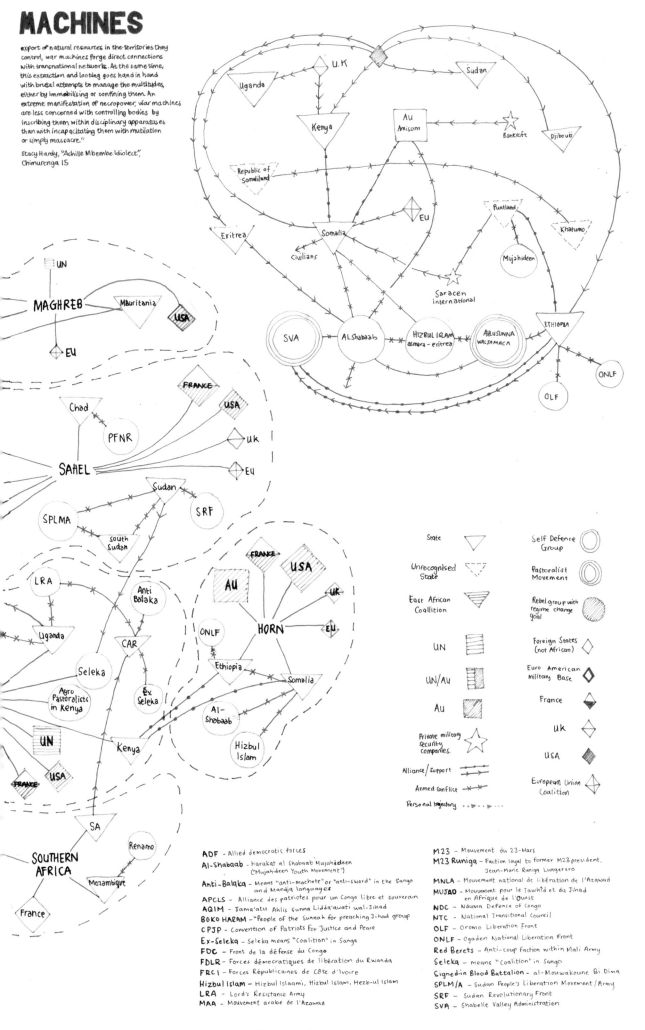

Sources:
Uppsala Conflict Database - www.ucdp.uu.se
International Crisis Group - www.crisisgroup.org
United Nations Peacekeeping - www.un.org
AU Peacekeeping - www.peaceau.org

UK Army - www.army.mod.uk
Olivier Fourt, 'Coup de vent dans les dunes: Barkhane succède à Serval', RFI
Nick Turse, 'America's Proxy Wars in Africa', The Nation

ADF – Allied democratic forces
Al-Shabaab – Harakat al Shabaab Mujahideen ("Mujahideen Youth Movement")
Anti-Balaka – Means "anti-machete" or "anti-sword" in the Sango and Mandja languages
APCLS – Alliance des patriotes pour un Congo libre et souverain
AQIM – Jama'atu Ahlis Sunna Lidda'awati wal-Jihad
BOKO HARAM – "People of the Sunnah for preaching Jihad group"
CPJP – Convention of Patriots for Justice and Peace
Ex-Seleka – Seleka means "Coalition" in Sango
FDC – Front de la défense du Congo
FDLR – Forces démocratiques de libération du Rwanda
FRCI – Forces Républicaines de Côte d'Ivoire
Hizbul Islam – Hizbul Islaami, Hizbul Islam, Hezb-ul Islam
LRA – Lord's Resistance Army
MAA – Mouvement arabe de l'Azawad

M23 – Mouvement du 23-Mars
M23 Runiga – Faction loyal to former M23 president, Jean-Marie Runiga Lungerero
MNLA – Mouvement national de libération de l'Azawad
MUJAO – Mouvement pour le Tawhid et du Jihad en Afrique de l'Ouest
NDC – Nduma Defence of Congo
NTC – National Transitional Council
OLF – Oromo Liberation Front
ONLF – Ogaden National Liberation Front
Red Berets – Anti-coup faction within Mali Army
Seleka – means "Coalition" in Sango
Signed-in Blood Battalion – al-Mouwakoune Bi Dima
SPLM/A – Sudan People's Liberation Movement / Army
SRF – Sudan Revolutionary Front
SVA – Shabelle Valley Administration

THE PRODUCTION OF AFRICA RISING

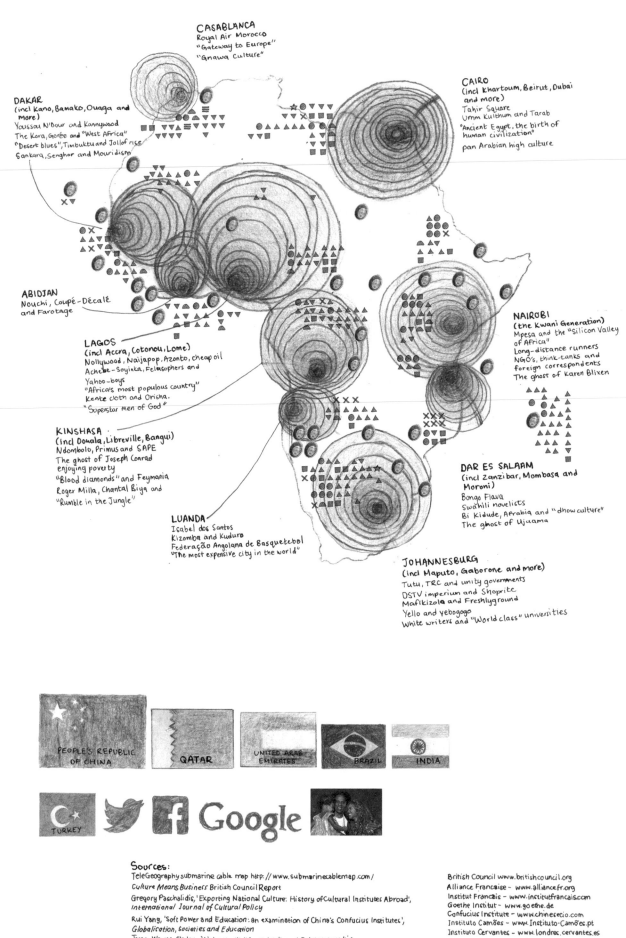

CASABLANCA
Royal Air Morocco
"Gateway to Europe"
"Gnawa Culture"

CAIRO
(incl Khartoum, Beirut, Dubai
and more)
Tahir Square
Umm Kulthum and Tarab
"Ancient Egypt, the birth of
human civilization"
pan Arabian high culture

DAKAR
(incl Kano, Bamako, Ouaga and
more)
Youssou N'Dour and Kannywood
The Kora, Gorée and "West Africa"
"Desert blues", Timbuktu and Jollof rice
Sankara, Senghor and Mouridism

ABIDJAN
Nouchi, Coupé-Décalé
and Farotage

NAIROBI
(the Kwani Generation)
Mpesa and the "Silicon Valley
of Africa"
Long-distance runners
NGO's, think-tanks and
foreign correspondents
The ghost of Karen Blixen

LAGOS
(incl Accra, Cotonou, Lome)
Nollywood, Naijapop, Azonto, cheap oil
Achebe-Soyinka, Feleosophers and
Yahoo-boys
"Africa's most populous country"
Kente cloth and Orisha.
"Superstar Men of God"

KINSHASA
(incl Douala, Libreville, Bangui)
Ndombolo, Primus and SAPE
The ghost of Joseph Conrad
enjoying poverty
"Blood diamonds" and Feymania
Roger Milla, Chantal Biya and
"Rumble in the Jungle"

DAR ES SALAAM
(incl Zanzibar, Mombasa and
Moroni)
Bongo Flava
Swahili novelists
Bi Kidude, Afrabia and "dhow culture"
The ghost of Ujuama

LUANDA
Isabel dos Santos
Kizomba and Kuduro
Federação Angolana de Basquetebol
"The most expensive city in the world"

JOHANNESBURG
(incl Maputo, Gaborone and more)
Tutu, TRC and unity governments
DSTV imperium and Shoprite
Mafikizolo and Freshlyground
Yello and Yebogogo
White writers and "World class" universities

PEOPLE'S REPUBLIC OF CHINA

QATAR

UNITED ARAB EMIRATES

BRAZIL

INDIA

TURKEY

Google

Sources:
TeleGeography submarine cable map http://www.submarinecablemap.com/
Culture Means Business British Council Report
Gregory Paschalidis, 'Exporting National Culture: History of Cultural Institutes Abroad',
International Journal of Cultural Policy
Rui Yang, 'Soft Power and Education: an examination of China's Confucius Institutes',
Globalisation, Societies and Education
Jesse Weaver Shipley, 'Living the Hiplife: Celebrity and Entrepreneurship
in Ghanaian Popular Music

British Council www.britishcouncil.org
Alliance Francaise - www.alliancefr.org
Institut Francais - www.institutfrancais.com
Goethe Institut - www.goethe.de
Confucius Institute - www.chinesecio.com
Instituto Camões - www.Instituto-Camões.pt
Instituto Cervantes - www.londres.cervantes.es

Previous spread:
Installation view,
'The Chimurenga
Library', The
Showroom, London,
2015. Photograph:
Dan Weill. Courtesy
Chimurenga and The
Showroom, London

Navigating pan-Africanisms:
On the Chimurenga Library

— Kodwo Eshun, Avery F. Gordon and Emily Pethick

Chimurenga, in its own words, is a project-based mutable object: a print magazine, a publisher, a broadcaster, a workspace, a platform for editorial and curatorial activities and an online resource. Based in Cape Town, it operates through different media, from the pan-African print gazette Chronic *and online broadcasts of the Pan*

Kodwo Eshun, Emily Pethick and Avery F. Gordon discuss the investigative aesthetics of 'The Chimurenga Library' and pan-Africanisms past and future.

African Space Station (PASS) to its ongoing function as a mobile site of education and research. From 8 October–21 December 2015, Ntone Edjabe, Chimurenga's editor-in-chief, Graeme Arendse, art director and designer, and Ben Verghese, producer, presented 'The Chimurenga Library' at The Showroom, London on the invitation of Kodwo Eshun and Anjalika Sagar of The Otolith Collective and Emily Pethick of The Showroom. Avery Gordon asked Eshun and Pethick to talk about the making of the project, which is where this conversation begins.

Avery F. Gordon: How did the project start?

Emily Pethick: Our proposal was to bring the Chimurenga Library to London, but we didn't realise until we got to Cape Town that there wasn't actually a physical library.

Kodwo Eshun: When you visit the Chimurenga Library on the *Chimurenga Magazine* website, you see 32 scanned front covers of post-War independent periodicals sourced from Zimbabwe, South Africa, Nigeria, Ghana, Canada, the US, Burkina Faso, the UK, Egypt, Kenya, Morocco, France, India, the DRC, Jamaica and Senegal. Clicking on a cover takes you to a description of each magazine, its editorial network, a family tree of like-minded periodicals, more links and commissioned

essays by poets, critics and novelists such as Akin Adesokan, Lesego Rampolokeng and Rustum Kozain. The Library is an online network that gathers the interrupted networks of Pan-African periodicals together. Some of these magazines, like South Africa's *Staffrider* or Morocco's *Souffles*, are celebrated. Others, like Zimbabwe's *Moto* or Egypt's *Amkenah*, are out of print and inaccessible.

EP: We kept the title, but it became another form of library – an expanded idea of what a library could be. Chimurenga sent us a list of around two hundred objects to be sourced, which included books, records, films and other materials for the exhibition, about half of which they had themselves already. They proposed that we borrow everything from existing collections – we were not to 'buy in' any of the objects – so the process of seeking the rest became an intrinsic part of the exhibition process. Chimurenga built the exhibition plan around what we could find, so it was a flexible map, and people kept bringing things. The theorist George Shire brought more books. It didn't assume a conventional form of an exhibition where everything is fixed and labelled and in boxes and vitrines. It was a more dynamic entity.

KE: The Library had to be built from available resources. We tapped into the local lending libraries in Edgware Road, university libraries, the personal libraries of friends and acquaintances. What you actually saw at The Showroom was six modest shelves supporting books and magazines that required a substantial effort to assemble.

AG: The library wasn't something that pre-existed its making. It's an interesting model for a public library because it differs so radically from the conventional state- or council-run public library that is public in name only. The public is a user, a part of producing the form and content of the library. I sent Robin D.G. Kelley a photograph with his passage about Fela Kuti on the floor of The Showroom. He replied by telling me he thought the

Chimurenga
headquarters, Cape
Town, 2017. Courtesy
Chimurenga

Chimurenga *Chronic* was one of the greatest publications of radical insurgent thought, and that, because of his affinity with it, he had once envisioned creating a department of Black Studies modelled on the Chimurenga *Chronic*. Kodwo, I'd like to ask you to describe the affinities between Chimurenga and The Otolith Group practice.

KE: Perhaps the clearest way to indicate those affinities is to point to the publication of *Chimurenga* 12/13 in 2008, which was a double issue titled 'Dr. Satan's Echo Chamber'. It was named in honour of Louis Chude-Sokei's magisterial essay on the Caribbean technopoetics of dub, which in turn was named after King Tubby's remix of the song 'Dr. Satan's Echo Chamber' by The Rupie Edwards Success All Stars. The double issue has two front covers, one for each magazine, and can be read from both

directions. Issue 13's front cover features an image from *Icarus 13* [2008], Kiluanji Kia Henda's photographic fictional series of a Pan-African state-sponsored space mission to the sun. Henda reimagined the Agostinho Neto Mausoleum in Luanda as the spaceship Icarus 13, built from a mix of steel and a covering of diamonds and powered by solar energy. I would argue that 'Dr. Satan's Echo Chamber' single-handedly reoriented the project of Afrofuturism towards an expansive complexity that is capacious enough to embrace continental fictions such as the malevolent schematics of Abu Bakarr Mansaray, James Sey's architectonic fabulations, Doreen Baingana's demiurgic tales and Jean-Pierre Bekolo's cinema of social horror. Chimurenga's preoccupations resonate with Otolith's ongoing concern with mutation and alienation. Both of us are drawn, asymptotically speaking, towards the

syncretic synthesis of futures old and new. We operate between creation, criticism and curation. We are preoccupied by the will to complicate. We are interscalar vehicles that mobilise knowledges outside of the academy along vectors unbound by disciplinary protocols. We are informal socialities of study operating in the key of musics and the light of screens.

What is critical is that the Library did not aim to introduce South African literature to the London art world. What PASS did instead was to estrange Londoners' ownership over the memory of the city by confronting them with memories of an exilic London that is cherished in Cape Town and unremembered in London. A London inhabited by jazz-avant-gardists such as drummer Louis Moholo, bassist Johnny Dyani, trumpeter Mongezi Feza, saxophonist Dudu Pukwana, pianist Chris McGregor and bass-

ist Harry Miller, all of whom were forced into exile by Hendrik Verwoerd's apartheid regime. Many of these artists can be seen, styled and posed in sets designed by photographer George Hallett for the front covers of novels by authors like Meja Mwangi and Williams Sassine that were published in Heinemann's prestigious African Writers Series. Those covers now appear as scenes that document an expatriate community in a process of staging themselves. Another example of this process of defamiliarisation occurred when the artist Michael McMillan recalled his extraordinary experiences as an award-winning teenage playwright invited to participate in the Second World Black and African Festival of Arts and Culture [FESTAC] in Lagos in 1977. As McMillan evoked the spectacular opening ceremony of FESTAC '77 at the National Stadium, listeners found themselves face to face with

the provincialism of British media that was unable, then and now, to grasp the complexity of African cultural politics.

AG: I'd like to ask you to talk about what it means to use the term 'Pan-African', or 'Pan-Africanism', today. What does it mean to activate that term today? How do the London collaborators fit into a living pan-Africanism?

KE: Perhaps it's useful to distinguish between the antagonistic and asymptotic trajectories of Pan-Africanism understood as a practice of statecraft and pan-Africanism as a practice of political aesthetics. The initial heroic Promethean phase could be located in the Fifth Pan-African Congress in Manchester in October 1945, organised by the revolutionaries Kwame Nkrumah and George Padmore, who theorised the preconditions for the economic and military unification of the liberated continent in *Towards Colonial Freedom: Africa in the Struggle against World Imperialism* [1945] and *Pan-Africanism or Communism? The Coming Struggle for Africa* [1956].

That was followed by a period of official optimism in which the policy of continental unification was debated by delegates attending the All African People's Conference in Accra, organised by Padmore and hosted by Nkrumah in December 1958. Those debates were codified by the Organisation of African Unity, founded in 1963 in Addis Ababa, whose legacy continues in the present in the shape of the African Union. A profound disenchantment with Pan-Africanism then takes hold amongst intellectuals in the 1970s and 1980s, as numerous one-party states adopt Pan-Africanist vocabularies in order to legitimate their authoritarian-populist policies of exclusionary Africanisation. The predatory Pan-Africanist policies practised by Zaire's Mobutu Sese Seko, Kenya's Daniel arap Moi and Cameroon's Paul Biya – to name but three – inspire the critiques of Kwame Anthony Appiah's *In My Father's House: Africa in the Philosophy of Culture* [1992] and Achille Mbembe's influential *African Modes of Self-Writing* [2002], which target the discredited state ideologies of Pan-Africanism.

At the same time, the debates over the promises and the problematics of Pan-Africanism were enacted in and by the global cultural festivals staged on the continent throughout the 1960s and 1970s. From 2008, Ntone Edjabe, Stacy Hardy and Dominique Malaquais of Chimurenga embarked on extensive research into the cultural politics of those festivals that were inaugurated in April 1966 with the World Festival of Negro Arts [FESMAN] in Dakar, as conceived by Senegal's Léopold Sédar Senghor. That was followed by the Pan-African Festival of Algiers, opened by Houari Boumedienne in July 1969. In October 1974, Mobutu Sese Seko welcomed audiences to attend the world heavyweight boxing championship between Muhammad Ali and George Foreman, also known as the 'Match of the Century' or the 'Rumble in the Jungle', in Kinshasa. Finally, in 1977, Nigeria's Lieutenant General Olusegun Obasanjo hosted FESTAC '77 in Lagos and Kaduna. Taken together with the investigations of the Chimurenga Library, these two research projects indicate the intranational ambitions of Pan-Africanist political aesthetics from the perspective of the pan-African present. One way of characterising the practice of Chimurenga is to look at their methods for inventing investigative aesthetics, which are flexible enough to move within and between these scales so as to reveal the practices of aesthetic sociality that exceed and elude and complicate the state-sponsored spectacle of the global festival.

EP: I was thinking about how an exhibition can work not only to share what you know, but also to create space to find what you don't know. Through 'The Chimurenga Library', or rather the sourcing of objects, things emerged that we hadn't been looking for. There were the photographs by George Hallett that Christine Eyene offered, George Shire brought in unpublished Dambudzo Marechera manuscripts – all sorts of things that started to broaden the picture. PASS became a live broadcasting programme of music, interviews and events with Chimurenga collaborators in London, which included musicians, writers, curators, film-makers, journalists, etc. We invited the sorryyoufeeluncomfortable collective to have a residency in conjunction with the project and to programme a slot of PASS, and they were a good conduit for bringing in and giving space to a younger generation. The radio broadcast was interesting for me because of the durational aspect of five days, and how the audience fluctuated in relation to this. The speakers were sitting with their backs to the audience. You don't know who's listening, but people did come to the space saying that they'd been listening all day. Or you'd see responses from remote listeners on Twitter. A project can resonate on many different levels and it's important for us to figure out how these things translate across different registers.

KE: The guests were continually narrating events and speculating on the implications of those recollections in ways that generated a continuous complexification of what pan-Africanist practices had been, could be and might be.

AG: The Chimurenga Library took place at the same time as a large exhibition and set of public programmes titled 'No Colour Bar: Black British Art in Action 1960–1990' [10 July 2015–24 January 2016], which, with a lot of work, trouble and Heritage Lottery Fund money, managed to get into London's Guildhall Art Gallery. The show was anchored in the Black Arts Movement, with a reproduction of the Walter Rodney Bookshop designed by Michael McMillan in the centre. There were vitrines in which you could read moving letters between Eric and Jessica Huntley, and artworks hanging on the walls – a conventional form. I was struck by the difference between these two shows, which felt like two different and deeply disconnected worlds. Not only the exhibition venues – one next door to the Bank of England and the other in a North African and Middle Eastern working-class neighbourhood – but the different art and social worlds surrounding them. I think it unlikely that the people involved in 'No Colour Bar' came to The Showroom, and this speaks of a certain split politically, especially with the older generation who were involved in Pan-African and radical Black diasporic politics in an earlier era and still today. What do you think? Does it tell us something about what pan-Africanism and radical Black politics means, and doesn't mean, in London today?

KE: There are generational, aesthetic and political distinctions between the works exhibited in 'No Colour Bar' and those in 'The Chimurenga Library'. In the former, we can see artists that allied themselves with practices invented by the Caribbean Arts Movement and the Black Arts Movement. These

influences converged in a diasporic Third World-ism epitomised by the epic gatherings around the International Book Fair of Radical Black and Third World Books, founded by activist-publishers John La Rose and Jessica Huntley in the early 1980s. 'No Colour Bar' narrated a transgenerational genealogy of post-War artistic politics practised by artists that actively participated in the contingent process of black British becoming. The works exhibited in 'No Colour Bar' speak of the political triumphs and defeats faced by generations that were all too aware of their position within a 'colony' whose existence emerged in reaction to state indifference and popular racism. Artists like Fowokan and Chila Kumari Burman envisioned the colony as a community whose cosmopolitanism could withstand the structural conditions of state-sanctioned subordination. The emboldened defiance of many of the works in 'No Colour Bar' speaks to and from the dynamics of this struggle; painting and sculpture plays a key role in this movement. 'The Chimurenga Library', by contrast, integrated murals of front covers, Palestinian Liberation Organization posters and videos by the Kongo Futurists into a network of quotations that form a cartography of thought.

EP: But also Chimurenga is not strictly 'art'. They include art and use the exhibition as an expanded editorial approach that spatialises knowledge and draws the connections between things in ways that can't be done in a two-dimensional format. There's a whole series of cartographies that Chimurenga made in an issue of the *Chronic* earlier this year, which are all reproduced in pencil. Graeme Arendse, Chimurenga's art director and designer, described how every time they thought they'd settled on a map someone would make a change and they would have to redraw the whole thing. He described how they hand-drew the maps through a desire not to present them as fixed entities – an approach to representation that's not about claiming an authority. In some ways the exhibition worked like this. It was a kind of sketch, mapping out different routes and drawing out strands of thinking without trying to claim authority. I have the feeling that Chimurenga invites its contributors, followers and audiences to think with them, rather than broadcasting as a one-way channel.

AG: For me, you touch on something very important that has to do with the tension between politics and culture. The generation of 'No Colour Bar' you're talking about, Kodwo, to a large extent they thought about making art in the service of a political project, and the form that project took was community organising as minority communities. That's very different than the case in South Africa, where it was about majority – not minority – organising. Your generation said we have a different notion of aesthetics, a different notion of cultural politics: we are not artists in the service of the revolution. In the past, people created community organ-

isations to deal with police harassment and police killings, or to deal with Black children being IQ tested in schools, or to organise lawyers for prisoners and refugees; the people who created a bookstore where none existed. That is a different political culture than working as a politically engaged artist in the contemporary art world. I wish more people from the community-politics

> ### *The political aesthetics of pan-Africanism share space with and are mutated by discourses and styles of Afropolitanism, Afropessimism and Afrofuturism.*

world had seen 'The Chimurenga Library', because it's not only the undisciplined/disciplined *process* of how they work, but the capaciousness of the ideas, the taking of positions that are historically intimate and at the same time critical and sharp, and in the present moment are not obsequious to power, while always being reflective about the representational format and forms of communication. We need that politically, not just artistically.

KE: Chimurenga recognises the extent to which contemporary audiences find themselves isolated from the interrupted networks of previous aesthetico-political struggles. It continually invents formats for navigating between intergenerational histories. Using the floor as a space to unfold the pages of the periodical, it invites visitors to move within texts selected and organised according to specific trajectories. This citational aesthetic alludes to the ways in which people move from link to link. It suggests the work of building *forms* of articulation. The majority of people that visited The Showroom did not visit Guildhall Art Gallery and vice versa. Chimurenga's navigational aesthetic draws attention to the gaps in knowledge that simultaneously function as channels between knowledges. Those arrows that point to quotations draw attention to the ways in which people process pan-Africanism now. The political aesthetics of pan-Africanism share space with and are mutated by discourses and styles of Afropolitanism, Afropessimism and Afrofuturism. People move between these vocabularies all the time without a map to

orient them. 'The Chimurenga Library' invited you to navigate these worlds of thought, which are conceived as mutable spaces of sustained complexity.

EP: I think in relation to this sense of disconnection between what was happening at Guildhall and what was happening at The Showroom you could ask, what does the space of an exhibition lend? I do think it's a site where you can bring things into contact. That, in a way, is part of the curatorial approach of Chimurenga, in thinking along these different trajectories or routes in relation to each other and finding ways to cross-read these different things in order to produce a more complex picture. And at the same time, the approach of the exhibition was about bridging between different communities, or people meeting and other relationships being forged through it.

KE: 'The Chimurenga Library' instituted itself as a time and a space in which people could meet. People planned future activities. It became a social space where pan-Africanist aesthetic politics were mutable and navigational. That is what people enjoyed about the space and that's what people miss. The Library insisted on that missing space which still does not exist. It drew people's attention to the implications of that absence.

Tendencies and Confrontations: Dakar 1966

– Cédric Vincent

From 1–24 April 1966, following three years of intensive preparations, Dakar hosted the Premier Festival mondial des arts nègres (First World Festival of Negro Arts). This huge event was organised by the Senegalese state and the African Society of Culture, an international network structured around the influential Paris-based journal *Présence Africaine*, and backed by UNESCO. The objective was ambitious: the festival wished to provide a forum for the expression of a new society grappling with the promises of independence in Africa. A diverse range of art disciplines was represented, in dance, theatre, cinema, visual art, handicrafts, literature, poetry and music. And the city of Dakar itself was transformed: vast building sites were started, whole neighbourhoods renovated, and hotel complexes built as well as a museum.

Of all this cultural ferment, the exhibition of contemporary art called 'Tendances et confrontations' ('Tendencies and Confrontations') remains the least documented section of the festival. A catalogue was published but not distributed. The national daily *Dakar-Matin*, which covered the preparations for the festival widely, made little effort to publicise 'Tendances et confrontations'. In general, very few photos of it circulated. In the recent history of art in Africa, however, the exhibition is noteworthy as a first attempt at a panoramic representation of contemporary

Cédric Vincent addresses the complex intersection of Pan-Africanism, *Négritude* and Black identities at the 1966 Premier Festival mondial des arts nègres.

African art. The work of more than 200 artists – some 25 nationalities – was featured.[1] To assess its influence on the representation of contemporary African art in the post-independence era – as this article proposes to do – is not to try to rehabilitate the exhibition but rather to attempt an understanding and description of its form and structure; and such an assessment must take into consideration what was at stake in the festival as a frame for production and protest.

Dakar, April 1966

According to official reports, the Senegalese president Léopold Sédar Senghor was the personification of the festival. Through this event, his goal was to remove the concept of *Négritude* from its usual literary-philosophical context in order to demonstrate its practical applications. He would put this Pan-African philosophical model to the test, for it constituted, in his eyes, both the expression of African cultural unity and the best way to perform it. In Senghor's inaugural speech, he outlined the import of this project: 'In short, if we have taken on the huge responsibility of organising this festival, then it is for the defence and illustration of *Négritude*. For here and there in different parts of the world, people continue to deny the existence of Negro art and *Négritude*, I mean, the Negro values of civilisation.'[2]

The festival attracted thousands of spectators from all over the world. The dates of the event corresponded to both the anniversary of Senegal's independence and the religious festivals of Tabaski and Easter, which undoubtedly contributed to the effervescence of the event. Representatives of some thirty independent African countries gathered in Dakar, and six countries with an important African diaspora were also represented: Brazil, Haiti, France, Trinidad and Tobago, the United Kingdom and the United States. Over the course of three and a half weeks, more than 2500 artists, musicians, writers and politicians gathered in Dakar, amongst them Aimé Césaire, Haïlé Sélassié, André Malraux, Michel Leiris, Langston

1 It is still difficult to confirm the number of artists and delegations that took part. Some uncertain areas remain that prevent the cross-checking of the archives and the catalogue; the latter can't be claimed as a reliable source of information.

2 Léopold Sédar Senghor, 'Fonction et signification du premier festival mondial des arts nègres', *Liberté 3*, Paris: Seuil, 1977, p.58. All translations from the French by Catherine Petit and Paul Buck.

Hughes, Duke Ellington, Josephine Baker and Wole Soyinka. The list of those who took part can be read as a *Who's Who* of some of the greatest black cultural figures of the beginning and middle of the twentieth century, as well as some of the leading Africanists of the time. However, it should be noted that the choice of participants largely favoured a generation of artists and intellectuals deemed politically and aesthetically conservative by many amongst the younger generation, who would express their resistance more openly three years later, at the first Pan-African cultural festival in Algiers.[3]

Christian Lattier, *L'orchidée* (*The Orchid*). Installation view, 'Tendances et confrontations' ('Tendencies and Confrontations'), Dakar, 1966

The festival opened with the symposium 'Function and significance of Negro art in the life of the people and for the people', held at the National Assembly, which set out the intellectual stakes for the entire event. This formal, ceremonial opening was in keeping with the great Pan-African conferences of the twentieth century.[4] The symposium generated eight days of discussion, in which an international array of writers, playwrights, film-makers, musicians, visual artists, dancers, archaeologists, curators, historians and ethnologists participated. Working groups were set up to reach concrete resolutions concerning how to 'create conditions favourable to Negro arts in today's world'.[5]

But the 'real heart of the festival', to use Senghor's words once again, was the exhibition 'L'Art nègre: Sources, evolution, expansion', held at the Musée dynamique, a museum built for the occasion.[6] Gathered under the same roof for the first time in Africa were a selection of 'masterpieces' of African art drawn not only from the great number scattered in museums and private collections across Europe and the United States, but also those kept within chiefdoms and royal treasuries in Africa. 'Tendances et confrontations' must have paled into insignificance in the shadow of this larger exhibition.

3 On these issues see David Murphy (ed.), *The First World Festival of Negro Arts, Dakar 1966*, Liverpool: Liverpool University Press, 2016; and Anthony Ratcliff, 'When Negritude was in Vogue: Critical Reflections of the First World Festival of Negro Arts and Culture 1966', *Journal of Pan African Studies*, vol.6, no.7, 2014, pp.167-86.
4 For example, the project of a festival of Black culture to be staged at regular intervals on the African continent was first launched in 1959, at the Second Congress of Black Writers and Artists held that year in Rome.
5 *Premier Festival mondial des arts nègres. Colloque sur l'art nègre*, t.1. Paris: Présence Africaine, 1967, p.6.
6 For more about that exhibition and the building of the Musée dynamique, see Cédric Vincent, '"The Real Heart of the Festival": The Exhibition of L'Art nègre at the Musée dynamique", in D. Murphy (ed.), *The First World Festival of Negro Arts, Dakar, 1966, op. cit.*, pp.45-63.

Christian Lattier,
Le Panthère (The Panther), n.d.
Installation view,
'Tendances et confrontations'
('Tendencies and Confrontations'),
Dakar, 1966

John Povey, who was to launch the journal *African Arts* the following year, claimed that in comparison with the exhibition at the Musée dynamique

> *the display of contemporary arts* [in 'Tendances et confrontations'] *... seemed rather inadequate, though that is as unfair a comparison as to wander from a Greenwich Village gallery into the Metropolitan Museum* [of Art in New York] *and to comment on the difference there. Nevertheless the arts of many national exhibits phased off too readily into handicrafts; oils jostled with pictures made of seashells and pairs of decorated leather shoes.*[7]

Although such a response may display certain prejudices of its own (no doubt encouraged by the curatorial framework), Povey's view was shared elsewhere. The title of an article in *The Washington Post* provided a rather abrupt summary of the exhibition: 'African artists disappoint viewer at World Festival of Negro Arts'.[8]

In his opening speech, however, Senghor tried to convince his audience that the exhibition of contemporary art occupied a central position within the overall festival plan: as 'L'Art nègre' represented the art of the past, 'Tendances et confrontations' was designed to represent the art of 'a new vision of the world ... of the new Negro'. He added that 'the Negro-African artists, the Senegalese artists, help us to live better, today, more and better'.[9] Under the presidency of Senghor, art was given an active role in the development of society. Senghor represented this synthesis of the political and the artistic through his status as a 'poet-president'. African arts, especially modern arts, were to save the Black subject and show the world the true value of African culture. New cultural structures emerged that would favour the visual arts, as well as an important cultural policy informed, shaped by and founded in *Négritude*.

7 John Povey, 'The First World Festival of Negro Arts at Dakar', *Journal of the New African Literature and the Arts*, Autumn 1966, p.5.
8 Donald H. Louchheim, 'African artists disappoint viewer at World Festival of Negro Arts', *The Washington Post*, 9 April 1966.
9 L. Senghor, 'Fonction et signification du premier festival mondial des arts nègres', *op. cit.*, pp.60-61.

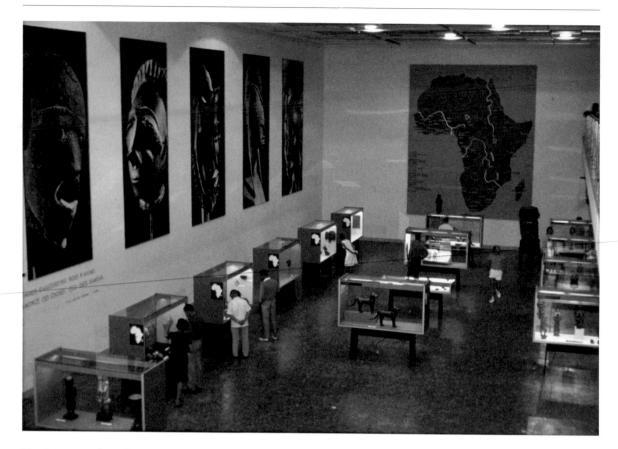

Tendencies and confrontations

Despite the importance attached to it, contemporary art was not mentioned in the initial plans for the festival discussed in 1963. At that stage, two exhibitions were planned. The first, 'Sources de l'art africain' ('Sources of African art'), was envisaged as a display of 'masterpieces' borrowed from European and American private collections and museums. The second, 'Tendances et confrontations', was imagined as a very different exhibition to the one that would eventually be realised under that title: organisers planned a display whose purpose would have been to evoke the 'place of art in the life of the community and to underline the expression of African art, along with art from Brazil and the Antilles, as well as the influences of African art on contemporary painting, sculpture and music'. These two axes would eventually be combined within 'L'Art nègre'.

The organisation of the actual 'Tendances et confrontations' was initially entrusted to Senegalese artist Papa Ibra Tall, director of the École des Arts in Dakar. Indeed, he appeared the perfect choice to act as President of the Commission for Contemporary Art: his work celebrated Pan-African themes and, for a lot of people, he incarnated the visual interpretation of Senghor's writings on *Négritude*. Tall's convictions were shaped during his years spent in Paris, where he mixed with adherents of *Négritude*. But, from 1965, it was Iba N'Diaye who would lead the project to completion. Though the reason behind this handover remains a mystery, one hypothesis is that Tall's departure from the Dakar art school to found and direct a tapestry school, Manufacture Nationale de Tapisseries in Thies (which opened in December 1966), had caused him to neglect preparations for the exhibition.

Studies of the Senegalese art scene in the sixties regularly oppose these two artists, both trained in Paris.[10] Tall's objective, particularly in his teaching, was to provide a framework for the development of a new art form, modern Senegalese art. This modern art was predicated on the innate creativity of the artist rather than on academic training. In contrast, N'Diaye firmly defended technical training and the acquisition of a broad aesthetic culture as prerequisites for the expression of an artist's singularity.

But this divergence in views had little impact on the organisation of the exhibition. The role of the President of the Commission was not that of an omnipotent curator but rather of

Installation view,
'L'Art nègre',
Musée dynamique,
Dakar, 1966

10 For example, Elizabeth Harney, *In Senghor's Shadow: Art Politics, and the Avant-garde in Senegal, 1960—1995*, Durham, NC: Duke University Press, 2004; and Joanna Grabsky, 'The École des Arts and Exhibitionary Platforms in Post Independence Senegal', in Monica Blackmun Visonà and Gitti Salami (ed.), *A Companion to Modern African Art*, Chichester, West Sussex: Wiley-Blackwell, 2013, pp.276—93.

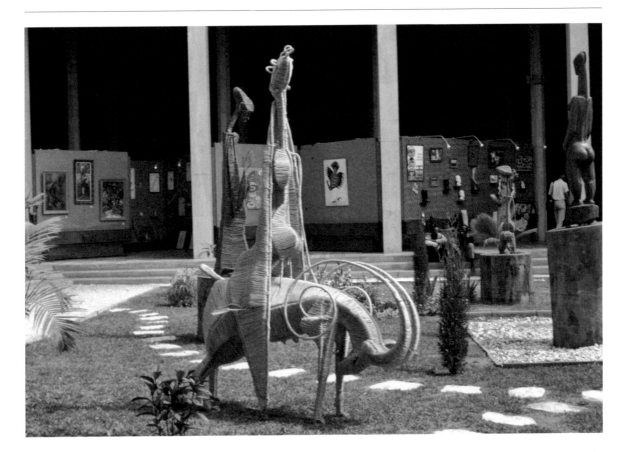

Christian Lattier,
Le Bélier (*The Ram*).
Installation view,
'Tendances et
confrontations'
('Tendencies and
Confrontations'),
Dakar, 1966

a supervisor, or coordinator. He did not intervene in the choice of artists or works presented – these decisions fell to the delegations wishing to take part.[11] It is worth remembering that the transport of the artworks, or indeed the artists (although few made the journey), was the responsibility of each country. If we are to believe the archived correspondence, it was unclear how many art pieces and artists each delegation could claim. The regulations imposed a maximum surface area that a delegation could occupy (32 square metres). Additionally, the space allocated was not very functional: the great hall of Dakar's court of law, with an open-air atrium in the centre, had been fitted with partition walls made of movable panels that permitted the exhibition to enjoy its own defined space without inhibiting either the free movement of personnel or the maintenance of court activity. Following the logic of the organisers, the hanging of artworks was allocated by country and not by artist or according to thematic or formal choices.

The decision of the festival's organisers to work with national delegations prioritised international cultural relations over the promotion of individual artworks. Most of the official documents relating to the festival attest to this fact, including the programme of concerts and performances, which mainly refers (sometimes exclusively) to the nation due to perform on a given date. This reveals the paradoxical dynamic of the festival as a vector for the expression of Pan-African unity while also offering a forum for countries in the process of creating a national culture and the invention of traditions.

An aggregate of conceptions about contemporary art
Though the title 'Tendances et confrontations' was not originally intended for a contemporary art exhibition, Iba N'Diaye believed that it fit perfectly:

> *The prudent title given to this presentation of paintings and sculptures, 'art contemporain, tendances et confrontations', corrected the overly ambitious intention declared by the organisers of the festival: to make it reflect 'the unity and the original-*

11 According to the catalogue, those present were: Brazil, the Central African Republic, Congo-Brazzaville (the present-day Republic of Congo), Congo-Léopoldville (the present-day Democratic Republic of the Congo), Dahomey (present-day Benin), Ethiopia, France, Gabon, Gambia, Haiti, Ivory Coast, Liberia, Madagascar, Mali, Morocco, Nigeria, the United Arab Republic (UAR), Senegal, Togo, the United Kingdom and the United States.

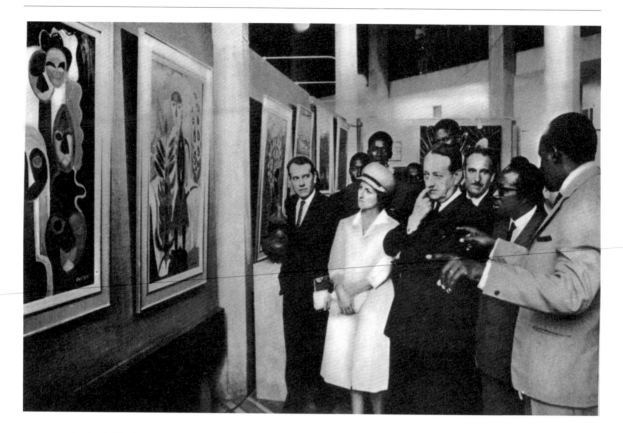

ity of today's black world'. In reality, Dakar's exhibition was characterised by a great heterogeneity, whose source was regretfully not to be found in the originality of the various artistic currents of contemporary Africa![12]

Iba N'diaye, Léopold S. Senghor and André Malraux at 'Tendances et confrontations' ('Tendencies and Confrontations'), Dakar, 1966

The 'heterogeneity' to which N'Diaye refers (with a touch of irony) echoes the confusion detailed by Povey in his description of an unsatisfactory exhibition that prevented the public from grasping the outlines of contemporary art in Africa and that sat uneasily within the festival's overall project. For some critics, the reason for the disparity between the works – or even their poor quality – was a selection policy that favoured the work of 'friends'. Sticking to the term 'salon', which had been used initially for 'Tendances et confrontations' instead of 'exhibition', might perhaps have helped to prevent these deceptive impressions regarding its lack of coherence and its resonance with the festival's overall project.

It is easy to believe that the disparity of the works presented and the themes addressed might have confused the majority of visitors, who had little familiarity with these new forms of artistic production: from demonstrations of lyrical abstraction to the academic prowess of artists who had attended European art schools; or from expressions of a national identity to post-traditional productions. The new genres were nonetheless, or however, based on practices already anchored in local communities. It was the divergence between these practices that characterised the largely infrastructural asymmetry between artistic scenes.

This 'heterogeneity' could also be conceived as a manifestation of the different understandings of contemporary art that held sway amongst the various delegations and their artists. For example, Gabon was represented by sculptors in wood who had trained in workshops; this left little room for dialogue with the ten painters from Senegal, including Walid Diallo, Ibou Diouf, Mor Faye, Papa Ibra Tall and Iba N'Diaye. These artists' paintings, in turn, had little affinity with the conventional figuration of an artist such as Léon Fylla, who represented Congo-Brazzaville (today, the Republic of the Congo).[13] In fact, one might have expected Congo-Brazzaville to have been represented by the famous artists of the Poto-Poto workshop, whose founder, Pierre Lods, was at the time a professor at Dakar's art school. But perhaps these artists' works were perceived as still being excessively rooted in the colonial period.

12 Iba N'Diaye, 'La jeune peinture en Afrique Noire. Quelques réflexions d'un artiste africain', *oeuvres africaines nouvelles*, Paris: Musée de l'Homme, 1970, p.34.
13 Léon Fylla had the honour of having his painting *Joueur de sanza* (1963) reproduced on a stamp of Congo-Brazzaville at the time of the festival. Of the stamps printed for the occasion, it is the only representation of a contemporary artwork; the other delegations opted for traditional art objects.

Colloque sur l'art
nègre, Premier
Festival mondial des
arts nègres (First
World Festival of
Negro Arts), Dakar,
1966

However, if one pays closer attention to some of the individual selections, it is possible to notice connections between 'Tendances et confrontations' and the more homogeneous selection proposed that same year in a publication directed by Evelyn Brown for the American foundation Harmon. Brown's text was an early attempt at establishing an appraisal of contemporary creation in Africa, as can be seen from its lengthy title: *Africa's contemporary art and artists: a review of creative activities in painting, sculpture, ceramics, and crafts of more than 300 artists working in the modern industrialized society of some of the countries of sub-Saharan Africa.* Its editorial line sought to classify a contemporary African artistic practice through a catalogue of artists, mostly from English-speaking countries, who specifically saw themselves as practitioners of modern art. From a similar perspective, the Dakar exhibition offered, apart from the Senegalese delegation, a fairly typical representation of contemporary African art of the period.

Pioneering figures were present at the festival. The Ivorian sculptor Christian Lattier won the grand prize for visual arts. The Nigerian Ben Enwonwu, who was close to many of the figures associated with *Présence Africaine*, does not appear to have exhibited his work, but at the symposium he defended his vision of an art marked by nationalist vigour.[14] His rival Felix Idubor was one of the sixteen Nigerian artists whose work was exhibited. The Nigerian delegation also included the 'Zaria Rebels': Demas Nwoko, Uche Okeke and Bruce Onobrakpeya. They had been the leading members of the former Zaria Art Society at the Nigerian College of Arts, Science and Technology, and they defended a new approach to art called 'Natural Synthesis'. Their project aimed to reconcile European techniques with the forms and styles of specific Nigerian cultures. Also featured in the exhibition were works by the Ethiopian artists Skunder Boghossian and Gebre Kristos. The latter had been awarded the Haïlé Sélassié Prize in 1965 for being 'one of the main innovators in non-figurative art' in Ethiopia.[15]

It is also interesting to consider the participation of the United Kingdom, which was represented by only four artists, according to the catalogue: Uzo Egonu, Ronald Moody, Aubrey Williams and Frank Bowling. In later accounts of Black British art, the Second Festival of Negro Arts (FESTAC) in Lagos in 1977 is cited as the key event that 'contributed to the extent to which Black artists in Britain were, by the 1970s, starting to cluster around designations

14 See Ben Enwonwu, 'The African view of art and some problems facing the African artist', in *Premier Festival mondial des arts nègres. Colloque sur l'art nègre*, t. 1, Paris: Présence Africaine, 1967, pp.417-26.
15 Sydney W. Head and Gebre Kristos Desta, 'A Conversation with Gebre Kristos Desta', *African Arts*, vol.2, no.4, 1969, p.20.

of ethnicity as means of advancing their own practice'.[16] Yet Egonu, Moody, Williams and Bowling were amongst the prominent artists whose work was exhibited at both FESTAC and the 1966 festival. (Bowling received the grand prize for painting at the latter, but much to his regret his paintings came back damaged.)

Dancers from Alvin Ailey dance troupe training in front of Musée dynamique, Dakar, 1966

The turbulent involvement of the United States

In some cases, the necessity for the artist to represent his or her nation and its cultural identity generated an unexpected fluidity, whereby place of residence superseded place of origin. Gerard Sekoto did not represent South Africa but France, where he had lived since 1947.[17] (He was close to the group associated with *Présence Africaine* and had made a poster for the Congrès des écrivains et artistes noirs (Congress of Black Writers and Artists) in Rome in 1959.) The presence of the Martiniquan painters Mathieu Jean Gensin and Louis Laouchez as part of the Ivory Coast delegation might come as an even bigger surprise, but it is evidence of the decisive role that artists from the Antilles were coming to play there. In other cases, the notion of representativeness had led to tensions between members: the power struggle initiated by the artists within the United States delegation (overseen by Virginia Innes-Brown, a white philanthropist) was one of the most blatant manifestations of this.

Often perceived as an autonomous exhibition, 'Ten Negro Artists from the United States' was in fact part of 'Tendances et confrontations'. Originally, the US visual arts committee had wanted to exhibit around eighty artworks by some forty living artists, so as to provide a significant representation of African-American art. That project proved to be too ambitious: for one, the space of the law court was too small; second, the funds allocated were not sufficient to support such an undertaking. Just a few weeks before the opening, the selection was reduced to sixteen artists. At that point, budgetary restrictions led to a deeper conflict between the artists and the committee.

The dispute concerned the unfair treatment of visual artists, who were not paid for their participation in the festival while performers such as the gospel singer Marion Williams and the Alvin Ailey dance troupe were remunerated. Romare Bearden declared to a *New York Times* journalist that: 'The full weight of sacrifice was placed solely on the

16 Eddie Chambers, *Black Artists in British Arts: A History since the 1950s*, London: I.B. Tauris, 2015, p.42.
17 In *Africa's contemporary art and artists*, Sekoto is, in a way, put in his rightful place – in South Africa.

Entrance to the
Musée dynamique,
Dakar

Following spread:
View of the Musée
dynamique from
Corniche Ouest,
Dakar

visual artists'.[18] Bearden and other protesting artists were linked to the Spiral collective,[19] which had been fighting for greater inclusion of Black artists on the visual arts scene and thus situated its participation in the festival within the history of the civil rights and Black Power movements. Bearden had submitted works to the committee, amongst them his collages *Conjur Woman* (1964) and *Watching the Good Trains* (1964), but in the end became the spokesman for a group of sculptors and painters who withdrew from the exhibition in protest.[20]

One consequence of these defections was to highlight the aesthetic disparities amongst the ten remaining artists. Several of them – Barbara Chase, Sam Gilliam, Richard Hunt and William Majors – insisted upon exhibiting totally abstract pieces. Others, like Jacob Lawrence and Charles White, were working in figuration and the depiction of social realities as experienced by African Americans.[21] White's work, for instance, proposed a model of Blackness completely different from that imagined by the partisans of *Négritude*. This was also the case with Majors, who separated identity claims from his artistic practice to the point where he refused the grand prize for illustration and printmaking, which Senghor was due to present to him during a visit to New York a few weeks after the close of the festival. In an interview about the Spiral group published in *ARTnews* in 1966, Majors confirmed: 'I don't care about going to Africa ... I just work.' In that same piece, however, Bearden defended the position that some aesthetic ideas produced by African writers like Senghor were worth discussion.[22] After his withdrawal, Bearden's sole contribution to the festival was his poem written specifically for the occasion, which was published on the first page of the catalogue *Ten Negro Artists*.

Majors was far from the only figure to adopt such a stance. The Nigerian poet Christopher Okigbo refused to go to Dakar, and rejected the prize for poetry because he

18 Richard F. Shepard, '10 painters Quit Negro Festival in dispute with US Committee', *The New York Times*, 10 March 1966.
19 Spiral was active from 1963-1965. The group included, amongst others, Charles Alston, Emma Amos, Romare Bearden, Calvin Douglass, Norman Lewis, William Majors, Richard Mayhew, Earl Miller, Merton D. Simpson and Hale Woodruff. See Jody Blake, 'Cold War Diplomacy and Civil Rights Activism at the First Festival of Negro Arts', in Ruth Fine and Jacqueline Francis (ed.), *Romare Bearden: American Modernist* (exh. cat.), Washington DC: National Gallery of Art, 2011, pp.45-58.
20 Charles Alston, Norman Lewis, Richard Mayhew, Raymond Saunders and Hale Woodruff joined him. Others (Jacob Lawrence, William Majors and Charles White) only withdrew some of their works.
21 Tobias Wofford, 'Exhibiting a Global Blackness: The First World Festival of Negro Arts', in Karen Dubinsky et al. (ed.), *New World Coming: The Sixties and the Shaping of Global Consciousness*, Toronto: Between the Lines, 2009, pp.179-86.
22 See Jeanne Siegel, 'Why Spiral?', *ARTnews*, September 1966, pp.48-51.

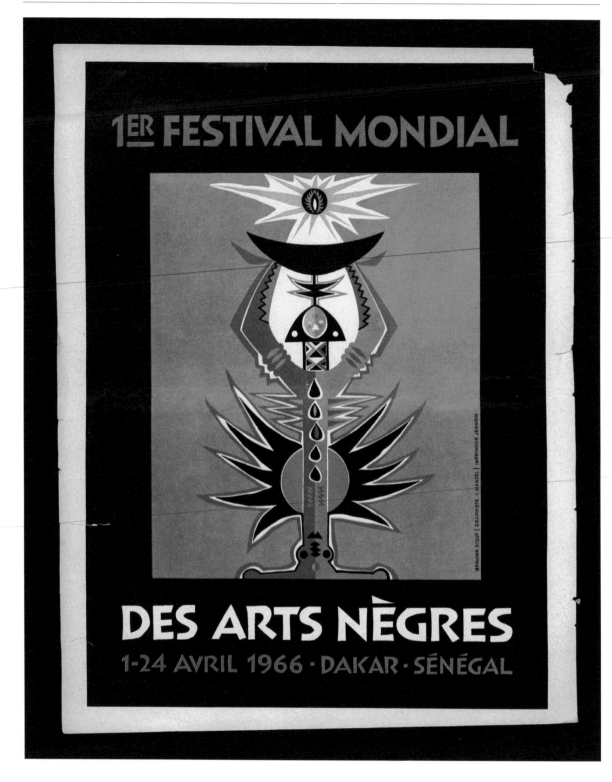

Poster for the
Premier Festival
mondial des arts
nègres (First World
Festival of Negro
Arts), Dakar, 1966

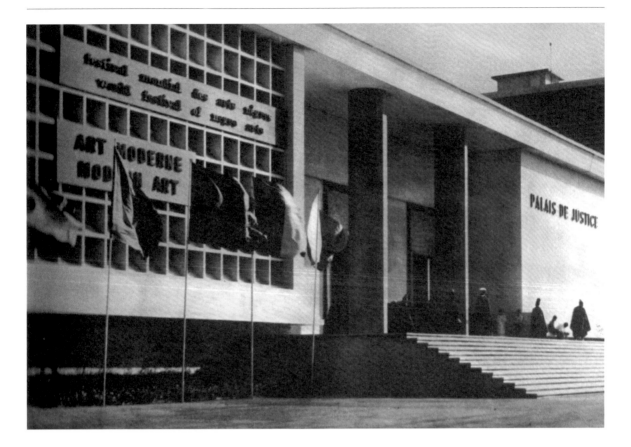

Entrance to the
Palais de Justice,
Dakar, 1966.

found 'the whole idea of a Negro arts festival based on colour quite absurd'.[23] This sentiment seems to have been shared by Iba N'Diaye, despite his official role in the festival, and the special prize he was awarded for his oeuvre (on the strong recommendation of Michel Leiris) even though he was only 38 years old at the time. N'Diaye ended up leaving his country for France one year later, in profound disagreement with the direction of the arts under the patronage of Senghor's state, which was guided by the philosophy of *Négritude*. Nonetheless, the majority of Senegalese artists viewed 'Tendances et confrontations' as marking the birth of the 'École de Dakar', a collective term for post-independence artists for whom the emblematic figure was Papa Ibra Tall.[24]

For Senghor, the festival was conceived to act as a living illustration of *Négritude*. However, as was demonstrated by 'Tendances et confrontations', it did not result in a monolithic affirmation of *Négritude* as a unifying Black identity. In this sense, the exhibition did not fulfil its mission, and was perhaps overly inclusive in the way it was organised, but it undoubtedly constituted the most profound expression of the festival's role as a form of laboratory in which one could question, defy, debate and explore – rather than simply asserting or passively accepting a global Black identity/community and the artistic and cultural manifestations that might represent it. Instead, the festival became a forum in which the various actors could negotiate their own understanding of Black culture and its art in complex and often contradictory ways.

23 Donatus Ibe Nwoga (ed.), *Critical Perspectives on Christopher Okigbo*, Washington DC: Three Continents Press, 1984, p.33.
24 J. Grabsky, 'The École des Arts and Exhibitionary Platforms', *op. cit.*, p.288.

Translated from French by Catherine Petit and Paul Buck. The author would like to thank David Murphy for his careful reading.

Fish, Kin and Hope: Tending to Water Violations in *amiskwaciwâskahikan* and Treaty Six Territory

– Zoe Todd

*We as humans live in a very narrow spectrum of ideal conditions. Those
ideal conditions have to be there for us to exist. That's why it's very impor-
tant to talk about ecology, the relationship. If those ideal conditions are not
there, you and I are not going to last for very long. Just text Neanderthal.
Ask the dinosaurs. What happened to them? We asked one of our elders,
'Why did those dinosaurs disappear?' He thought about it for a while and
he said, 'Maybe they didn't do their ceremonies.'*
– Leroy Little Bear[1]

On 21 July 2016, Husky Energy Inc. spilled around 200,000 litres of oil mixed with diluents
into the North Saskatchewan River, near the Saskatchewan-Alberta border.[2] The oil spill
breached the containment booms that had been built in the river, and flowed past cities and
First Nations lands downstream of the leak. The cities of Prince Albert and North Battleford
and the James Smith Cree Nation were forced to enact emergency drinking-water measures.
Beyond the spill's technical and infrastructural impact, the oil and diluents killed many
more-than-human beings within the river:

> *Members of the James Smith Cree Nation have watched in horror as foam, oil sheen,
> dead crayfish and tar have washed up along their portion of the riverbank. They
> say birds, frogs, butterflies and other wildlife that used to be seen around the river
> have disappeared from its banks since July 25, and are attributing the damage
> directly to Husky.*[3]

I watched these events unfold from my new home in Ottawa, in eastern Canada. I was
horrified as I read posts that friends uploaded to social media showing dead beavers and
herons and other beings floating down the river. I grew up along the *kisiskâciwani-sîpiy*
(North Saskatchewan River), in the city of *amiskwaciwâskahikan* (Edmonton, Alberta).

In the aftermath of an oil spill in the North Saskatchewan River, Zoe Todd urges a rethink of human and more-than-human relations.

To speak of Edmonton/*amiskwaciwâska-hikan* is to speak a water truth. It is nestled along, and spans, the banks of the mighty *kisiskâciwani-sîpiy*, which has carved its way deep into the soil and clay and sand and stone to yield steep banks that cut through Edmonton like an artery, supplying the city with water, with life. The river binds Edmonton to a broader watershed. The clear mountain waters, which originate deep in the Rocky Mountains at the Columbia Icefield, become tur-bid and inscrutable by the time they flow past the factories and sewage plants and homes and bridges of *amiskwaciwâskahikan*. But upstream of Edmonton, a four-hour drive south-west of the city, near Rocky Mountain House, you can still see the river running clear and with promise. The North Saskatchewan River, which my family is so deeply bound up with, is, in many ways, an unassuming prairie river. It winds its way, insistently, through the foothills to the west of the province, and rushes along vast stretches of prairie towards the clay-and-

1 Leroy Little Bear, 'Big Thinking and Rethinking: Blackfoot Metaphysics "Waiting in the Wings"',
 lecture at the Congress of the Humanities and Social Sciences, University of Calgary, 1 June 2016,
 available at https://www.youtube.com/watch?v=o_txPA8CiA4 (last accessed on 15 November 2016).
2 Carrie Tait, 'The Husky Spill', *The Globe and Mail*, 27 August 2016, available at http://www.theglobeand
 mail. com/news/national/husky-oil-spill-has-critics-questioning-independence-of-saskatchewans-
 regulatorysystem/article31585612/ (last accessed on 6 November 2016).
3 Elizabeth McSheffrey, 'Feeling Neglected by Husky, First Nation Crowdfunds to Clean Up After Oil
 Spill', *National Observer*, 23 September 2016, available at http://www.nationalobserver.com/2016/09/23/
 news/feeling-neglected-husky-first-nation-crowdfunds-clean-after-oil-spill (last accessed on
 6 November 2016).

soil-rich banks of my prairie home town, which it moves languidly through, its steep banks covered, variously, in aspen, spruce, wild roses, caragana, hazelnuts and *misaskwatomina* (Saskatoon berries). Within the city, the river lays bare dramatically steep cliffs, which, as a former *nicimos* (sweetheart/lover) taught me, hold dinosaur bones in secret pockets of the river valley. These fossils, which hide in a city of a nearly million people, act as reminders of an order of existence in this place that today churns and turns on the risks and riches of Alberta's oil and gas economy.

The fossil fuels which animate the political economy of my home province are a paradoxical kind of kin – the bones of dinosaurs and the traces of flora and fauna from millions of years ago which surface in rocks and loamy earth in Alberta act as teachers for us, reminding us of the life that once teemed here when the place that we know as Alberta was home to myriad species who made life, made worlds, within lands and waters I now know as *pehonan*. But, the insatiable desire to liberate these long-gone beings from their resting place,[4] to turn the massive stores of carbon and hydrogen left from eons of life in this place, weaponises these fossil-kin, these long-dead beings, and transforms them into threats to our very existence as humans in prairie metropolises like my home town. The oil economy turns these fossil beings into threats to the 'narrow conditions of existence', which Blackfoot scholar Leroy Little Bear reminds us we are bound to.[5]

What does it mean to approach carbon and fossil beings, including those spilled into the kisiskâciwani-sîpiy, as agential more-than-human beings in their own right?

Fossils are not the only markers of our entanglements in a petro-capitalist state of being in the North Saskatchewan watershed. As I have learned from the work of my colleague Heather Davis on human-plastic relations, other progeny of the fossil fuel economy find their way into the lands and waters and atmospheres of my home province.[6] The growing presence of these fossil-fuel progeny in every aspect of these territories creates urgency in our collective work to tend to ongoing reciprocal relationships between humans and more-than-humans in the prairies. Those long-dead dinosaur-era beings, liquefied as they are, now manifest their presence as bitumen, oil, natural gas and the plethora of materials produced from petrochemical processes that humans consume every day. The plastics, pesticides and oils, mixed with proprietary chemicals[7] to ease their movement through pipelines that pervade every corner of my home province are constantly moving through the territories those dinosaurs and ancient plants and other beings once roamed. This summer (2016), the oily progeny of the petro-economy breached the banks of the river that four generations of my Métis family has been born alongside. This watery violation of the river prompted many people to take stock of socio-political, economic and legal-governance responsibilities we hold to the lands, waters, fish, beavers, herons and other more-than-human beings of the prairies.

From its origins in the Saskatchewan glacier in the Columbia Icefield of the Rocky Mountains, the *kisiskâciwani-sîpiy* (swift flowing river) flows 1287 kilometres east towards the Alberta-Saskatchewan border and beyond, where it joins the mighty South Saskatchewan River at the Saskatchewan River Forks. Together, these watery bodies become the Saskatchewan River, which winds its way across the prairies, flowing into Lake Winnipeg in Manitoba. The waters of Lake Winnipeg eventually flow out into the Hudson's Bay, and make their way up into the Arctic Ocean and out into the North Atlantic and rejoin the earth's water cycle. These humble waters that cut across the prairies eventually make their way into broader earth water/hydrogeologic systems, making the struggles of unassuming prairie rivers a matter of global concern.

4 Richard Van Camp, in an interview with Shelagh Rogers on *The Next Chapter* on 11 August 2014, referenced a story in his book *Godless But Loyal to Heaven* (2012), which is also printed in the anthology *Dead North*, "On the Wings of this Prayer", a fictional tale which posits the Alberta Tar Sands as ground zero for a future/present zombie outbreak. In an earlier, but now archived, interview with Rogers from 10 June 2013, Van Camp explored the ways in which the Alberta Tar Sands feed, or operate through similar logics to, a kind of insatiable windigo/witiko spirit. The interview is available at http://www.cbc.ca/radio/thenextchapter/august-11-2014-january-2014-encore-1.2732866?autoplay=true (last accessed on 21 November 2016).
5 L. Little Bear, 'Big Thinking and Rethinking: Blackfoot Metaphysics "Waiting in the Wings"', *op. cit.*
6 See Heather Davis, 'The Queer Futurity of Plastic', lecture at the Sonic Acts Academy, Amsterdam, 28 February 2016, available at https://vimeo.com/158044006 (last accessed on 5 November 2016).
7 C. Tait, 'The Husky Spill', *op. cit.*

❄

I was born along the North Saskatchewan, at the Royal Alexandria hospital in Edmonton on a very snowy day in January 1983. My dad was born in 1948 in the same city, along the same river that animates my stories, my thinking and my scholarship. My grandfather – *nimosôm* – George Todd, was born in 1912 in St Paul des Métis settlement, north of Edmonton, and still within the North Saskatchewan river watershed. He lived a life that took him to many of places – particularly construction and road-building sites – he was a heavy-machine operator by trade. I only know him through stories, in the same way that I only know past-Edmonton (*amiskwaciwâskahikan*) through stories, and I only know the waters and fish that were once healthy and abundant and flowing in my home territory through stories about once-strident-and-teeming fish populations in Alberta.

In my life, I have been bound to fish. Fish have been my teachers. My multigenerational urban Métis family found ways to situate ourselves with care in relation to more-than-human beings in the heart of the prairie metropolis where we found ourselves. My grandfather, *nimosôm*, was animated by a different animal, horses. So to start, I want to tell you a short story about *nimosôm* and his horses. He was bound to land animals, and I feel a connection to his lifelong care and attention to horses, which I see echoed in my own artistic, philosophical and activist responsibilities, and my passion for fish.

> *I want art that strikes right to the core of my heart. I want art that honours the dreams of* mosôms *like* nimosôm *who had nowhere to show his work but the walls of the rental houses he lived. He drew dream horses right onto the walls of those prairie houses. He dreamt of someday having land and horses of his own.*
> *He died but those horses keep running wild in those houses.*
> *And you will never see them.*
> *I want art that is tender and caring towards those who aren't coming into your sterile white galleries.*
> *I want art that enters my veins and comes pouring out like fish, stories about the river, struggling against the current.*
> *Carrying stories to you, for you to mull over and chew and swallow and feast and rave about as you laugh and sing and dance and move unapologetically on your own terms.*
> *I want art that remembers that the stories we tell through it tie us to land and fish and dreams and past and present and future all at once and I want art that is attentive and tender to the stories that are told even in forms illegible to funding agencies and academic analyses.*
> *I want art that builds up spaces for others.*
> *I want art that declares itself to be sister, cousin, auntie and tease.*
> *I want art that remembers that it can manifest the otherwise and build things beyond our wildest imagination.*
> *I want art like those horses, running wild through those old houses, galloping beyond pages you will never see.*

In *nimosôm*'s tending to horses through the upheavals of his life as a Métis man navigating the colonial pressures of mid-century prairie Canada, I find a manifestation of the care, love and kinship towards more-than-human beings that shaped his life and philosophy. This article is an attempt to tend to the rivers and waters of my home province with the care that my grandfather lavished on his dream horses and the worlds and hopes and dreams (and escape) they promised him. I bring his love of horses to bear on the urgent and entangled challenges of the settler-colonial and petro-state violations of the waters of my homeland. I also imagine that he drew horses on the walls of settler-colonial prairie homes as a way of re-inscribing his/our reciprocal responsibilities to more-than-human beings within landscapes that had been heavily violated by settler-colonial economic and political exigencies.[8]

I have written elsewhere about how working with members of the Inuvialuit community of Paulatuuq in the Northwest Territories taught me about the dynamic and creative ways in which Paulatuuqmiut (Paulatuuq people) assert their own legal-governance paradigms and Indigenous legal order to protect the well-being of fish in the face of complex colonial and

8 Even if George could not live with horses the way he had as a child, he found a way to right the erasures of Indigenous human-horse relations within the prairies. This is instructive for me as I formulate artistic and philosophical responses to the devastation of water-worlds in my home province.

environmental challenges.[9] This work, with avid fishermen and community leaders such as Andy Thrasher and Millie Thrasher and their family, has also taught me that my own Métis upbringing – albeit an urban one – had oriented me to a Métis legal order which informs my responsibilities to fish, water and the more-than-human beings that populate Treaty Six Territory along the North Saskatchewan, Red Deer, Battle and Athabasca Rivers.[10] Further, this upbringing taught me the necessity of *thinking about and thinking with fish* in the urban context. I just didn't know to look for the implicit legal-governance and ethical imperatives these relationships with urban fish were imparting to me. Indigenous legal scholar Val Napoleon argues identifying and rebuilding Indigenous legal orders in Canada is a challenge because

> *much Indigenous law is implicit, or unsaid. In other words, many Indigenous peoples are not aware of the law they know – they just take it for granted and act on their legal obligations without talking about it. This is in contrast to explicit law, in which everything is explained and talked about and written down. Sometimes Indigenous peoples think that their laws have to look like Western laws and so they try to describe them in Western terms.*[11]

Through the work of Napoleon, and of my friends and interlocutors Andy and Millie Thrasher, I have finally come to understand that my Métis dad and non-Indigenous mom's work in teaching me about the lands, waters, fish, berries, invertebrates and other beings of where I grew up was an instructive form of philosophy and praxis which imbued within me a sense of my reciprocal responsibilities to place, more-than-human beings and time. But what of my responsibilities to 'inert' or polluting materials, like the oil that spilled into the North Saskatchewan River this summer? What does it mean for me to dwell in an active and philosophical way in the realities of the 'modernist mess' and 'toxic vitalism' which provinces like Alberta and Saskatchewan have been saddled with through extractive settler-colonial political economies?[12]

<div align="center">❀</div>

Returning to the spill on the North Saskatchewan River in July of last year, I am forced to tease apart my relationality to the various agents involved in, and impacted by, the breach of the Husky pipeline. In my work interrogating the role of fish-as-political-citizens in northern and western Canada,[13] I engage the political philosophies of fishermen in Paulatuuq. Having come to understand fish as nonhuman persons, it is possible for me to situate fish within the legal-political landscapes of Indigenous de-colonial resistance and refraction in Canada. Far harder for me to address have been the ways in which the very pollutants involved in the Husky oil spill are themselves the extracted, processed, heated, split and steamed progeny of the fossilised carbon beings buried deep within the earth of my home province. In this sense, I must contend with the paradoxes of the weaponisation of carbon beings within capitalist petro-state economies. What does it mean to approach carbon and fossil beings, including those spilled into the *kisiskâciwani-sîpiy*, as agential more-than-human beings in their own right?

I have turned to the works of Heather Davis and Kim TallBear to help me better understand the ways in which oil can be conceptualised as kin. Davis urges us to tend to our relationality and reciprocal responsibilities to the progeny of the petro-capitalist state, and in her work she explores how humans are making sense of, and tending to, the growing global geologic presence of plastic. She asks that we tend to these offspring of our petrochemical politics as *kin*[14]. Davis's approach to plastic as kin, and Kim TallBear's discussion of pipestone as kin

9 My 'Fish pluralities: Human-animal Relations and Sites of Engagement in Paulatuuq, Arctic Canada', *Etudes/Inuit/Studies*, vol.38, no.1-2, 2014, pp.217-38.
10 My 'From fish lives to fish law: learning to see Indigenous legal orders in Canada', *Somatosphere: Ethnographic Case Series*, 1 February 2016, available at http://somatosphere.net/2016/02/from-fish-lives-to-fish-law-learning-to-see-indigenous-legal-orders-in-canada.html (last accessed on 7 November 2016).
11 Val Napoleon, 'Thinking About Indigenous Legal Orders', research paper for the National Centre for First Nations Governance, 18 June 2007, available at http://fngovernance.org/ncfng_research/val_napoleon.pdf (last accessed on 7 November 2016).
12 Kim Fortun, 'From Latour to Late Industrialism', *HAU: Journal of Ethnographic Theory*, vol.4, no.1, 2014, pp. 309-29.
13 My 'From fish lives to fish law', *op. cit.*
14 See H. Davis, 'The Queer Futurity of Plastic', *op. cit.*

Dakota territory,[15] has forced me to reorient my relationship to fossils and stone. I have, admittedly, viewed oil and oil-progeny as contaminants, or pollutants, and the oil itself as imbued with messy human politics, which extract it from the ground and flood pipeline arteries stretched across the entire continent. Davis's work challenges me to train my attention not only towards the fleshy beings I am so intimately familiar with – fish and birds and beavers and moose – but to also mobilise those aspects of Métis law that I grew up with in the service of imagining how we may de-weaponise the oil and gas that corporate and political bodies have allowed to violate waters, lands and atmospheres across the prairies.

So, if I am to take both Davis's and TallBear's work on our messy and paradoxical kinship entanglements with the progeny of the petro-capitalist economy seriously, what do oil/gas pluralities look like? It is not the oil itself that is harmful. It rested beneath the loamy soil and clay of what is now Alberta for eons. Anecdotes of the Dene people's use of the bituminous tar that occurs naturally along the Athabasca River in northern Alberta to patch canoes reminds me that these oily materials are not, in and of themselves, violent or dangerous.[16] Rather, the ways that they are weaponised through petro-capitalist extraction and production turn them into settler-colonial-industrial-capitalist contaminants and pollutants. It is here that I am challenged to reconsider my reactions to the oil flowing along the river. The oil in the Husky spill is, yes, a contaminant. And the ineffective responses of state and corporate bodies alike enabled the oil to breach its containment, to endanger drinking-water systems.[17] But it is not this material drawn from deep in the earth that is violent. It is the machinations of human political-ideological entanglements that deem it appropriate to carry this oil through pipelines running along vital waterways, that make this oily progeny a weapon against fish, humans, water and more-than-human worlds.

So what other worlds can we dream of for the remnants of the long-gone dinosaurs, of the flora and fauna that existed millions of years ago? What legal-governance and philosophical paradigms can we mobilise to de-weaponise oil today? How can we tend to these narrow conditions of existence that Leroy Little Bear reminds us we live within? I am not sure if I have an immediate answer, other than that we must shift the logics of the petro-economy, which are emboldened to contaminate whole rivers and watersheds with oil and diluent, because those narrow conditions of existence are narrowing ever more in the context of the so-called Anthropocene. If we fail to do so, we may go the way of the dinosaurs, and it will be because the dominant human ideological paradigm of our day forgot to tend with care to the oil, the gas and all of the beings of this place. Forgot to tend to relationships, to ceremony (in all the plurality of ways this may be enacted), to the continuous co-constitution of life-worlds between humans and others.

For my part, I take a page from my grandfather's life, and I keep trying to draw the fishes of my home territory. With this I must also engage with the complex responsibilities that come with re-framing fossils and fossil-beings – including the petrochemical products of decayed matter buried deep within the earth of my home province – as a kind of kin. This is a difficult philosophical and political negotiation for me to make, for I have, throughout my entire life, seen oil solely in its weaponised form. However, the lessons from *nimosôm*, from fish, from Leroy Little Bear and others bring this necessary philosophical and practical engagement into focus. I hope that I can encourage settler Canadians to understand that tending to the reciprocal relationality we hold with fish and other more-than-human beings is integral to supporting the 'narrow conditions of existence' in this place.

15 See Kim TallBear, 'Beyond Life/Not Life', lecture at UCLA Center for the Study of Women, Los Angeles, 5 November 2013, available at https://www.youtube.com/watch?v=TkUeHCUrQ6E (last accessed on 6 November 2016).
16 See 'Early Oil Sands History and Development', Institute for Oil Sands Innovation at the University of Alberta website, http://www.iosi.ualberta.ca/en/OilSands.aspx (last accessed on 6 November 2016).
17 See E. McSheffrey, 'Feeling Neglected by Husky', *op. cit.*

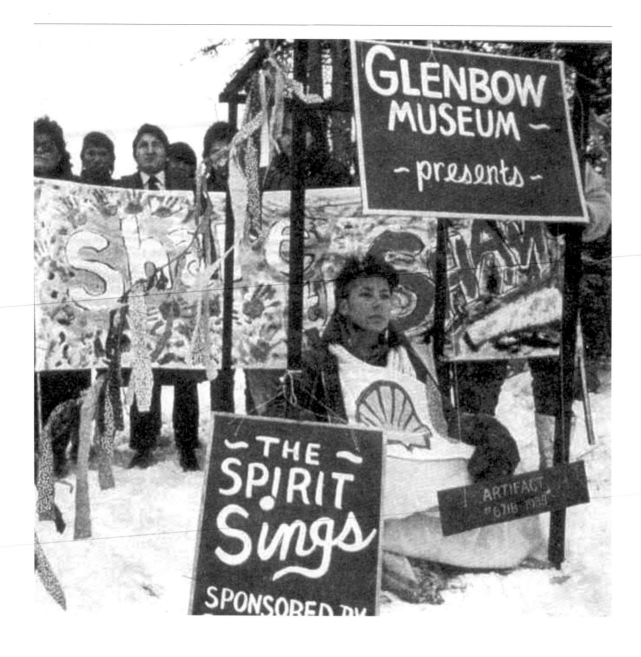

Anger and Reconciliation: A Very Brief History of Exhibiting Contemporary Indigenous Art in Canada

– Lee-Ann Martin

In 1986, while working in a university museum in the US state of Maine, I began to hear media reports regarding the planning of an exhibition titled 'The Spirit Sings: Artistic Traditions of Canada's First Peoples'.[1] Organised by the Glenbow Museum in Calgary, Alberta to coincide with the 1988 Olympics held in that location, 'The Spirit Sings' was to include over 650 historical objects borrowed from national and international ethnographic collections.[2] I was angry and frustrated to learn that the curatorial committee included no Indigenous curators. My anger was exacerbated by the fact that the exhibition would include only historical objects, without regard to contemporary realities – typical of the exclusionary practices of museums that had amassed significant collections of Indigenous historical objects while denying intellectual and physical access to the objects by the very communities from which they were taken.

I was not alone in my anger. 'The Spirit Sings' was part of a sequence of exhibitions and events during the late 1980s and early 90s that profoundly impacted the content of, and contexts for, exhibitions of Indigenous art. Artistic and community activism, exhibitions, conferences and a task force forever transformed relationships between museums and Indigenous peoples in Canada; this essay is an attempt to weave together a history of the turbulent dynamic of this time.

The fact that 'The Spirit Springs' came to my attention as early as 1986 can be attributed to a widely publicised campaign by the Lubicon Cree Nation – a small Aboriginal community living sovereignly in northern Alberta – to boycott the exhibition, which brought issues of museum representation and First Nations cultural heritage to the forefront of the national debate. From the perspective of the Lubicon Cree, the exhibition glorified numerous romantic stereotypes associated with historical Aboriginal cultural objects while denying complex contemporary realities. In their case, that reality was the destruction wrought on their culture and

Lee-Ann Martin describes how Indigenous artists, curators and activists in Canada have transformed long-held institutional discourses and practices.

livelihood by Shell Canada, the corporate sponsor of the exhibition, as well as the complicity of major cultural institutions in Shell's corporate agenda, through organising or lending work to the show. Indigenous artists, communities and political organisations across the nation strongly supported Lubicon's perspective and boycott.

On 12 January 1988, three days before 'The Spirit Sings' opened to the public, Rebecca Belmore burst into the national arts consciousness with her performance piece *Artifact #671B*. In minus 18 degrees Celsius weather, she sat immobile on the frozen ground in a museum case outside the Thunder Bay Art Gallery in Ontario. Her performance expressed the collective anger of the many Indigenous people throughout Canada who condemned the organisers and sponsor of 'The Spirit Sings'. Four days earlier, the exhibition 'Revisions' had opened at the Walter Phillips Gallery in Banff, Alberta (about an hour from Calgary). Strategically timed to coincide with 'The Spirit Sings', 'Revisions' included eight Indigenous artists from both Canada and the US.[3] Conceived to counter the historic and ethnographic focus of 'The Spirit Sings', 'Revisions' asserted the significance of contemporary Indigenous culture and arts practices. The artists sabotaged ethnographic stereotypes

1 Note on terminology: 'Indigenous' is the preferred terminology used today with specific reference to the arts in the Canadian context and internationally. However, throughout this text, I use the terms 'Native', 'Indian' and 'First Nations' to respect their historic context and usage in Canada.
2 The exhibition ran from 15 January–1 May 1988 at the the Glenbow Museum, before travelling to the Canadian Museum of Civilization in Ottawa, 1 July–6 November 1988.
3 'Revisions' took place 8–28 January 1988. The participating artists were Joane Cardinal-Schubert, Jimmie Durham, Hachivi Edgar Heap of Birds, Zacharias Kunuk, Mike MacDonald, Alan Michelson, Edward Poitras and Pierre Sioui.

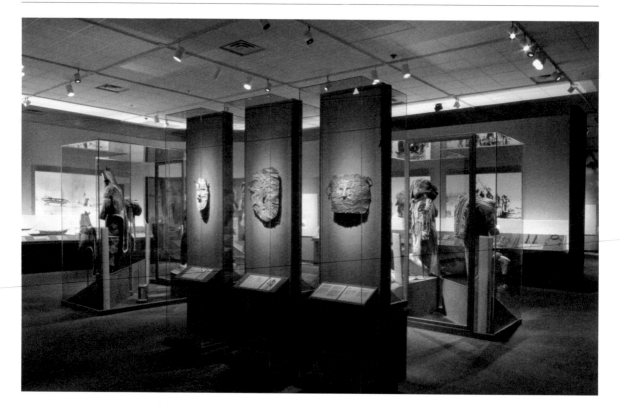

in order to redress their present and future cultural identities. They were concerned with 'deconstructing Eurocentric versions of native history and proposing their own counter-narratives';[4] for example, Jimmie Durham and Joane Cardinal-Schubert both angrily parodied the devices of museum display as they created their own contemporary artifacts as history lesson and ethnographic critique. These interventions responded to the housing of Indigenous artifacts in Caucasian museums in North America and in Europe and the categorisation of Indigenous art practices in ethnographic terms. (These conditions are largely still the case.) Even with the growing public awareness of Indigenous sovereignty in the late 1980s, sympathy for Indigenous peoples was usually based on paternalistic notions of cultures forever locked in history. While 'Revisions' was important as one of the first exhibitions to focus on the disruption of institutional practices through an Indigenous lens, its impact was limited until the accompanying catalogue was published in 1992.

In conjunction with the last days of the second presentation of 'The Spirit Sings', from 1 July–6 November 1988 at the Canadian Museum of Civilization[5] in Gatineau, Quebec (across the river from Ottawa), the Assembly of First Nations and the Canadian Museums Association jointly organised a conference to debate the full range of concerns voiced by the Lubicon Cree. 'Preserving Our Heritage: A Working Conference Between Museums and First Peoples' brought together over 150 academics, artists, curators, museum profession-als, politicians and Indigenous knowledge keepers. Sponsorship, representation, access to collections and training were some aspects of the vital and multifaceted discussions at this conference. Following the recommendations of conference participants, and officially initiated by the Assembly of First Nations and the Canadian Museums Association in 1990, the Task Force on Museums and First Peoples – for which I was coordinator – convened consultations and meetings and conducted research over a two-year period. The final report, *Turning the Page: Forging New Partnerships Between Museums and First Peoples* (1992), contains guidelines and recommendations 'to develop an ethical framework and strategies for Aboriginal Nations to represent their history and culture in concert with cultural institutions.'[6]

At this time I also conducted an independent survey on the status of contemporary Native art within 29 contemporary Canadian art institutions; this involved studying a

Installation view, 'The Spirit Sings: Artistic Traditions of Canada's First Peoples', 1988, Glenbow Museum, Calgary, Alberta. Courtesy Glenbow Museum

4 Helga Pakasaar, in *Revisions* (exh. cat.), Banff, Alberta: Walter Phillips Gallery, 1992, p.3.
5 Now the Canadian Museum of History.
6 *Turning the Page: Forging New Partnerships Between Museums and First Peoples*, a report jointly sponsored by the Assembly of First Nations and the Canadian Museums Association, Ottawa, Ontario, 1992.

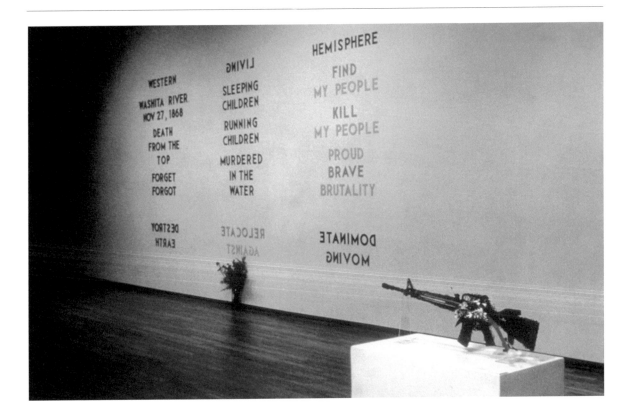

Edward Poitras, *Lost for Words (M-16)*, 1987. Installation view, 'Revisions', 1988, Walter Phillips Gallery, Banff Centre for the Arts and Creativity, Banff, Alberta. Courtesy the Walter Phillips Gallery, Banff Centre for the Arts and Creativity

number of museum functions: acquisitions, exhibitions, publications, programming, staffing and relationships to Aboriginal (arts) communities.[7] Written acquisition policies of the period contained subtle exclusionary phrases such as 'highest quality collections', 'finest visual art available' and 'important artists'; such language was used to denote a single acceptable standard, to perpetuate the myth of the Western European model of race hierarchy and to deny the complex issues of diverse art discourses and practices. The study concluded by detailing the systemic exclusion of contemporary Indigenous art from Canada's foremost art museums.

With few exceptions, curators and directors rationalised this exclusion with statements that they didn't want to 'segregate' or 'reduce to a ghetto status' these works. Although many stated that they were fearful of 'different' treatment for these artists, they overlooked the fact that contemporary Aboriginal artists had been treated differently and negatively for far too long. The majority of the museums displayed an aversion to thematic exhibitions based 'solely on cultural origins' of artists; the integration of contemporary Indigenous art with contemporary Canadian art seems to have been beyond their scope at that time.

❀

The mobilisation around 'The Spirit Sings' built upon years and decades of Indigenous activism, organisation and resistance. I became increasingly aware of this as of 1987, when I began graduate work in museum studies at the University of Toronto, to research, critique and enter into a field less travelled by Indigenous peoples at that time. I soon learned about the third National Native Indian Artists Symposium that was organised at K'san, British Columbia in 1983, where Kwakwaka'wakw and Haida artists who had worked on museum projects in Victoria and Vancouver during the previous two decades shared their skills with over a hundred artists and students.[8] (The symposium itself was held on the site of the Kitanmax School of Northwest Coast Indian Art, which in 1967 had initiated an artist training programme to revitalise Nisga'a art and cultural traditions.) Immediately

7 The study was supported by the Canada Council as part of a residency I was then undertaking at the Canadian Museum of Civilization, Gatineau, Quebec.
8 Funded in part by the federal Department of Indian Affairs and Northern Development (now Indigenous and Northern Affairs Canada), previous symposia included: Symposium I, Manitoulin Island, Ontario, October 1978; and Symposium II, Saskatchewan Indian Federated College, Regina, Saskatchewan, September 1979.

following the symposium, a working group was organised to address the ongoing exclusion of Indian art by mainstream art institutions; the group incorporated as the Society of Canadian Artists of Native Ancestry (SCANA) in January 1985. Two artists highly respected as innovators within their respective traditions of Iroquoian sculpture and Northwest Coast sculpture, David General and Doreen Jensen, were the first co-chairs of SCANA. Throughout the 1980s and the early 90s, the group worked tirelessly to increase the recognition of contemporary First Nations artists. The mandate of SCANA, as an informally organised national group, was to act as liaison amongst the growing number of Native artists, the provincial and federal funding agencies, and art museums. It was a strong advocate in the many debates around museum representation in this period; amongst its accomplishments was the organisation in 1987 of 'Networking', the fourth National Native Indian Arts Symposium, at the University of Lethbridge, Alberta.[9]

Importantly, SCANA also collaborated with several cultural institutions to develop exhibition projects, including the pioneering 'Beyond History', presented at the Vancouver Art Gallery in 1989.[10] A partnership involving SCANA, the Woodland Cultural Centre and the Vancouver Art Gallery, this exhibition signalled 'the creation of a new ideology which is highly personal and political, unlike the collective tribal response proclaimed during the sixties'.[11] 'Beyond History' included mixed media works by artists who came to prominence in the 1980s, and who shared a critique of popular ethnographic stereotypes and a focus on the impact of colonisation in Canada on Indigenous peoples. However, these artists were by no means a homogeneous group: they came from different cultural heritages, art traditions, political persuasions and personal experiences.

Parallel to the activist history of Aboriginal artists, First Nations artist-run centres also emerged throughout Canada beginning in the 1980s. This movement exemplified the ways in which artists seized control of how their art was presented, providing alternative spaces free from the limitations of public institutions. The Native Indian/Inuit Photographers' Association in Hamilton, Ontario was the first such collective, created in 1985; by the mid-90s other centres were operating with broad, multidisciplinary mandates,

Rebecca Belmore, *Ayum-ee-aawach Oomama-mowan: Speaking to their Mother*, 1991. Banff, Alberta, megaphone, sound, animal hides and leather. Courtesy the artist

9 At this event, artists and representatives of Canadian arts and funding institutions debated issues surrounding the definitions of and contexts for contemporary Indigenous art. See Alfred Young Man (ed.), *Networking: Proceedings of the Fourth National Native Indian Arts Symposium*, Lethbridge, Alberta: University of Lethbridge 1987.
10 Karen Duffek and Tom Hill, *Beyond History* (exh. cat.), Vancouver: Vancouver Art Gallery, 1989.
11 *Ibid.*, p.5.

amongst them Sâkêwêwak Artists' Collective in Regina, Saskatchewan (1993); Tribe Inc. in Saskatoon, Saskatchewan (1995); and Urban Shaman Contemporary Gallery in Winnipeg, Manitoba (1996). Additionally, the Aboriginal Film and Video Art Alliance (formed in 1991) was instrumental in developing the framework for the multidisciplinary Aboriginal Arts Program at the Banff Centre in 1995.

During the late 1980s, the mounting debates surrounding the inclusion of contemporary Indigenous art and access to historical collections were compounded by a turbulent sociopolitical landscape in Canada. Land claims and struggles against corporate development resulted in direct action by First Nations communities throughout the country. By 1990, political events galvanised Indigenous solidarity and provided the impetus for heightened activities that would resonate throughout the next decade. Massive land claims were slowly proceeding in British Columbia, Ontario and the Yukon; the Quebec government announced plans to begin the second phase of the James Bay hydroelectric project; and the late Elijah Harper, a Cree member of the Manitoba Legislative Assembly, said 'No' to the Meech Lake Accord, the proposed constitutional legislation that would have denied recognition of Aboriginal peoples while affirming the province of Quebec as a distinct society with special status.

> *We hoped to shock non-Indigenous viewers out of their complacency and ignorance of Indigenous history and contemporary realities. But we also hoped to connect with Indigenous audiences throughout North America who knew about and lived this painful history.*

And then there was Oka. For 78 days in the summer of 1990, the Mohawk people of Kanehsatake defended their land against the impending encroachment of a golf course in the neighbouring town of Oka, in Quebec. The Canadian Armed Forces and the Quebec Provincial Police used physical force against the many people who struggled to defend their land. Once again, artist Rebecca Belmore produced a powerful artwork. For her community-based performance and sound installation *Ayum-ee-aawach Oomama-mowan: Speaking to their Mother* (1991–96), Belmore travelled to First Nation communities and urban areas throughout Canada and the US, inviting people to address the land directly in response to the Oka standoff. Hundreds of Indigenous and non-Indigenous people joined in addressing Mother Earth through a megaphone encased in a massive wooden amplifier bound together with leather and animal hides.

❋

In 1992, official events marked the 500th anniversary of the arrival of Christopher Columbus in the Americas, a largely Italian-American celebration of 'discovery' that was receiving considerable funding and media attention on both sides of the Atlantic. Indigenous peoples did not share this celebratory spirit, as the legacy of European colonisation has largely rendered Indigenous peoples invisible in their own territories. But 1992 was also the culmination of a decade-long escalation of Indigenous frustration in Canada, with a colonial state that steadfastly refused to uphold the rights that had been recognised and affirmed in the Constitution Act of 1982. Once again, artists raised their voices in anger, reflection, conciliation and affirmation of cultural identity. Following 500 years of oppression and exclusion, Indigenous peoples tenaciously affirmed their own histories, experiences and identities within a thoroughly contemporary context.

That year, two international touring exhibitions heralded a significant new direction for the production and presentation of contemporary Aboriginal art in Canada. 'INDIGENA: Perspectives of Indigenous Peoples on Five Hundred Years', curated by myself and Gerald McMaster, opened at the Canadian Museum of Civilization; across the Ottawa River, 'Land Spirit Power: First Nations at the National Gallery of Canada' was the result of the curatorial collaboration of that institution's Diana Nemiroff, independent curator and Saulteaux artist Robert Houle and anthropologist Charlotte Townsend-Gault. 'INDIGENA' was the first Indigenous-curated internationally touring exhibition organised by a high-profile national institution. Its organisation began in the mid-1980s, while I

was living in the US, where I worked with colleagues – Tewa curator Margaret Archuleta and Tlingit artist Jim Schoppert – to develop a national project to de-celebrate the impending quincentennial of Columbus's arrival; I continued the project in Canada in collaboration with McMaster. (SCANA also supported the exhibition project by providing a grant for my curatorial fee.) Our primary audiences were the Euro-Canadian and US occupiers of the Americas. We hoped to shock non-Indigenous viewers out of their complacency and ignorance of Indigenous history and contemporary realities. But we also hoped to connect with Indigenous audiences throughout North America who knew about and lived this painful history.

The government of Canada chose not to recognise the quincentennial of the United States. But they did plan to celebrate the 125th anniversary of Canada. As Indigenous curators, we could not acknowledge any such celebrations of Western dominance and oppression, so we seized that moment to present, on our own terms, issues of importance to our communities. 'INDIGENA' was a logical extension of the Canadian Museum of Civilization's commitment to contemporary Indigenous art; the museum had opened three years earlier, and many of its staff members were participants on the Task Force on Museums and First Peoples. The exhibition brought together works by visual, literary and performing artists from across the country that engaged in an Indigenous critique of 500 years of colonial history. Essays, performances, paintings, installations, videos and photographs examined the tangled complex of history, language, identity, stereotypes and contemporary realities that defined Indigenous cultures at the time. The primacy of Indigenous voices, representation and community support were central tenets of the project; hosting venues in both Canada and the US were selected based upon the involvement of local Indigenous communities.

Opening in September 1992, and overlapping with 'INDIGENA' for one month, 'Land Spirit Power' was the first major international exhibition of contemporary First Nations art from Canada and Native American artists from the US to be held at the National Gallery of Canada. The curatorial premise sought to 'recognise a new generation of First Nations artists whose work was individual and personal, yet reflected a distinct cultural experience within mainstream North American art'.[12] Most of the artists, including three who were also exhibiting in 'INDIGENA' (Carl Beam, Domingo Cisneros and Lawrence Paul Yuxweluptun), worked within contemporary mainstream idioms. 'Land Spirit Power' also presented the work of artists who contemporised their culture-specific and customary practices (Dempsey Bob, Robert Davidson and Dorothy Grant were noteworthy in this respect). This exhibition was significant in including diverse artists who expressed their 'distinct cultural experiences' through individual notions of the land as a spiritual and political legacy.

As two of the first major exhibitions of art and contemporary issues as seen through Indigenous lenses, 'INDIGENA' and 'Land Spirit Power' disrupted long-held institutional discourses and practices. They mark an important turning point, and the point at which I will end this brief history. Writing today, 25 years later, I remain angry and frustrated. Indigenous arts professionals throughout Canada and the world have developed a formidable intellectual force that challenges the basic premise of Western mandates and practices. But drastic conditions still exist throughout Canada – evidence of the persistence of the country's colonial history and its lingering effects today. Thousands of missing and murdered women, high rates of suicide amongst our youth, the incarceration of Indigenous men, poverty, lack of drinking water and educational needs plague our communities – not to mention the constant struggle for sovereignty over traditional lands. Much work remains to be done.

12 Diana Nemiroff, Robert Houle and Charlotte Townsend-Gault, 'Land, Spirit, Power', in *Land Spirit
 Power: First Nations at the National Gallery of Canada* (exh. cat.), Ottawa: National Gallery of Canada,
 1992, p.11.

Kuchyran Yuri,
Kuara-Langa (Echo),
2004, meditative
performance.
Photograph:
Konstantin
Semyonov.
Courtesy the
artist

Ethno-Futurism: Leaning on the Past, Working for the Future

– Anders Kreuger

In life nothing disappears without a trace. This is also true of Udmurt shamanism, the peculiar world of tuno. *Many of its elements were transferred to folk songs, dances, rhymes, cumulative recitative songs or tongue twisters, and also to healing rituals (known as* tuno-pelyó *and* pelyasskis*). Still in the late 1960s I could, as an eight-year-old boy, observe a man dancing, with strange body movements, at a celebration for a newborn child (*nuny syuan*). As he danced he stripped off his clothes, crawled on the floor, cried, imitated lovemaking (thus echoing shamanic initiations?) to the mirthful laughter of the others present.*

– Kuchyran Yuri, 'Udmurt Shamanism: My Antiquity and My Modernity', 2001[1]

I know the topic of this essay will appear obscure to some, if not most, of our readers. Nevertheless, I think it should be relevant to a wider auditorium than those who usually follow the cultural politics of the so-called Finno-Ugrian world. Ethno-futurism started as a political joke by an eighteen-year-old poet in the Estonian university town of Tartu, at the twilight of Soviet power. No one expected it to grow into a movement with its own international conferences, festivals and creative workshops, informally headquartered in the Udmurt Republic and still alive after more than 25 years. Moreover, I think we should include the distant cousins of the Estonians and the Finns inside Russia in our discussion about what 'indigeneity' means today. It complicates the concept, since these peoples cannot be categorised either as indigenous 'tribes' or as fully autono-

Anders Kreuger travels to the Finno-Ugrian republics of Russia to explore the past, present and future of the ethno-futurist art movement.

mous 'nations'. (Not wishing to digress into a survey of the tricky terminology used to describe how peoples see themselves or how others see them, I leave the inverted commas hanging.)

In 2005, the curators at the then-new Kumu art museum in Tallinn, the Estonian capital, asked me for project proposals, and high on my list was an exhibition about their faraway kin. The response was one of perplexed dismay. 'Don't you think we had enough of all that *ugri-mugri* [an ironic term not found in any dictionary] in the 1970s? We were forced to go on ethnographic expeditions to those godforsaken places as students back then. And besides, the whole discourse of ethnic solidarity is now considered very nationalist and right wing. No, it's a terrible idea!' I must have misunderstood the Estonians' sense of humour, because I thought the topic was dead, but a couple of years later they got in touch again. 'We have some European funding. When can you go and do your research?' So, in the summer of 2007, I found myself travelling in the Finno-Ugrian republics of Russia, together with a small group of invited artists from Estonia, Lithuania, Finland and Hungary, and in the winter of 2008 an exhibition titled 'The Continental Unconscious: Contemporary Art and the Finno-Ugrian World' opened at Kumu.[2]

Along the way, I made friends amongst the ethno-futurists around the Great Volga Bend, where the Mordvins, the Udmurt and the Mari coexist quite amicably with the Turkic-speaking descendants of the medieval Kazan Khanate (and, of course, with the Russian-speaking majority population), and in the more northern Republic of Komi, which, in the 1920s, dreamt of establishing direct shipping links with Petsamo, the seaport on the Kola Peninsula that belonged to Finland before the war. I included a number of these artists in the exhibition,

1 Kuchyran Yuri (Yuriy Lobanov), 'Udmurtskiy shamanizm: moya arkhaika i moya sovremennost', available at http://www.suri.ee/etnofutu/idnatekst/kutsiran_ru.html (last accessed on 12 February 2017). Also published in Estonian, under the title 'Udmurdi šamanismist', in *Kunst*, no.2, 2001, pp.94–96. Unless otherwise noted, all translations are by the author.

2 'Kontinentaalne alateadvus: Kaasaegne kunst ja Soome-Ugri maailm', 14 March–18 May 2008. A longer version of the catalogue essay for this exhibition was published in the Ghent-based journal *A Prior Magazine*, no.16, 2008, and is still available online at http://www.eurozine.com/the-continental-unconscious/ (last accessed on 12 February 2017).

15.06.94

along with heraldry, book illustrations, tapes from the television archives in the various republics' capitals (Saransk, Izhevsk, Yoshkar-Ola and Syktyvkar) and many other things. Just recently, in the winter of 2017, I returned to the region, to see how my previous collaborators and their ethno-futurist movement had been faring while my attention was focussed elsewhere.

Where Do They Come From? What Are They? Where Are They Going?

Living on the banks of the big Siberian rivers flowing from south to north, these people associated the south, the upper streams of the rivers, with the Upper World, the world of celestial gods, and the north, the lower streams of the rivers, with the Lower World, the world of death and evil spirits.
– Vladimir Napolskikh, 'Earth-Diver Myth (A812) in Northern Eurasia and North America: Twenty Years Later', 2012[3]

Before I address the current situation I feel should situate my protagonists in cultural space-time. I am aware that this perceived necessity is a reverberation of the colonising violence that pushes the subjugated subject out of the field of metropolitan vision and turns her into an object of 'discovery'. That is why I paraphrase Paul Gauguin's title for his large painting of the three stages of life, a panoramic tableau set in French Polynesia, the still-colonial Oceanian archipelago that is, in so many ways, an instructive mirror-image of the Eurasian inland empire to which the Finno-Ugrians are confined.[4]

It is common knowledge that most languages in Europe are related to each other and to languages in India and Iran, and also that Finnish, Estonian and Hungarian are not Indo-European, but few non-linguists would know the other members of the larger language family they belong to. It is named after the not very prominent Ural Mountains in northern Russia, where geographers in the eighteenth and nineteenth centuries decided that continental Europe becomes Asia. Philological convention tells us that this Uralic family tree has two trunks connected at the base, Samoyedic and Finno-Ugric, and one loosely attached thicker branch, Sami.

The Samoyeds (this is a Russian derogatory name meaning 'self-eaters', i.e. cannibals) are divided into four nomadic or semi-nomadic tribes, currently numbering 30,000 altogether and living along the Arctic coast on both sides of the Urals. Of the Ugric languages, three survive. Khanty and Mansi are spoken by just 15,000 people in oil-rich western Siberia. Hungarian, on the other hand, is spoken by almost fifteen million people. Despite some elaborate theories, no one has quite been able to explain how and why this Ugric nation ended up on the Danube and in Transylvania without losing its language. The 85,000 Sami are divided into a number of smaller groups, and they are scattered over the northern parts of Norway, Sweden and Finland, and on Russia's Kola Peninsula. Some researchers think they may have adopted their present languages – which are interrelated but distinct – from their south-eastern neighbours.

The Finnic language group is divided into four subgroups. The three that concern us here – Permic (Udmurt, Komi-Zyryan, Komi-Permyak), Mari (Hill Mari, Meadow Mari) and Mordvin (Erzya, Moksha) – are spoken by around three million people altogether. Baltic Finnic (consisting of Finnish, Karelian, Vepsian, Votian, Estonian, Livonian and a few smaller, intermediate dialects) is the fourth and largest subgroup. Finnish is spoken by some five million and around a million speak Estonian; the other languages have far fewer speakers, and are dwindling. Several Finnic-speaking populations in today's central Russia, notably the Merya and the Muroma, have either gone extinct or become assimilated since the late Middle Ages. Despite this loss of linguistic and cultural identity, or perhaps because of it, they keep resurfacing as 'phantom limbs' in contemporary Russian culture.

The recently forged consensus between linguists and archaeologists is that the speakers of Proto-Uralic must have inhabited the region between the Great Volga Bend and the Ural Mountains sometime around 2000 BCE. When new data from population genetics and paleogenetics are factored in, together with additional linguistic theorising (such as the recon-

3 Available at https://www.academia.edu/4918926/Diving_Bird_Myth_after_20_years_2012? (last accessed on 12 February 2017). Slightly edited by the author.
4 Gauguin's *D'où venons-nous ? Que sommes-nous ? Où allons-nous?* (1897–98) belongs to the Museum of Fine Arts, Boston.

structed link between Uralic and all-but-extinct Yukaghir in eastern Siberia) and the neces-
sarily speculative results of comparative mythology (such as studies of the widely distributed
so-called Earth-Diver Myth[5]) it becomes possible to assume that Proto-Uralic was part of a
much larger constellation of languages and cultures originating several millennia earlier, in
north-eastern China, and including the ancestors of today's Manchu-Tungus peoples (the
elite of the Qing dynasty, who lost power in 1911).

 Pre-revolutionary Russia offered no codified rights for the *inorodtsy* (literally 'those of
alien birth' – ethnic minorities without access to the higher echelons of society), but because
of general underdevelopment they mostly remained settled in rural areas and could there-
fore preserve their own languages and customs. After the revolution, the Bolshevik takeover
and the disastrous civil war, the national minorities became a major preoccupation of the
new rulers. A certain Iosif Vissarionovich Dzhugashvili, better known as Stalin, was People's
Commissar of Nationalities from 1917 until 1923, and thus instrumental for the territorial
reordering of the empire into what eventually became a multitier system of Soviet Socialist
Republics, Autonomous Soviet Socialist Republics and various autonomous provinces and
districts. In the 1920s and early 30s the keyword was *korenizatsiya* (derived from the Rus-
sian word for 'root' but translatable as 'indigenisation'): the promotion of proletarian culture
in the many national languages of the USSR and the creation of new indigenous elites.

 This ended abruptly and lethally with Stalin's great purges, culminating in 1937, which
specifically targeted the new elites. Many peoples of the USSR also shared the fate that befell
the Chechens and the Crimean Tatars in 1944, when their entire populations were deported
to Central Asia. The last four decades of Soviet rule brought some degree of economic devel-
opment – but also steady and thorough Russification – to most parts of the vast country, in-
cluding the Finno-Ugrian ASSRs. In the Mordvin and Komi republics, this process was am-
plified by the many prison camps. (Two members of Pussy Riot famously did time in
Mordovia a few years ago.) Udmurtia was a closed zone, because of the secret military plants
located there. (They are still thriving, not least the factory in Izhevsk that makes Kalashnikov
rifles.) The Mari Autonomous Republic has always been economically backward and poorly

Udmurt participants
in the First Ethno-
Futurist Conference
visiting Udmurt
students in Tartu,
1994. Photograph:
Olga Listratova.
Kuchyran Yuri is
fourth from left in
the back row.
Courtesy Kuchyran
Yuri

5 The Uralic peoples, and many other peoples throughout Eurasia and North America, tell different
 versions of the story of a bird – or some creature capable of diving – who fetches soil from the bottom of
 the primordial sea to fashion the earth. See V. Napolskikh, 'Earth-Diver Myth (A812) in Northern
 Eurasia and North America', *op. cit.*

Yuriy Lisovskiy, *Utka nesushchaya zhizn'* (*Duck Carrying Life*), 2013, marker and ink on paper, 62 × 86 cm. Courtesy the artist

governed, but has also remained culturally more indigenous than the others. (There is, for instance, a lively Mari-language pop music scene.)

To be fair, the USSR did not treat its national minorities as natives on reserves. Literature and scholarship in Finno-Ugrian languages was tolerated and even promoted. Socialist Realism, in all the arts, was supposed to be 'socialist in content, national in form'. In the 1960s and 70s, operas were composed around librettos in Meadow Mari and Udmurt, while the Komi got a 'national ballet'; all these were staged in purpose-built theatres that are still open to the public. Jimmie Durham, after travelling to Yakutia (a vast republic for the mainly Turkic-speaking population of north-eastern Siberia) in the mid-1990s, wrote: 'They have their own Academy of Sciences, but most tolerate also an outpost of the Russian Academy of Sciences. [...] They, as Siberians – so many groups, tribes, cultures, histories – would like to see the continuation of the union of Soviet states. But without Russian dominance. For them the Russians are like the Americans to us: loud, arrogant, infantile and completely destructive.'[6]

Other national minorities, such as the Tatars or various Caucasian peoples, are more visible in Russian public life and have secured more de facto autonomy over their republics than the Finno-Ugrians, who have often opted for an elusive modus vivendi in their relations with the Empire. But not always. The Cheremis wars of the sixteenth century (this was the pre-revolutionary name for the Mari) were just as unforgivingly brutal as the Caucasian wars three hundred years later. Like Grozny in Chechnya, Yoshkar-Ola ('Red City') was built as a fort for putting down indigenous rebellion. Though officially Orthodox, the Mari and the Udmurts (and to a somewhat lesser extent the Mordvins) also preserved many elements of their pre-Christian beliefs and rituals – therefore they are sometimes called 'Europe's last pagans'. But we should note that the open-air communal meals and praying events that take place today reflect a post-Soviet syncretism: a mix of genuine tradition, Russian Orthodox influences, the political neopaganism of the 1990s and New Age.

6 Jimmie Durham, 'Report to Molly Spotted Elk and Josephine Baker', in Anders Kreuger (ed.), *Jimmie Durham: A Matter of Life and Death and Singing* (exh. cat.), Antwerp and Zürich: M HKA / JRP|Ringier, 2012, p.20.

Ethno-Futurism as a Cultural Phenomenon

The number of internet users has grown to c. 45 million and is still only at its starting point.[...]

The net helps Ugrians to preserve the dispersed way of life peculiar to them, without losing contact with the rest of the world. It helps to make use of unseen possibilities for self-expression and association. No nation has a lead of centuries in using the net; it is new in America as well as in Scandinavia and Siberia.

The Ugrians' plan to conquer the world relies on the creative harmony of the ancient turn of mind and contemporary technology.

This is the great hidden opportunity for the Finno-Ugrians.

Ethno-futurism, putting in motion creative powers, is not an ideology but a way to survive as well as a modus vivendi.

– First Ethno-Futurist Manifesto, 1994[7]

The late 1980s and early 90s saw a great wave of activity in the decaying Soviet empire. Many greeted its collapse with optimism, despite the uncertainty and economic distress it brought. It is, I believe, wise to take the dystopian vision of a degrading transition now propagated in Russia (and endorsed by what feels like a majority of the population) with a grain of salt. This was also a very political period, a period of creative and sometimes unrealistic ideas, a period when freedom of expression was real and young people made a difference.

Eesti Kostabi-$elts, the Estonian Kostabi $ociety, was named after the Estonian-American painter Kalev Mark Kostabi, who used to take out full-page ads in *Flash Art* because he had the dollars to pay for them. It was founded in Tartu in 1989 by the five young writers

7 Kauksi Ülle, Andres Heinapuu, Sven Kivisildnik and Maarja Pärl-Lõhmus, 'Etnofuturism: mõtteviis ja
 tulevikuvõimalus?' '(Ethno-Futurism as a Mode of Thinking for an Alternative Future?'), written after
 the First Ethno-Futurist Conference, Estonian National Museum, Tartu, 5-9 May 1994. I have slightly
 edited the translation by Sven-Erik Soosaar available at http://www.suri.ee/etnofutu/efleng.html (last
 accessed on 12 February 2017).

of the Hirohall group: the poets Sven Kivisildnik, Valeria Ränik, Karl Martin Sinijärv (who had come up with the term 'ethno-futurism') and Kauksi Ülle, joined by the novelist Jüri Ehlvest. Like all radical young people in this part of the world at this time, they flirted with neoliberal ideas (a commercial art market seemed like a utopian joke to them), but their lasting contribution to post-Soviet cultural history was the gathering organised to mark the fifth anniversary of their $ociety. True to the tradition of *ugri-mugri*, they invited around a hundred representatives of Finno-Ugrian peoples – including the Udmurts, Komi, Mari, Erzya Mordvins, Karelians, Livonians, Sami and Hungarians, as well as the Setu minority of southern Estonia – to the First Ethno-Futurist Conference in Tartu in 1994.

In the 1990s, some prominent Estonian intellectuals, such as the poet Jaan Kaplinski or the political scientist and politician Rein Taagepera, began to promote ethno-futurism as a suitable ideology for smaller peoples seeking to productively reconcile cultural identity and societal progress. Taagepera, who also wrote on the politics of the Finno-Ugrian minorities in Russia,[8] elaborated the 'ethno-futurist triangle' by adding two neologisms of his own invention: 'cosmofuturism' (progress erases ethnic traditions, and this is a good thing) and 'ethno-praeterism' (the ethnic past is 'pure', and its replacement through new and alien phenomena is a bad thing).[9] There was a will to theorise ethno-futurism by paying homage to the 'ethno-philosophers' who

> *'Ethno-' is the link to the national and the indigenous; 'futurism' is the attempt to find a place and be competitive in the post-modern contemporary world. – Viktor Shibanov*

supposedly prefigured it, such as the Estonian theologian and detractor of 'Standard Average European Thinking', Uku Masing (1909–85), or the Komi-born anti-Kantian inventor of 'Limitism', Kallistrat Zhakov (1866–1926), who finished his days in independent Latvia.[10]

Ethno-futurism was conceived as a future-oriented mode of thinking, so much so that its initial tech-optimism now appears quaint, almost misguided. It should be noted that the term was never meant to reference the futurisms of the early twentieth century, despite attempts back then at applying the programmes of Marinetti or Mayakovsky in the new, smaller eastern European nation states and, to a more limited extent, in the Finno-Ugrian outposts of the USSR. For the exhibition in Tallinn in 2008, for instance, we brought all the contents – and some employees – of a rural museum dedicated to the Udmurt futurist poet and cross-dressing actor Kuzebai Gerd, who stood accused of plotting to dig a 2000-kilometre-long tunnel to Finland and perished in the Gulag in 1932.

The fate of ethno-futurism as a movement in art was, in fact, to be determined by those guests at the conference in Tartu, many of them on their first trip to the 'West'. In a group photograph from that occasion, the young printmaker and graphic designer Yuriy Lobanov from Izhevsk stands out. Still in his early thirties, he had just authored the black-white-red flag and man-bird coat of arms of the Udmurt Republic. (He was not the only artist to make such a contribution to his republic. The Mordovian flag was conceived by the artist Andrey Aleshkin (born in 1959), another early ethno-futurist; Izmail Efimov, yet another member of the movement, was until recently responsible for the heraldry of the republic of Mari El.) As part of his project to revive traditional names, Lobanov had chosen for himself the *vorshud* (protector of the kin) Kuchyran, a reference to the 'Owl Clan'. Adding the Udmurt form of his Russian first name after the clan name, according to the old Finno-Ugrian custom that is still official usage in Hungary, he became Kuchyran Yuri. He also presented friends and associates with such reconstructed names.[11]

Kuchyran Yuri is a free spirit and a spiritual traveller, as anyone who has witnessed his free-form shamanic live performances can testify, but also a skilled and dedicated organiser with a sure instinct for staying out of politics while securing official support for his projects. He has an almost uncanny talent for incorporating new ideas into his own thinking and activities. While the Estonian inventors of ethno-futurism always treated it with some irony,

8 See Rein Taagepera, *The Finno-Ugric Republics and the Russian State*, New York: Routledge, 1999.
9 See Heinapuu Ott and Andres Heinapuu, 'Some Treatments of the Concept of Ethno-Futurism in Estonia', available at http://www.suri.ee/etnofutu/idnatekst/ethno_en.html (last accessed on 12 February 2017).
10 See Kari Sallamaa, 'Uku Masing as the Pioneer of Ethno-Futurism', available at http://www.suri.ee/etnofutu/vanaisad/masing/sall-uku.html (last accessed on 12 February 2017)
11 The sound piece *Kuchyran võtyós (The Dreams of Kuchyran, 2009)*, in which he dives into the dark netherworld and emerges with an array of new *vorshud* names, was released on CD.

he and his Udmurt contemporaries, notably the theatre director Olga Alexandrova and the writers Pyotr Zakharov and Viktor Shibanov, took it seriously. They saw it as plausible cultural policy for the Finno-Ugrian peoples and other ethnic minorities in Russia, and with the Second International Ethno-Futurist Conference in Izhevsk in 1998, they launched a new and longer-lasting wave of ethno-futurism, based on cultural practice rather than political speculation.

Artists, fashion designers, theatre directors and musicians around the Great Volga Bend saw ethno-futurism as a more permissive and experimental alternative to the watered-down versions of Socialist Realism ('capitalist in content, socialist in form') that still today dominate the Russian art scene. Colleagues amongst the Turkic-speaking Chuvash, Tatars and Bashkirs joined their Finno-Ugrian neighbours. Perm, a Russian-speaking city of more than a million inhabitants, has hosted the ethno-futurist festival KAMWA since 2006.

Art historians have also contributed to the movement, notably Elena Butrova from Saransk, specialising in the remarkable Mordvin-born sculptor Stepan Nefedov-Erzia (1876–1959; the work he made in Argentina in the 1920s and 30s deserves an essay of its own in these pages), and Elvira Kolcheva from Yoshkar-Ola. A certain level of academic self-reflection was thus built into 'second-generation' ethno-futurism from the beginning – another reason why we should engage with it critically and not merely affirm it as a manifestation of indigeneity. In her doctoral dissertation, titled 'Ethno-Futurism as a Cultural Phenomenon', Kolcheva summarises the achievements of the Izhevsk crew:

> The main ethno-futurist Finno-Ugrian events were the yearly festivals in Izhevsk in the Udmurt Republic, organised by the informal group Odomaa ('Native Land' in Udmurt). The impulse to form this new creative association was the international ethno-futurist conference held in Izhevsk in 1998. Its members worked in different genres in the different arts. In the core group of Odomaa were Sergey Orlov, Vyacheslav Mikhailov, Zoya Lebedeva and Yuriy Lobanov (Kuchyran Yuri). With support from the Ministry of National Policies of the Udmurt Republic, they started realising their mega-project 'Ethno-Futurist Festival', which brought eleven international ethno-futurist festivals into the world:

> 1. Egit gondyr veme [A House for a Young Bear], June 1998;
> 2. Odomaa [Native Land], July 1998;
> 3. Erumaa [Land of Love], October 1998;
> 4. Kalmez [Fish–Man], March–April 1999;
> 5. Mushomu [Land of Bees], May–July 2000;
> 6. Tangyra [Udmurt Tamtam], April 2001;
> 7. Inda [a legendary hero], May 2002;
> 8. Pel'nyan ['Ear-Bread', a Eurasian ravioli], June 2003;
> 9. Yur-yar [Noisy Gathering], July 2004;
> 10. Artana [Wood Stack], August 2005;
> 11. Kuara-langa [Echo], March 2006.

> The continuation of this mega-project was another grandiose mega-project, 'Ethno-Futurist Symposium', which started with the creative symposium Ser no tur ('Light of Art') in Izhevsk in 2007.[12]

The symposia have continued, in various locations across the Udmurt Republic and elsewhere, almost every year, in both summer and winter, with participants from the region and from further abroad. The consistent use of Udmurt titles reflects the pragmatic linguistic activism of the organisers. Since 2010, these activities have been managed by the Emnoyumno (Divine Elixir) group, a successor of Odomaa, founded by Kuchyran Yuri and his younger colleague Zhon-Zhon Sandyr (Alexander Pushin). It is part of the larger association Izhkar (the Udmurt name for Izhevsk), which comprised of the groups Thanatos (Sergey Orlov and Envil Kasimov) and Belmikhaibat (an acronym combining the surnames of the members Valentin Belykh, Vyacheslav Mikhailov and Viktor Batyrshin).

12 Elvira Kolcheva, Etnofuturizm kak yavlenie kul'tury, monograph based on doctoral thesis, Yoshkar-Ola: Mariyskiy Gosudarstvennyi Universitet, 2008, pp.24–25. See also E. Kolcheva, 'Formation of Ethno-Futurism', Mediterranean Journal of Social Sciences vol. 6, 2015, p.233 (available at /react-text http://www.mcser.org/journal/index.php/mjss/article/view/6867/6572, last accessed on 12 February 2017).

Pavel Mikushev,
Nerest (Spawning),
2016, acrylic on
cardboard, 70 × 90 cm.
Courtesy the artist

The artists behind Emnoyumno chose the ethno-futurist motto 'leaning on the past, working for the future', a quote from the Mexican painter Rufino Tamayo, and used it in two manifestos: one internal, one for external use. It may seem paradoxical that ethno-futurism, which seeks to reinterpret rural traditions for alternative futures, should have its informal headquarters in an industrial, Russian-speaking city of more than 600,000 inhabitants, but as Viktor Shibanov points out, it is 'a bird with two wings': '"Ethno-" is the link to the national and the indigenous; "futurism" is the attempt to find a place and be competitive in the post-modern contemporary world.'[13]

Those I spoke to during my recent trip expressed some concern for the future of ethno-futurism. It appears to be having trouble renewing itself and recruiting new practitioners. Most artists who identify with the movement are now in their fifties. It may be difficult to sustain it as the cultural climate in Russia changes. Yet on 13 January 2017, I attended a screening of the works produced during Zhon-zhon Uddyadi, the Fifth International Ethno-Futurist Symposium for Performance and Video Art that had taken place in the village of Uddyadi (officially named Karamas-Pelgin) the week before. These short and unassuming performance-based videos are deliberately and liberatingly simple. I found them both formally subtle and dryly entertaining. Some of the authors, such as the Udmurt artist Chimali (Ksenia Voronchikhina), are in their mid-twenties.

Visual artists and other cultural practitioners who live and work outside of Moscow and St Petersburg do not address their fellow citizens from a position of strength unless they choose to become politically active in the ruling party. There are examples of that in Izhevsk, notably the painter Envil Kasimov (who is now in charge of public security in the Udmurt Republic) but also the accomplished folk-jazz singer Nadezhda Utkina. Even those who do their best not to be too outspoken may come under political fire. In 2016, a certain Igumen Vitaliy, signing as 'Cleric of the Ivanovo-Voznesensky Diocese', published an ominously titled article on the right-wing nationalist site *Russkaya Narodnaya Liniya* (The Russian National Line). 'Ethno-Futurism and Separatism' argues that the ethno-futurists' quest for a new Finno-Ugrian identity, especially when associated with neopaganism and when situating itself 'out-

13 Conversation with the author at the Udmurtia publishing house in Izhevsk, 12 January 2017.

Post-Vogue,
Mimikriya, Misteriya
Chudi (Mimicry,
Mystery of the Chud'),
2003, performance at
the Pel'nyan ethno-
futurist festival.
Photograph: Natalya
Shostina. Courtesy
Kuchyran Yuri

side every connection with the history of the Russian people and of Russian statehood', is to be equated with other tendencies aimed at 'breaking up the Russian Federation', such as the promotion of a specifically Siberian identity.

The writer takes special offence at what we might call 'third-generation' ethno-futurism, namely the attempts to reconstruct a 'Meryan' Finno-Ugrian identity for the central regions of European Russia, championed by a small group of media artists and local-history activists contributing to the website merjamaa.ru. The group centres on the artist and graphic designer Andrey Malyshev-Meryanin, who used to live in Moscow but has now moved to Minsk. Meryan ethno-futurism appears to be a mainly urban phenomenon, driven by nostalgia for the rural childhood of parents and grandparents. It has found a mainstream outlet in the feel-good films of Alexei Fedorchenko, a director based in Ekaterinburg.[14] Overreacting to an exhibition by Malyshev-Meryanin in the city of Ivanovo in 2014, Igumen Vitaliy wrote: 'It is fully possible that we will see a time when, in Central Russia, from Moscow to Nizhniy Novgorod, everyone can be forced to speak a "Meryan" language. [He used the word mova, which means 'language' in Ukrainian.] And this will be taught at school as the national language. We find contemporary examples of such things rather close to us, in the historical as well as the geographical sense.'[15]

Critical Ethno-Futurism and Protuberances of Cosmic Love

1. Ethno-futurism is not a style, but a direction of movement and an ideology.

2. Artistic creation is a departure from mediocrity and a 'serious game' with symbols, archetypes and mythological elements of national culture. It therefore gives them new meaning in the light of the contemporary. It is the sacred art of light, with positive and pure energy.

3. The possibility for national cultures and universal human values to coexist and enrich each other.

4. Enliven the world with the help of the deep unconscious, to make society more human, subtle and receptive.

5. Spiritual mutual assistance, as an instrument for brighter manifestations of individuality.

– Kuchyran Yuri, Sergey Orlov and Zhon-Zhon Sandyr, 'Ethno-Futurism: Theses for a Manifesto, 2011[16]

This 'institutional' recapitulation of ethno-futurism should not be regarded as exhaustive or even comprehensive. When introducing regional art histories to international audiences we are rarely at liberty to present a fully argued account. We tend to synthesise the facts and offer only the enticing details. As we move on to discuss the works of individual artists, we should reinsert some of the nuance that had to be forsaken in the overall narrative. We should not renounce our critical faculties just because we want to give people credit for being part of a movement. We should also acknowledge that any act of situating beginnings and origins in space and time, and identifying them with concrete deeds by concrete people, is inevitably subjective. It is to do with how things are remembered and by whom, but also, on a deeper level, with becomings and transformations, which can almost never be retraced and retold in linear fashion.

The shift in outlook and ambition amongst some artists and writers in the Finno-Ugrian republics had already happened before they joined their European kin at the First Ethno-Futurist Conference in Tartu. Otherwise they would not have gone there. During the last years of the USSR, there was renewed interest in national languages and cultures all over the country,

14 Notably *Ovsyanki* (the title translates to 'oatmeal', though the English-language version was released as *Silent Souls*), an explicitly 'Meryan' film nominated in 2010 for the Golden Lion at the 67th Venice Film Festival, and *Olyk Mariy-vlakyn kavase vatysht / Nebesnye zhёny lugovykh Mari (Celestial Brides of the Meadow Mari*, illustrated book with DVD. Ekaterinburg: Uralskiy rabochiy, 2013).

15 Igumen Vitaliy, 'Etnofuturizm i separatizm', *Russkaya Nardodnaya Liniya*, 8 February 2016, available at http://ruskline.ru/monitoring_smi/2016/02/08/etnofuturizm_i_separatizm (last accessed on 12 February 2017).

16 This is the 'external manifesto'. Document provided to the author.

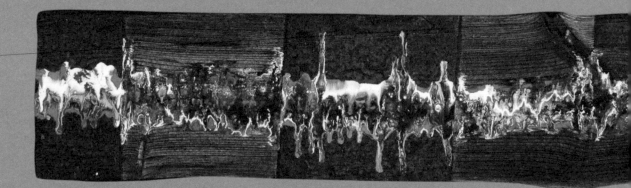

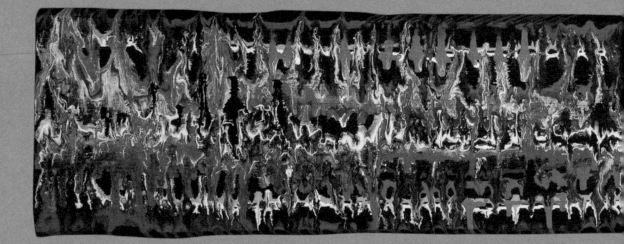

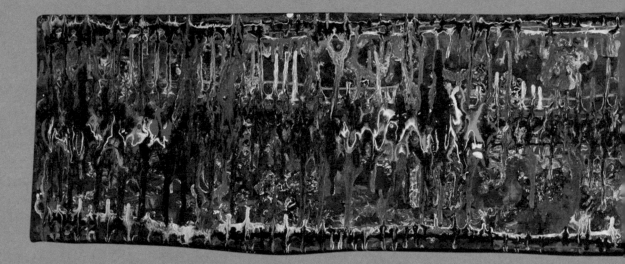

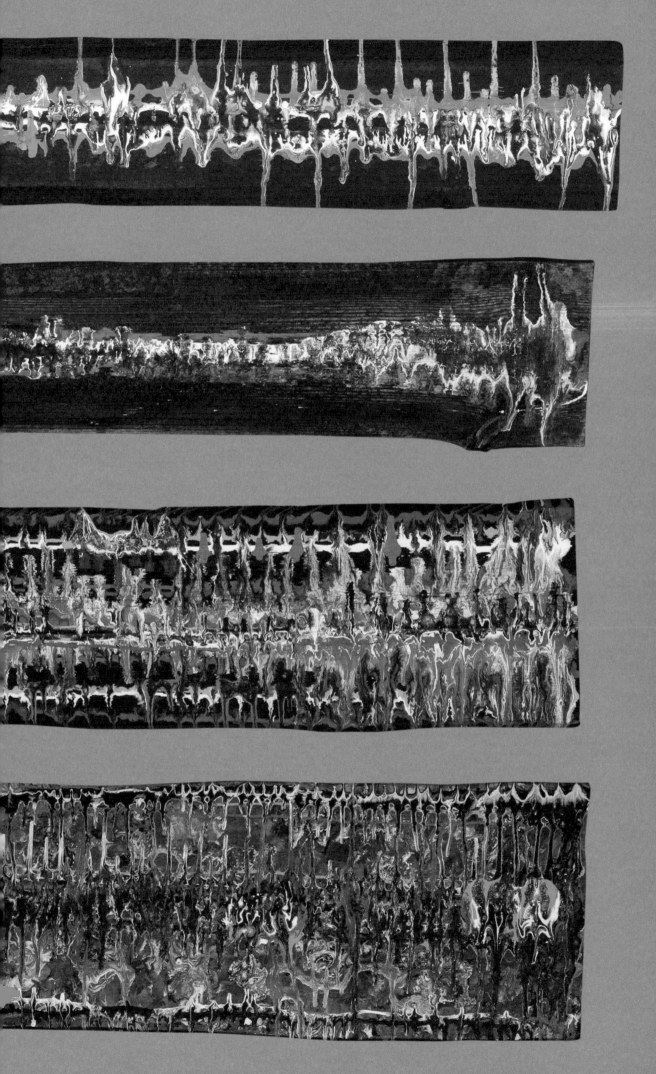

also amongst the Finno-Ugrians. People had become less fearful. There was a new openness to experimental, 'non-conformist' culture. When the first meeting of Finno-Ugrian writers in Russia took place in Yoshkar-Ola in 1989, the Youth Association of the Finno-Ugrian Peoples (commonly abbreviated to MAFUN) was founded as a result; when it convened again in 1990, an exhibition of young Finno-Ugrian artists was organised, offering a new generation of painters an opportunity to show works that deviated, if only a little, from the norms and methods of Socialist Realism. It was the first independently organised exhibition in the USSR with an explicitly Finno-Ugrian theme. There was another MAFUN exhibition in Izhevsk in 1993, and the First International Exhibition of Finno-Ugrian Artists took place in Syktyvkar in 1994. Participants have told me that it was more professionally installed than the exhibition accompanying the conference in Tartu that same year, but also that a television programme criticised the artists – already then – for flirting with neopaganism.

Clearly, some kind of movement existed before the term 'ethno-futurism' was adopted. What persuaded artists, mostly painters and printmakers, in the Finno-Ugrian republics to let go of the ideological restraints of Socialist Realism, and of the comforting self-identification with approved knowledge and professional standards that it offered? What encouraged them to embark on experiments with form and content for which no guidance was available? We should remember that these people, on the 'periphery of the periphery', had almost no access to modern or contemporary art. They were cut off from the Russian avant-garde of the 1910s and 20s due to the dogmatic education they received, and also from the international art world, because of a general lack of resources and poor language skills. In Russia's largest cities at the time, contemporary art was, I would argue, seen less as a path towards radically new self-understanding and more as a foreign arena to be conquered as fast as possible – if necessary with spectacular displays of 'Eurasian barbarity'.[17]

Even if the artists in Syktyvkar or Izhevsk or Yoshkar-Ola or Saransk could have had more access to Moscow and St Petersburg in the early 1990s, it might not have helped them much. Instead, to find a way forward they turned inward and backward: to individual memories of village life (Kuchyran Yuri says that growing up in rural Udmurtia in the Soviet 1960s and 70s was like 'living in a fairy-tale'[18]) and to collective memories of a more distant past, coded into ethnographic or archaeological artefacts. Perhaps taking cues from printmakers and illustrators in Estonia and the other Baltic republics, whose work was respected throughout the USSR, these Finno-Ugrian artists engaged with densely coded visual systems regarded as unambiguously 'national'. They were attracted by traditional embroideries in red wool on white linen, and, above all, by the zoomorphic or anthropomorphic bronze figurines in the Permian animal style (c.800 BCE–1200 AD), attributed to the ancestors of today's Udmurts and Komi.

The Syktyvkar cultural scene should probably be characterised as low intensity. Amongst the main local references are Wassily Kandinsky's seminal stay in the remote northern city (then called Ust-Sysolsk) in 1889, and the fact that Komi-Zyryan was one of the first Finno-Ugrian languages to yield written documents, in a special alphabet created by Russian Orthodox missionaries in the fourteenth century. Again we see the past holding more attraction than the present or the future. How can artists challenge this mindset?

The city's ethno-futurist art scene essentially consists of two painters: Yuriy Lisovskiy (born in 1964) and Pavel Mikushev (born in 1962), who both graduated from the city's art college in 1990. Since the early 1990s they have been fine-tuning their distinctive personal idioms, reconciling the nonlinear narrative structure of Finno-Ugrian mythology and the linear economy of the Permian animal style. Mikushev's paintings of bears, elks, fish, waterfowl and other beings that may be either natural or supernatural are painstakingly finished, like preciously filigreed art deco objects. They are endless variations on given themes. Lisovskiy, who works mostly in black ink on paper, prefers to depict the transformative interaction across the three 'levels of the world' in Finno-Ugrian tradition: the netherworld (water), the surface world (earth) and the upper world (sky). He commands a self-consciously inclusive aesthetic that borders on the illustrative and the decorative (and therefore perhaps betrays his western Ukrainian origins). To this he has added a pedagogical practice that amounts to 'delegated performance' of his own visual programme and encourages people from all walks of life, but mostly children, to express themselves. 'My technique allows everyone to draw

17 Oleg Kulik's and Alexander Bremer's performances of the 1990s, with their carefully calibrated destructivity, come to mind.
18 Conversation with the author, 11 January 2017.

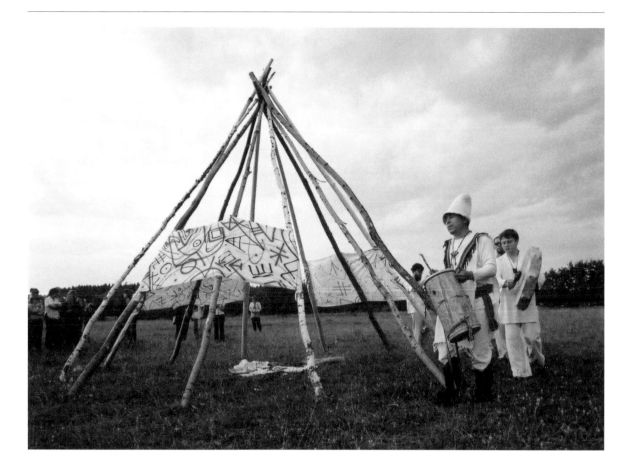

without complexes. Proportion, for instance, is not important, nor is perspective.'[19] Both Mikushev and Lisovskiy suspect that ethno-futurism may have run its course as a movement in art, but they believe that its ethos will remain relevant as young professionals, also in Russia, are increasingly choosing to live and work in rural areas with sufficient internet access.

The perhaps most original and innovative ethno-futurist painter is Izmail Efimov, in Yoshkar-Ola. He is also the most senior – in terms of age (he was born the Hill Mari region of the Mari ASSR in 1946), education (he graduated from the prestigious Surikov State Art Institute in Moscow in 1977) and social status (he chaired the Mari section of the Soviet/Russian Artists' Union from 1987–89 and 1992–94, and was named Distinguished Artist of the Russian Federation in 2006). This makes his transition in the late 1980s and early 90s even more remarkable. He went from being a successful Socialist Realist – using its repository of conventional forms for conveying an artfully simple vision of rural life – to developing a singular syncretic mix of figuration and ornamentation, of free fabulation and semiotic precision informed by his firm grasp of both traditional applied art and contemporary heraldry. Interestingly, he has continued to refine both aspects (or 'wings') of his practice, allowing his ethno-futurist experiments to contaminate the grand 'realistic' compositions that he still produces, and vice versa. Efimov's synthesis of abstraction, animism and *bande dessinée* fantasy in series of watercolours such as *Ethno-Structures* or *Arche-Graphics* (c.1989–95) does indeed, as Elvira Kolcheva points out, evoke 'a performance on paper'.[20] His ethno-futurist compositions sit, self-assuredly but nonetheless awkwardly, somewhere between the abstract and the magical. Studded with infra- or supra-human 'eyes', they can, at any moment, turn into ambiguous, two-dimensional spirits that, on balance, come across as teasingly malicious. Should we dub Efimov a 'critical' ethno-futurist for his implicit refusal to illustrate a New Age-inspired, ultimately apolitical vision of spiritual positivity?

Kolcheva applies phenomenological methods of analysis to ethno-futurist art (with particular focus on the Mari painters, whom she characterises as 'lone wolfs') and relies on Carl Jung's notion of archetypes as indications of a collective, transpersonal unconscious.[21] This is how she summarises the fundamental characteristics of ethno-futurist art: 'Heightened

19 Conversation with the author, 6 January 2017.
20 E. Kolcheva, *Reki vselennoy: Neomifologizm v tvorchestve mariyskikh khudozhnikov*, Yoshkar-Ola: Mariyskoe knizhnoe izdatel'stvo, 2010, p.21.

attention to the author's own voice in the form of mythopoetic creation; a tendency towards syncretism between the various categories of artistic activity; a tendency towards blurring the boundaries between the actual and the virtual; a conflation of artistic and ritual acts.'[22]

In Izhevsk, too, there were future-oriented stirrings before the ethno-futuristic mega-projects. The Udmurt painter Sergey Orlov (born 1957) graduated from the Surikov Institute ten years after Efimov, in 1987. That same year, he and a few contemporaries organised the first presentation of avant-garde art in Izhevsk, in the city's opera house: paintings, prints, installations and sculptures by artists from Izhevsk, Kazan and Moscow. The group called itself Lodka (The Boat); its other members were Pavel Aksenov, Mikhail Basov, Viktor Chuvashov and Envil Kasimov. They organised another exhibition in 1988, but after a few years the group reorganised itself as Thanatos. Orlov himself went on to become a prolific painter (and much-appreciated pedagogue). He trawls the occult for insights that he can exploit for precise but ultimately ungovernable visual effects, as in the series of paintings with runny printing ink on cardboard featured in 'The Continental Unconscious' at Kumu in Tallinn in 2008, or in his recent series of vivid, untitled 'plank paintings', in acrylic on salvaged wood, where control and chance have become indistinguishable.

Kuchyran Yuri's neo-shamanic performances – or 'therapeutic happenings', as he sometimes calls them – are in many ways emblematic of ethno-futurism as a 'direction of movement and ideology' for the Finno-Ugrian world. They are distinctly and programmatically intuitive, emotional, infra-intellectual. And just like the whole complex of ethno-futurist

21 Incidentally, Soviet scholars used to quote Jung rather freely but tended to avoid Freud, perhaps because of the former's emphasis on the 'collective', or perhaps because of the latter's explicitly sexual metaphors.

Andrey Aleshkin,
Iz kruga zhizni (*From the Circle of Life*), 2002, encaustic on canvas, 58 × 56 cm. Courtesy the artist

thought and action, in all its specificity and vagueness, they embody the difficulties observers like myself face when we take it upon ourselves to insert a little-known phenomenon into the problematic context of contextualisation and problematisation.

It is certainly possible to critique Kuchyran Yuri's practice from an aesthetic and curatorial point of view, and I have often done so in discussions with him. Is it really such a good idea to use those funny-looking props? I understand the drum and the little bell, they are sonic implements that facilitate spiritual travelling for you and those around you, but the phallic, white felt-wool hat, is it strictly speaking necessary for the transcendental experience or is it rather a piece of 'identity art'? You write about 'the irrepressible urge of the artist to share the shock of what he saw on his journey to the trans-liminal',[23] but did your theatrical solo performance *Oti-tati, otsi-tatsi* (*Here and There, This and That*, 2002) really need the expressive black-and-white painted backdrops? You tell me that art should be about emitting 'protuberances of cosmic love', but would the sensation that *this is really happening* not be stronger if you were wearing your everyday jeans and sweaters, or at least plain, white-linen shirts and trousers, like the musicians in your multimedia performance *Pelyó-pelyó* (*The All-Seeing Ear and the All-Hearing Eye*, 2005)?

It should already be clear that I cannot claim the role of the *outside* observer in relation to the artists and art historians of the ethno-futurist movement. I already know them too well to want to exoticise them, which might be a good thing. But perhaps I am therefore at risk of lowering my critical standards, out of sympathy with the marginalised lives they and their peoples lead, which would almost certainly be a bad thing. Yes, ethno-futurism is a curious blend of the obscure and the lucid, the irreparably provincial and the potentially universal. It is, by its very nature, out of context – if by that we mean the context in which *Afterall* is produced and consumed. It sometimes falls into the trap of exoticising and marginalising itself. Why, for instance, have the creative symposia been going on for a decade, with collective performances being staged in remote rural locations, without anyone asking about possible parallels to the group Kollektivnye deystviya (Collective Actions), masterminded by Andrei Monastyrski in the fields and villages around Moscow in the late 1970s (and featured in the Russian pavilion at the Venice Biennale in 2011)?

Yet perhaps these professional qualms are somehow beside the point. I must concede that ethno-futurism is at its best when it defies all attempts at categorisation or interpretation and succeeds in conveying just mental energy and physical presence. There is a video by the Emnoyumno group, shot on a smartphone and only a little bit longer than six minutes, titled *Bur na! Syödmurcha shur!* (*Hello! Spirit of Syödmurcha River!*, 2014).[24] We see the hands of the participants in the action, breaking the thin viscous ice over a dark river at night – reaching into the hole and greeting the water in six individual ways. We hear Kuchyran Yuri's bell and the sounds that the people and the river make together; that is all.

22 E. Kolcheva, *Etnofuturizm kak yavlenie kul'tury*, op. cit., p.70.
23 Kuchyran Yuri, Sergey Orlov and Zhon-Zhon Sandyr, *Ethno-Futurism: Theses for Internal Manifesto*, 2011, document provided to the author.
24 Available at https://www.youtube.com/watch?v=xtXxhpkxyck (last accessed on 12 February 2017).

Contributors

Hannah Black

Hannah Black is a writer and artist. Her work in video and installation has been shown at Arcadia Missa, London; Chateau Shatto, Los Angeles; and Bodega, New York. Her solo show 'Small Room' opens at mumok, Vienna in March 2017. Black's writing has previously appeared in publications including *Artforum* and *Harper's*, and her book *Dark Pool Party* was published in 2016.

Chimurenga

Chimurenga is a project-based mutable object: a print magazine, a publisher, a broadcaster, a workspace, a platform for editorial and curatorial activities and an online resource.

Ntone Edjabe

Ntone Edjabe is the founder and editor of Chimurenga and its siblings, including the *Chronic* and Pan African Space Station (PASS).

Irmgard Emmelhainz

Irmgard Emmelhainz is an independent translator, writer and researcher based in Mexico City. In 2016, she published *La tiranía del sentido común: la reconversión neoliberal de México*. Her work about film, the Palestine question, art, culture and neoliberalism has been translated into Chinese, German, Italian, Norwegian, French, English, Arabic, Turkish, Hebrew and Serbian. She has presented it at an array of international venues including the Harvard Graduate School of Design in Cambridge, Massachusetts; the March Meeting at Sharjah Art Foundation; and, in New York, the New School and the Americas Society. She is a member of the editorial board of the journal *Scapegoat*, and has a book forthcoming on Jean-Luc Godard's political film-making and her Palestine chronicles.

Kodwo Eshun

Kodwo Eshun is lecturer in contemporary art theory at Goldsmiths, University of London; visiting professor at Haut ecole d'art et design – Genève; and co-founder of The Otolith Group. He is the author of *More Brilliant than the Sun: Adventures in Sonic Fiction* (1998) and *Dan Graham: Rock My Religion* (2012, in the Afterall One Work series), and a co-editor of *Post Punk Then and Now* (2016), the *Third Text* issue 'The Militant Image: A Ciné-Geography' (vol.25, no.108, 2011), *Harun Farocki: Against What? Against Whom* (2010) and *The Ghosts of Songs: The Film Art of the Black Audio Film Collective, 1982-1998* (2007).

Avery F. Gordon

Avery F. Gordon is professor of sociology at the University of California, Santa Barbara. Her most recent books are *The Workhouse (The Breitenau Room)* (co-authored with Ines Schaber, 2014), *Keeping Good Time: Reflections on Knowledge, Power, and People* (2004), *Ghostly Matters: Haunting and the Sociological Imagination* (1997) and *The Hawthorn Archive: Letters from the Utopian Margins* (forthcoming).

Anders Kreuger

Anders Kreuger is senior curator at M HKA in Antwerp and one of the editors of Afterall. He was previously director of the Malmö Art Academy; exhibitions curator at Lunds konsthall, in his native Sweden; and a member of the programme team for the European Kunsthalle in Cologne.

Pablo Lafuente

Pablo Lafuente is a writer and curator based in São Paulo and Porto Seguro, Brazil. He was a co-curator of the 31st Bienal de São Paulo (2014) and the curator of 'A Singular Form' (2014) at Secession, Vienna. He is currently organising the long-term project Zarigüeya/Alabado Contemporáneo at the Museo de Arte Precolombino Casa del Alabado in Quito, Ecuador and is part of the ongoing research group Museal Episode, organised by the Goethe-Institut Latin America. He is one of the founding editors of the Afterall *Exhibition Histories* book series.

Lucy R. Lippard

Lucy R. Lippard is a writer, activist and sometime curator. Since 1966, she has published 23 books on contemporary art and cultural studies, most recently *Undermining: A Wild Ride Through Land Use, Politics, and Art in the Changing West* (2014). Lippard has curated more than fifty exhibitions and co-founded various artists groups, including the Ad Hoc Women Artists' Committee, Heresies, Printed Matter and Political Art Documentation and Distribution (PAD/D). She lives in Galisteo, New Mexico.

Lee Maracle

Lee Maracle is the author of a number of critically acclaimed literary works, amongst them *Bobbi Lee: Indian Rebel* (1990), *Ravensong* (1993), *I Am Woman: A Native Perspective on Sociology and Feminism* (1998), *Bent Box* (2000), *Daughters Are Forever* (2002) and *Will's Garden* (2002), and a co-editor of a number of anthologies, including the award-winning publication *My Home As I Remember* (2000). She is widely published in anthologies and scholarly journals internationally and is a member of the Stó:lō Nation.

Lee-Ann Martin

Lee-Ann Martin is one of the most senior contemporary Indigenous curators in Canada, having curated and written extensively for the past thirty years. She is the former curator of contemporary Canadian Aboriginal art at the Canadian Museum of History, Gatineau, Quebec and the former head curator of the MacKenzie Art Gallery in Regina, Saskatchewan. A small selection of Martin's curatorial projects includes: the international exhibition 'Close Encounters: The Next 500 Years' (Plug In Institute of Contemporary Art, Winnipeg, Manitoba, 2011); the nationally touring exhibitions 'Bob Boyer: His Life's

Work' (MacKenzie Art Gallery, 2008), 'Au fil de mes Jours (In My Lifetime)' (Musée national des beaux-arts du Québec, 2005), 'The Powwow: An Art History' (MacKenzie Art Gallery, 2000), 'EXPOSED: The Aesthetics of Aboriginal Art' (MacKenzie Art Gallery, 1999) and 'Alex Janvier: His First Thirty Years, 1960-1990' (Thunder Bay Art Gallery, 1993); and the internationally touring exhibition 'INDIGENA: Perspectives of Indigenous Peoples on 500 Years' (Canadian Museum of Civilization, Gatineau, 1992).

Walter D. Mignolo
Walter D. Mignolo is William H. Wannamaker Professor and Director of the Center for Global Studies and the Humanities at Duke University in Durham, North Carolina. He is an associated researcher at the Universidad Andina Simón Bolívar in Quito, Ecuador and an honorary research associate for the Center for Indian Studies in South Africa (CISA) at the University of the Witwatersrand in Johannesburg. He is a senior advisor of the Dialogue of Civilizations (DOC) Research Institute, based in Berlin, and received a Doctor Honoris Causa Degree from the Universidad de Buenos Aires.

Emily Pethick
Emily Pethick is, since 2008, director of The Showroom, London. From 2005-08, she was director of Casco - Office for Art, Design and Theory, Utrecht, the Netherlands; and from 2003-04, curator at Cubitt, London.

Griselda Pollock
Griselda Pollock is professor of social and critical histories of art and director of the Centre for Cultural Analysis, Theory and History at the University of Leeds. In her many books, articles and exhibitions, she has addressed the challenges of international, postcolonial and queer feminist creative and theoretical work for transformation.

Michelle Sommer
Michelle Sommer is an architect, a researcher and a curator in the visual arts. She completed her PhD in history, theory and criticism in 2016, with a focus on exhibition studies. She is currently a faculty member at the Escola de Artes Visuais do Parque Lage and a post-doctoral researcher at the Universidade Federal do Rio de Janeiro.

Stavros Stavrides
Stavros Stavrides is an architect and activist. He is associate professor at the School of Architecture, National Technical University of Athens, Greece. He has published numerous articles on spatial theory, and his most recent book is *Common Space: The City as Commons* (2016). Forms of emancipating spatial practices and possible architectures of communing are the focus of his current research.

Zoe Todd
Zoe Todd (Métis) is from *amiskwaciwâskahikan* (Edmonton) in the Treaty Six Territory in Alberta, Canada. She writes about indigeneity, art, architecture and decolonisation in urban contexts. She also studies Métis legal traditions, human-animal relations, colonialism and environmental change in north-western Canada.

Cédric Vincent
Cédric Vincent is an anthropologist and a researcher at the Centre Anthropology of Writing based at the École des hautes études en sciences sociales in Paris. He is a co-director of the PANAFEST Archive, a multidisciplinary research endeavour addressing Pan-African arts and culture festivals of the 1960s and 70s; it was featured in the exhibition 'Dakar 66: Chronicles of a Pan-African Festival' (Musée du quai Branly - Jacques Chirac, Paris, 2016). He is professor of art theory at the high school of art and design in Toulon.

Haegue Yang, *Sonic Egg with Enthralling Tetrad – Brass Crater*, 2016, courtesy the artist

Wherever the Wind Carries
20 May – 17 September 2017

Rosa Barba
Charif Benhelima
Matthew Buckingham
Jimmie Durham
Maj Hasager
Olav Christopher Jenssen
Mary Kelly
Joachim Koester
Matts Leiderstam
Sharon Lockhart
Lars Nilsson
João Penalva
Nina Roos
Jim Shaw
Sophie Tottie
Emily Wardill
Haegue Yang

Lundskonsthall

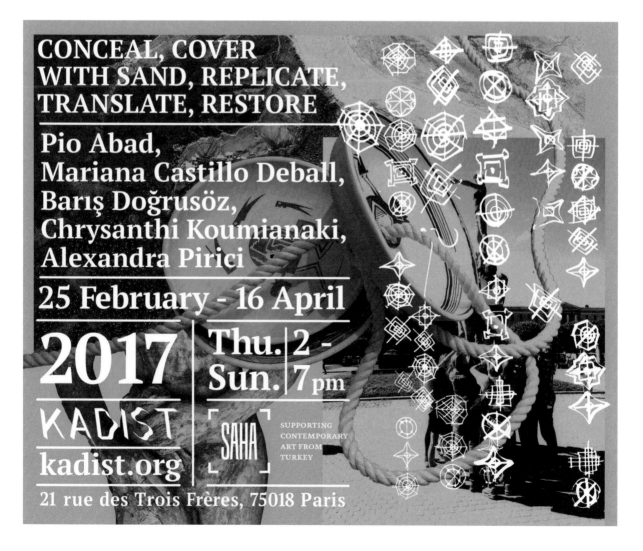

CONCEAL, COVER
WITH SAND, REPLICATE,
TRANSLATE, RESTORE

Pio Abad,
Mariana Castillo Deball,
Barış Doğrusöz,
Chrysanthi Koumianaki,
Alexandra Pirici

25 February – 16 April

2017 Thu. 2 – Sun. 7 pm

KADIST
kadist.org

SAHA
SUPPORTING
CONTEMPORARY
ART FROM
TURKEY

21 rue des Trois Frères, 75018 Paris

belmacz

THE NAME BELMACZ
WAS CONCEIVED BY
JULIA MUGGENBURG
SENSE OF EMPOWER
MENT SENSE OF SE
LF, STRIVE TO HA
VE A TALISMATIC
QUALITY AND IM
PART A TANGIBLE
SENSE OF JOY

45 DAVIES STR. LONDON

belmacz.com

Chausseestraße 128/129 — 10115 Berlin — nbk@nbk.org — www.nbk.org

n.b.k.

Hours and Hours of Inactivity
March 4 – April 30, 2017

Bani Abidi
March 7 – April 30, 2017

Über Leben – Biopolitische Perspektiven in Wissenschaft und Kunst
Conference **May 13, 2017**

With Ute Meta Bauer, Hartmut Böhme, Frank Fehrenbach, Inge Hinterwaldner, Peter Schiering, Georg Toepfer, Janina Wellmann a. o.

Conditions of Political Choreography
June 17 – July 16, 2017 Opening: Friday, June 16, 7 pm

Alexandra Pirici
August 12 – August 18, 2017 Opening: Friday, August 11, 7 pm

LOTTO STIFTUNG BERLIN

The Neuer Berliner Kunstverein is funded by the LOTTO-Stiftung Berlin.

SCHERING STIFTUNG

The conference *Über Leben* is supported by the Schering Foundation

neuer.berliner.kunstverein.e.V.

2 OR 3 TIGERS

EXHIBITION
APRIL 24 – JULY 3

CURATED BY
ANSELM FRANKE
AND HYUNJIN KIM

HKW

hkw.de Haus der Kulturen der Welt

Maps and Dreams:
Jack Askoty, Brittney and
Richelle Bear Hat, Jennifer
Bowes, Brenda Draney, Emilie
Mattson, Karl Mattson, Garry
Oker, Peter von Tiesenhausen
JUN 1 – JUL 29 2017
Audain Gallery

Research, Collections,
Publications, Projects, Talks
2017 – 2019
SFU Gallery

We Call
Cathy Busby:
Ongoing until APR 29 2018
Teck Gallery

AUDAIN GALLERY
SFU Goldcorp
Centre for the Arts
149 West Hastings Street
Vancouver BC, V6B 1H4

SFU GALLERY
SFU Burnaby Campus
Academic Quadrangle 3004
8888 University Drive
Burnaby BC, V5A 1S6

TECK GALLERY
SFU Harbour Centre
515 West Hastings Street
Vancouver BC, V6B 5K3

sfugalleries.ca

SFU GALLERIES

UNIDEE
UNIVERSITY OF IDEAS

UNIDEE – University of Ideas is an higher educational programme based on weekly residential modules investigating the relationship among art, public sphere and activism, by combining critical theory with practice. Through residential dynamics, **UNIDEE** is designed to form **artivators**, people who intend to use art as a methodology, practice and language, becoming agents for the activation of responsible actions and processes in the territories in which they live and carry out their professional activities. Into its third year, the 2017 programme is based on a close examination of three more macro-themes: **Revolution**, **Desire** and **Mediation**.

cittadellarte
FONDAZIONE PISTOLETTO
VIA SERRALUNGA 27 - 13900 BIELLA - ITALY

DEADLINES FOR SPRING&SUMMER TERM
apply online at www.cittadellarte.it/unidee

FOR INFORMATION ON THE PROGRAMME AND SCHOLARSHIPS:
unidee@cittadellarte.it

24th / 28th April, 2017

Errasmus Mundus.
The Desire of Error in
Revolutionary Times
MENTORS: **Etcetera**
(Federico Zukerfeld &
Loreto Garin Guzman)
GUEST:
Franco "Bifo" Berardi
DEADLINE: 07.04.2017

8th / 12th May, 2017

Proposal for Schizo-
analytical Seminar II:
Title Forthcoming
MENTORS:
Ayreen Anastas
and Rene Gabri
GUEST:
Carla Bottiglieri
DEADLINE: 21.04.2017

15th / 19th May, 2017

LudoCity. Designing
a site specific game
MENTORS:
Riccardo Fassone and
Juan Sandoval
(el puente_lab)
GUEST:
Gabriele Ferri
DEADLINE: 28.04.2017

5th / 9th June, 2017

Touch,
Don't Dominate
MENTOR:
Diego
Del Pozo Barriuso
GUEST:
Julia Morandeira
Arrizabalaga
DEADLINE: 19.05.2017

26th June / 3rd July, 2017

Expanded body.
An immersive explora-
tion of the Oasi Zegna
MENTORS:
Andrea Caretto |
Raffaella Spagna
SELECTION VIA OPEN CALL

10th / 14th July, 2017

The Revolution
of the Gaze.
Inside the Visible,
to grasp the Invisible
MENTORS:
Gianluca and
Massimiliano De Serio
GUEST:
Luigi Fassi
DEADLINE: 23.06.2017

17th / 21st July, 2017

The Dance of Attention.
What happens as soon
as we press 'record'
on a device
MENTORS:
Attila Faravelli
and Enrico Malatesta
GUEST:
Adam Asnan
DEADLINE: 30.06.2017

FALL TERM

will be mentored by:
Aria Spinelli (for a three weeks module co-funded by the *Creative Europe* Programme of the UE);
Adrian Paci with **Zef Paci** and **Leonardo Caffo**;
Assemble
(John Bingham-Hall
and **Amica Dall)**
with **Efrosini Protopapa**;
Rick Lowe
with **Elpida Rikou**

UNIDEE – University of Ideas is made possible thanks to the support of Piedmont Region, Compagnia di San Paolo, *Creative Europe*, Fondazione Zegna, illycaffè S.p.A.
Production Residency Collaborations & Scholarships: RESÒ Network, Qattan A. M. Foundation (Palestine), Inlaks Shivdasani Foundation (India).
Institutional Collaborations & Scholarships: ZKM Zentrum für Kunst und Medientechnologie Karlsruhe (D); *kim?* Contemporary Art Centre, Rīga (LV); Minister of Culture of the Republic of Albania (AL); Jyvaskylan Yliopisto, Jyväskylä (FIN); Austrian Culture Forum Moscow (RUS); École cantonale d'art du Valais – ECAV, Sierre (CH); Fundación Universitaria Bellas Artes, Medellín (CO); Instituto Superior de Arte-ISA, La Habana (CU); École supérieure d'art et design – ESAD, Grenoble (FR); Università degli Studi di Torino (IT); Università IUAV, Venice (IT); Accademia di Belle Arti di Brera, Milan (IT); Accademia di Belle Arti di Roma (IT); Accademia di Belle Arti di Firenze (IT); ISIA-Istituto Superiore per le Industrie Artistiche di Faenza (IT); IULM-Istituto Universitario di Lingue Moderne, Milan (IT); SACI Studio Art Centers International, Florence (IT); Fondazione Bevilacqua La Masa, Venice (IT); Queens Museum, New York (US); Center for Fine Arts (Bozar), Brussels (B); Galeria Sztuki Wspolczesnej Bunkier Sztuki, Kraków (PL); HYDRO, Biella (IT).

unidee@cittadellarte.it | **www.cittadellarte.it/unidee** | 🐦 @Unidee2017 | 📷 @UNIDEE2017
f **Unidee University of Ideas** | ▶ **unideevideo** | flickr flickr.com/photos/unidee/

April 6 – June 18, 2017

Jean-Luc Moulène
Rosa Barba
Anoka Faruqee

July – September, 2017

Alex Da Corte
Ericka Beckman

secession

www.secession.at Friedrichstraße 12 A-1010 Vienna

DAI ROAMING ACADEMY

APPLICATIONS OPEN 2017-2019

MOBILIZE OUR BODIES, OUR INTELLIGENCES

DAI proposes a vigorous curriculum that brings emerging artists, curators, activists and researchers together in MA courses curated and tutored by *Casco, If I Can't Dance I Don't Want To Be Part Of Your Revolution, Open!, The Showroom (London), the Van Abbe Museum* as well as by independent practitioners, in 2016-2017: *Bassam el Baroni, Sven Lütticken, Ruth Noack, Rachel O'Reilly, Sarah Pierce, Marina Vishmidt, Tirdad Zolghadr.* 10 x per year students and tutors plug into our Planetary Campus: a funky learning environment, temporary art commune, theory camp and think tank - in Arnhem or elsewhere in the world. Conviviality is at the heart of the program; infrastructures can be artworks too.

DAI
Dutch Art Institute
Roaming Academy

Vincenzo Latronico:
TO THE MALEVO-
LENT READER.
Guide to cosmic
communication
deciphered by local
alien

Johan Hjerpe:
FANTASTIC PERS-
PECTIVE. How to
withdraw from a p.o.v.
we're accustomed to,
and therefore
somewhat blind to

Lucy McKenzie:
15 QUODLIBETS.
Dissident commentary
in eye-fooling images

Jocelyn Penny
Small: IS LINEAR
PERSPECTIVE
NECESSARY?
One historian's take
on time and space in
2 dimensions

Mathew Kneebone
& James Langdon:
VECTORS FOR
LOOKING Vectors
for looking at & over,
around, between,
& through, words &
images in tandem

9mother9horse9eyes9:
THE INTERFACE
SERIES. Excerpts
from Reddit-dist'd
fragments: LSD,
Vietnam, Treblinka,
humpback wales, flesh
interfaces &c

Mark de Silva:
DISTANT VISIONS.
What does a
resurgent 'I' say
about contemporary
fiction and authorial
authority?

Abigail Reynolds:
LOST LIBRARIES.
Intrepid artist makes
cross-world journey
on motorbike through
remains of ancient
libraries

Sarah Demeuse:
CHAMPAGNE
WISHES AND
CAVIAR DREAMS.
Partial to bling,
indifferent to facts,
living the lifestyle
branding lifestyle

Jumana Manna
& Robert Wyatt:
NOTHING IS MORE
RADICAL THAN
THE FACTS.
Homely interview
on politics, art,
& keeping on

The Bulletins of The Serving Library
are published twice a year in summer
and winter. Individual PDFs are freely
available at servinglibrary.org, and the
printed journal may be purchased at
servinglibrary.org/shop. The current
issue presents various "perspectives,"
both literal and figurative.

On April 1 2017, we begin a long-term
residency at the Exhibition Research
Lab, Liverpool John Moores University.
For information on upcoming events
and teaching workshops, or to visit,
see servinglibrary.org/space.

THE INTERNATIONAL EXPOSITION OF CONTEMPORARY & MODERN ART

EXPO CHGO

13 – 17 SEPTEMBER 2017

OPENING PREVIEW WEDNESDAY 13 SEPT

CHICAGO | NAVY PIER

NORTHERN TRUST

Presenting Sponsor

Opening EXPO ART WEEK

CHICAGO ARCHITECTURE BIENNIAL

16 Sept – 7 Jan, 2018

PALAIS DE TOKYO

Off-site Exhibition
12 Sept – 29 Oct 2017

INSTITUT FRANÇAIS

Lake Series (Lake Michigan)
by Lincoln Schatz

expochicago.com

C

PUBLICATIONS

2016 — 2017

NTU **CENTRE FOR CONTEMPORARY ART SINGAPORE**

Ute Meta Bauer, Brigitte Oetker (Eds.)

SouthEastAsia Spaces of the Curatorial Räume des Kuratorischen

Sternberg Press

Published by
Sternberg Press
in collaboration with
NTU CCA Singapore

Edited on behalf of the
Association of Arts and
Culture of the German
Economy at the Federation
of German Industries

THEATRICAL FIELDS
Critical Strategies
in Performance, Film, and Video

Published by
NTU CCA Singapore,
König Books, London,
and Bildmuseet, Umeå

Becoming Palm

Simryn Gill
Michael Taussig

Published by
NTU CCA Singapore
and Sternberg Press

Tomás Saraceno
ARACHNID ORCHESTRA. JAM SESSIONS

Including Audio File

Published by
NTU CCA Singapore

NTU.CCASINGAPORE.ORG
NTUCCAPUBLICATIONS@NTU.EDU.SG

A

C

NANYANG TECHNOLOGICAL UNIVERSITY

Afterall Books
One Work

Afterall is pleased to present *Sigmar Polke: Girlfriends* by curator and academic Stefan Gronert, our latest title in the Afterall Books *One Work* series.

In his important early work *Freundinnen* (*Girlfriends*, 1965/66), Polke adopts the raster dots found in mass media reproductions, offering a statement about the use and social function of images.

Gronert's analysis offers rich insight to the art historical context in which this work was produced. Considering such topics as the distinction between Polke, Gerhard Richter and Alain Jacquet in their use of photographed material, between Polke's use of the raster technique and that of Roy Lichtenstein, and critical issues of gender and politics, the book draws on a variety of critical interpretations of Polke's work, including some material that has not yet been translated into English.

The *One Work* series is distributed by The MIT Press. Many of our titles are also available as e-books, they can be purchased at: mitpress-ebooks.mit.edu

Sigmar Polke
Girlfriends

Stefan Gronert

Afterall Books: One Work

MASTER OF VISUAL STUDIES

UNIVERSITY OF TORONTO
JOHN H. DANIELS FACULTY OF
ARCHITECTURE, LANDSCAPE, AND DESIGN

Studio Art & Curatorial Studies

The Master of Visual Studies (MVS) located in the Faculty of Architecture, Landscape and Design offers two streams of study: Studio Art or Curatorial Studies.

A two-year professional program with a close partnership with the Art Museum at the University of Toronto, where graduating students complete their research with a supported exhibition.

Early January 2018

Fall 2018 Admission
Application Deadline
Inquires:
graduate@daniels.utoronto.ca

III CCS BARD

M.A. PROGRAM IN CURATORIAL STUDIES

The graduate program at the Center for Curatorial Studies at Bard College (CCS Bard) is an intensive course of study in the history of the contemporary visual arts, the institutions and practices of exhibition-making, and the theory and criticism of the visual arts since the 1960s. The program is broadly interdisciplinary, and provides practical training and experience within a museum setting. It is uniquely positioned within the larger Center's tripartite resources, which include the CCS Bard Library and Archives and the Hessel Museum of Art, with its rich permanent collection. For more information visit www.bard.edu/ccs

Installation image from *We are the Center for Curatorial Studies*, October 15 - December 16, 2016.
Hessel Museum of Art, Bard College, Annandale-on-Hudson, NY. Photo: Lisa Quinones

Yearbook: New Art

A platform for art schools to present student work from MFA shows, open studio presentations, and other annual student exhibitions.

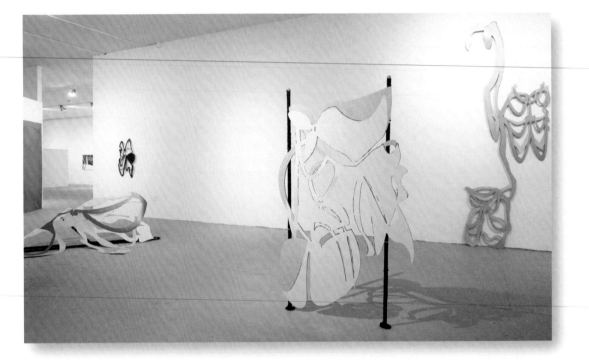

Judith Kakon and Anne Libby. Installation view, 2016. From the Milton Avery Graduate School of the Arts at Bard College MFA Class of 2017 Thesis Exhibition. Photo: Pete Mauney.

Academy of Fine Arts Nuremberg | Academy of Fine Arts Vienna | Columbia University School of the Arts | Ernest G. Welch School of Art & Design at Georgia State University | Goldsmiths, University of London | University of Fine Arts of Hamburg | Mason Gross School of the Arts at Rutgers University | Milton Avery Graduate School of the Arts at Bard College | Piet Zwart Institute at Rotterdam University | Sam Fox School of Design & Visual Arts at Washington University | School of Visual Arts | Städelschule | University of Pennsylvania | Yale School of Art

Art & Education

see more at artandeducation.net/yearbook
For more information please contact mail@artandeducation.net

MRes Art exhibition visit, Gasworks, London,
2017. Photo: William Howard

MRes Art:
Exhibition Studies

Applications for the MRes Art: Exhibition Studies course are now open for 2017-18 entry.

Delivered in collaboration with Afterall, this postgraduate research course at Central Saint Martins examines the history of contemporary art from the perspective of the exhibition form – analysing how artworks are encountered by publics, and shaped by display, discourse and critical reception.

The course, which lasts for two years and is taught three days per week, is directly tailored to individual interests and strengths, offering rigorous research training and a supportive environment for advanced study, including opportunities to undertake placements within the Afterall Research Centre. It is led by the course director, Yaiza Hernández, alongside course faculty, and joined by Afterall colleagues such as Lucy Steeds and Charles Esche. Recent visiting lecturers to the course have included Bart de Baere, Jakob Jakobsen, Pablo Lafuente, Laurence Rassel, Gayatri Sinha, Marina Vishmidt and many others.

The deadline for applications for the coming academic year (starting October 2017) is **30 June 2017**. Incoming Home, EU and International applicants wishing to qualify for the Vice-Chancellor's Postgraduate Scholarships must submit an application before 16:00 on **31 May 2017**.

ual: central
saint martins

FRIEZE ART FAIR

New York

May 5–7, 2017
Preview May 4
frieze.com

Media partner

FT
FINANCIAL TIMES

Global lead partner
Deutsche Bank